THE
MEMORY
PALACE

A BOOK OF LOST INTERIORS

Edward Hollis

BOOKS

First published by Portobello Books 2013

This paperback edition published by Portobello Books 2014

Portobello Books
12 Addison Avenue
London
W11 4QR

9 8 7 6 5 4 3 2 1

ISBN 978 1 84627 326 1

www.portobellobooks.com

Text designed and typeset in Van Dijck by Patty Rennie
Printed and bound by CPI Group (UK) Ltd, Croydon, CR0 4YY

MIX
Paper from
responsible sources
FSC
www.fsc.org FSC® C020471

Contents

Illustrations

INTRODUCTION

RECONSTRUCTION.
By Osbert Lancaster.

A Doll's House

IT'S ALMOST A MODEL: A LITTLE BRICK BOX, ONE OF THOUSANDS thrown down like toys somewhere in London's outer ring. The Doll's House, it's called; and it's only half a joke. It's so neat and symmetrical that it feels as if one could hinge open the facade to reveal the rooms inside.

Granny is waiting for me there, sitting in her sitting room. The fireplace is surrounded by pictures and little tables, upon which perch, precariously, flowers, ashtrays, and yesterday's *Daily Telegraph*. There's a sofa, four armchairs, a dining table, two corner cupboards, and two sideboards. There are two rugs, six curtains, and three mirrors. There are tens of pictures and hundreds of books, thimbles, paperweights, carriage clocks, statuettes, samplers, and vases. There are light bulbs, and biros, and a cupboard full of broken hoovers. The TV is on, at full blast, and so is the radio. There are more than 250 objects in there. I have counted them.

But it isn't a mess. Everything has been carefully constructed, arranged, collected, matched, and ordered to compose the whole room into a picture. There's a place for everything, and everything is in its place.

'Hello darling,' she says, and I bend down to kiss her cheek. It is powdery and as pale as that of a china doll. 'Would you like a tea? I'll get—'

But she doesn't get up. She can't. Two years ago, my grandmother lost the ability to walk up the stairs; and then one morning last January she woke up to find that she couldn't get out of bed. She was a model, once, and athletic, but now her legs are twisted, her feet crushed by years of pointed high heels into bunions as cruel as those on the most tightly bound feet in China. Rather as a monkey swings from tree to tree, she lurches from mantel to card table to cabinet to curtain, navigating from grip to grip. As a consequence, the simplest tasks take her hours.

'I've put out some biscuits on the side!' she shouts through, and she has. Granny has already arranged everything: I can see our supper congealing in saucepans on the hob, and even the bacon sitting in a saucer for tomorrow's breakfast, curling slightly at the edges. Granny has prepared everything in advance – you have to if you can't walk much – and however curiously it is set out, I resist the urge to rearrange it. It would infuriate her, and she would spend hours putting it all back again, exactly where she has memorized it to be.

And I come back with my tea, and sit down in the sitting room. 'How was London?' she asks. She already knows the answer: crowded, noisy, nightmarish. She hasn't been up for a couple of years now. 'And how are your boys?' Granny means my students. Even though I teach interior design, she assumes they're all boys. 'Did you see the news? Awful wasn't it? It's all just violence and celebrities now.' I always agree with her, firmly. It would be pointless to do otherwise.

It would be pointless for, as she and her friends become immobile or, worse, die, my grandmother finds herself more and more alone at home, less and less able to communicate with an outside world that, as a conse-

quence, appears to her more and more irrelevant and confusing. What was once a boundless domain now looks more and more like the direst stories on the telly – because that, increasingly, is all she's getting to see of it. A cluttered sitting room in a doll's house has become my grandmother's whole world. No wonder she arranges it with such care.

<p style="text-align:center">* * *</p>

This book is an anthology of rooms that might seem nothing like the one in which my grandmother sits. There is a cave where men turn into wolves, and a chair that, when it's put in the right place, connects heaven and earth. There's a dungeon in an enchanted island and a boudoir for an enchantress, lined with magic mirrors. There's a cage containing a priceless mountain of light, and a room that's made only of air. Strange they might seem, but they are all like the Doll's House, for each one of them is an interior.

It is only since the nineteenth century that people have been writing histories of them. Some, like Edith Wharton's *The Decoration of Houses*, are guides to high society taste and manners. Others, such as John Piles' exhaustive *History of Interior Design*, treat the interior as the inward extension of Architecture. Others still, such as Steve Parissien's *Interiors: The Home since 1700*, explore the middle-class values of comfort and display. More recently, Bill Bryson's *Home* is the latest in a long line of histories of domestic life. In general, histories of the interior have been written by, for, and about women like my grandmother: the homemakers of the aspirational bourgeoisie.

But this history will argue that the art of the interior is something even more important than the making of the middle-class home, for it has been provoked by the words of Mario Praz, who was both a historian of the home and a scholar of romantic literature. The interior, he argued, is:

A museum of the soul, an archive of its experiences; it reads in them its own history, and becomes perennially conscious of itself; the surroundings are the resonance chamber where its strings render their authentic vibration.[1]

In 1945, Praz wrote what has been translated into English as *An Illustrated History of Interior Decoration from Pompeii to Art Nouveau*; but the original Italian title was quite different: *La Filosofia dell'Arredamento* – 'The Philosophy of Furnishing'. It's a curious conflation, but one in the shadow of which this book has been written, for it will argue that the order of things in my grandmother's sitting room – or anyone's – resonates with the Order of Things in its widest philosophical sense.

This is a story about big ideas written in little cushions. It is the tale of how, like my grandmother, we have made ourselves at home in the world. It's a history that takes us from the cave to the cloud; but it's also an anatomy, for interiors are not made of any one thing. Rather they are the meeting places of many things: architecture and furniture, objects and surfaces, commodities and images, and, of course, people – giving birth, talking, thinking, making love, shopping, working, defecating, dying.

The ways in which we build, arrange, fill, and decorate the rooms we live in are exercises in building little worlds, and as our sense of the world has changed, so has its microcosmic model. The arrangement of chairs and benches in a medieval hall, for example, was a question of hierarchy within the family, the state, and the very chain of being. The battle between the fireplace and the television in the modern sitting room embodies a debate that goes far beyond the confines of the private home.

This book is, therefore, an archaeology of knowledge, written also in the shadow of another mistranslated title. Michel Foucault's *The Order of*

Things was originally published in French as *Les Mots et les Choses* – 'Words and Things' – and this is a story, written in physical words about material ideas.

Interiors are not abstract, but composed of evening sunlight on a grey curtain, and the glacial smoothness of polished mahogany, the sour smell and flaky touch of cheese straws balanced on occasional tables, and the crackle of tonic poured on ice at half past six. At the same time, they are ideological, for the situation I have just described, just like any other, pertains to a specific social class, of a particular philosophical complexion, at a particular moment in history.

Praz called such conjunctions of sense *Stimmung*, which translates roughly from the German as 'mood'. It's a musical metaphor: the word means, literally, 'tuning', and it relates to the verb *stimmen*, to ring. '*Das stimmt*,' they say in German, and in English it's the same, 'that rings true.' Mood and sound are intimately and invisibly related. 'You may be sitting in a room reading this,' wrote the composer Aaron Copland. 'Imagine one note struck on the piano. Immediately that one note is enough to change the atmosphere of the room.'[2] Conversely, John Cage's famous Four Minutes Thirty-Three Seconds of Silence turns the interior in which it is performed into an instrument, upon which the music of its inhabitation is quietly played.

Praz called interiors 'resonance chambers', because resonance is a matter of truth and beauty and all the rest of it; but is also a cooperative affair. An interior is a meeting place in which diverse elements resonate together to create a particular *Stimmung*; but that mood need not be the domestic bliss that is usually expected. There's nothing necessarily reassuring about the order of things.

* * *

Praz wrote his philosophy of furnishing in 1945, and in the introduction he
vividly described the destruction war had wrought on his subject:

> Wherever you looked, you could see only shattered ruined build-
> ings, the hollow orbits of windows, and fragments of walls, houses
> split in two with the pathetic sight of some still furnished corner,
> dangling above the rubble, surrounded by ruin: pictures hanging on
> broken walls, a kitchen with the pots still on the stove and there,
> in what must have been a drawing room, a sofa.[3]

He needn't have been so dramatic. Interiors are lost all the time. When we
move, we fill our new homes with objects from the old one; we repaint or
paper the walls; we might even knock them down. Then we lay the table,
light the candles, and sit down to eat. We know that soon enough, we will
finish the meal, and the flowers will wilt on the table. One day, others will
replace us in the house, bringing their own possessions with them. They
will repaint some walls, demolish some, and build others. One day even the
house will be gone.

Any *Stimmung* is a temporary sounding, and the art of the interior is
governed by one question above any other – not how big any room will be,
nor what it will be for, nor, indeed, how much will it cost, but quite simply
for *how long* it is for. Some of the interiors in this book were made of stone
and endured centuries. Others, made of silk, or marzipan, lasted for a few
hours or days. Some of them flash into and out of existence within seconds.
But they all disappear in the end.

True, there are rooms that have been re-assembled or preserved; but
without anyone to inhabit them, they, too, are lost. 'Where things are
listed in a catalogue,' wrote Praz, 'given numbers, fixed to walls or pro-
tected by velvet ropes so that no ill-disposed visitor may rob or deface,

there – in common opinion – all is death and graveyard.'[4] Ironically, it is exactly what has happened to his own apartment, which was turned into a museum after he died. Crowded with knick-knacks in pharaonic profusion, it's impossible to imagine anyone living in it.

Rooms disappear, and consequently any history of the interior encounters a problem of evidence, for its subject no longer exists. Praz admitted that his history of the interior was a history of *images* of rooms rather than of rooms themselves. He collected early nineteenth-century watercolours of interiors, but he was forced to admit that there was something uncanny about them:

> The precision of miniaturists of interiors ... has something odd about it. For who, in ordinary life ever observes with such minute accuracy the decoration of a room? Who doesn't limit himself to embracing the whole with a general glance, deriving vague and sometimes quite illusory impressions from it? If the owners them-selves ... can often not exactly remember all the details of the rooms they live in, how can we expect more casual visitors, or occa-sional guests? So it is not surprising that describers of the same room at times contradict one another ...[5]

Other media are similarly problematic. Descriptions are almost always written by temporary visitors rather than permanent inhabitants. Photographs taken of (rather than in) interiors show rooms that have been styled within an inch of their lives before being committed to film. Inventories and catalogues are drawn up after the fact of occupation has passed, for wills, bills, sales, and repossessions.

All too often, attention is only paid to interiors as they pass out of use or sight. In fact, rooms are often invisible until the moment of their

loss. On the one hand, signs hung on a door that say, 'Do not disturb', 'Engaged', 'Occupied', 'Meeting in Progress', show that interiors are in use. On the other, they deny entry to the curious, or disinterested. The very phrase 'the interior' when applied to the wider world, implies *terra incognita*.

So this book is a quixotic project, for the one common criterion for the inclusion of any interior in this history is that it must be lost. All the rooms in this book have, variously, been buried, their furnishings rearranged, their treasures dispersed, their decor redecorated, their contents sold, or switched off, their privacy violated. They are gone; and this text is one among the fragmentary traces they have left behind.

Rather than trying to restore them, this book will narrate the moments and modes of their disappearance, for the ways in which interiors are lost tell us as much about them as the ways in which they were created or inhabited.

When the Commons of England sentenced King Charles I to death in 1649, they sat upon his own seat of judgment; and after they had executed him, they broke the seat and buried it under the floor so that no king could ever sit there again. When, in 1789, the revolutionaries violated the secret boudoir of Marie Antoinette, they stole the locks and smashed the mirrors in which the queen used to gaze at her reflection. When the Great Exhibition came to an end in 1851, all of its contents, including the Crystal Palace itself, were sold on the very open market the exhibition had been designed to celebrate. *Damnatio memoriae*, the Romans called it — 'the damnation of memory'. They used to bury the houses of men whose memory they wished to condemn, ensuring, inadvertently, their preservation for posterity. Even the act of deliberate destruction is a memorial to the thing it is designed to destroy.

And the end is something that's there, unspoken, in my grandmother's

sitting room. 'Isn't it exhausting for you, living here, at home, on your own?' I ask; and her eyes flicker with irritation: she knows what I'm thinking. We've discussed it before. The Home.

There's even one she likes. Herenn House, it's called, and all her friends have been there. There would be people to talk to, and as much bridge as she could play. There would be no cooking and cleaning and mending to worry about, and no stairs to deal with.

But she won't go.

'Living here is my job,' she retorts, 'and doing it keeps me going.' She remarks on her friend Naomi, who is safely installed at Herenn House: 'She's got nothing to do, you know – she just sits looking out of the window.'

Granny would rather be busy and tired than inactive and bored; and busy she keeps, despite her relative immobility. From her armchair she joins battle with telephonists, plumbers, the neighbours, and the council, the objectives of her campaigns being the potholes in the road, the overgrown hedge next door, the leak in the roof, and the next fine arts society meeting. Living at home isn't a state. For her, it's an activity.

Granny was brought up to believe that entertaining was her profession, and she's still a pro. Once a month or so, she likes to invite friends round for lunch and bridge. Preparations begin a week in advance, when she must remember to ask someone else to take her to the supermarket, where she must remember to buy exactly what she needs – she will not be able to nip back there again before her guests arrive. Cooking a meal takes about three hours, and every move back to the kitchen to fetch a new course will take several minutes. As soon as her friends leave, Granny retires to bed. She won't wash up until the next day.

But it's during those lunch parties that the clutter of Granny's sitting room begins to make sense. The numerous little tables that litter the room

become plinths for bowls of snacks; the groupings of chairs and sofas opportunities for conversation; the polished mahogany table and the matching chairs the theatre for a long and complicated meal. Once the guests depart, the room reverts to its dormant state: a stage without actors, in the midst of which my grandmother enthrones herself with the remote.

Those lunch parties have been going on for years. They form short scenes from a long play; and the props have been around for as long as I can remember. The Doll's House is only one among many stages on which my grandmother has played out her life, and upon which those props have been arranged. Previous to the Doll's House she lived in the Garden Flat, made by a former Viceroy of India out of an old Ballroom in the Manor House. Before that there was Daljarrock, the Arts and Crafts house built by a Clydeside shipping magnate, and used by a maharajah to house his harem during the War. Then there was Elvisaran, the little cottage in Cornwall; the flat in Pinner; and the hotel in South Kensington where her own grandmother went to die. In the beginning there was Cranham Hall, her mother's childhood home. Now it's at the end of the District Line in Upminster, then it was a farm. It had been lived in once upon a time, Granny reminds me, by General Oglethorpe, who had founded the state of Georgia. The sitting room of the Doll's House is filled with relics of all the other sitting rooms she's ever occupied, even the earliest.

Granny comes alive as she talks about those vanished rooms, and so does the interior she is sitting in now. She gestures at it as she speaks, pointing her ringed fingers at things I have known all my life. 'Daddy [she means my grandfather, I think, but it is impossible] made that corner cupboard', she says, 'and Vicky got me the little cupids in Florence.' (There are six of them.) 'And the chairs – they're country chairs. I bought them from cousin Gerald's shop on the High in Oxford.' 'Tim made that

mirror for me – he was always so good with his hands. He lost his marbles in the end, you know – they found him outside, with no clothes on.'

I've never met most of these people; but I feel like I know them. At least, I know what Granny chooses to recall about them. In her sitting room, gesturing at the possessions she has arranged around her, Granny conjures up a jumble of the twentieth century I can never quite unravel, and never completely believe: a glamorous montage of seaplanes and golf in Le Touquet, country house clearances, gin, and the silver screen. The room, its contents, and the stories she tells about them are things my grandmother has spent a lifetime arranging and rearranging in order to tell an entertaining story.

As I sit and listen, I imagine Granny as a little girl. She is sitting on the window seat in the sitting room, picking at the pink and white *toile de Jouy* as her own grandmother talks, and her paid companions sit and listen, and the men smoke their cigarettes in the green billiard room next door. Granny Eve is conjuring pasts of her own from the very same objects I can see now.

Then I imagine it happening again, with some of the same things, eighty years before, as Granny Eve sits in another room and listens to her own grandmother. I've no idea where that room was, or how it was arranged, or even who she was.

Perhaps the house that contained that room has been demolished. I will never know who the first person was to sit on the chair I'm sitting in, or to drink from the glass I'm holding in my hand. Granny's sitting room is a stage in a relay between objects, buildings, furnishings, that stretches back, ultimately, over centuries. It is part of a chain so knotted and so long that I have no idea where it began. I only know that I too, as I sit and watch my grandmother conjure, am a link in it.

No wonder Granny won't go to The Home. She knows it won't be like

that at Herenn House. 'Naomi's lost her mind,' she remarks. 'She's got nothing left to think about, you see.' And nothing left for her memory to cling onto either. The Doll's House is hardly palatial; but to my grandmother, its crowded sitting room is arranged just as her memories are arranged. It is a treasury of her own constant and repeated creation, the museum of her own life and her fast disappearing way of life. One day – it is happening as I write – it will become her legacy.

<p style="text-align:center">* * *</p>

This isn't a book about modern interiors. In fact, it is an argument that there can be no such thing, for modernity implies a rejection of the past, a commitment to the future, and a deliberate forgetfulness.

Rooms and memories, on the other hand, have always been bound up with one another. Peel back the wallpaper on the wall and you'll only find more. Open a cupboard and it will spill forth treasures you haven't used for years. Once upon a time where, or if, we sat down reminded us who we were. Once upon a time we told and listened to stories by the fireside, and they reminded us where we came from.

All things are encoded with belief; but buildings and objects change much more slowly than the order of things that made them. The arrangement of rooms, on the other hand, clings closely to momentary concerns. As a consequence, interiors are ephemeral subjects made of permanent objects. Ancient buildings can contain modern interiors, and modern interiors can contain antique furniture. The rooms we live in are collages, constructed conversations between the past and the present.

The memories contained in the sitting room in the Doll's House, for example, operate over diverse durations. My grandmother presses the remote control to replace one artificial memory on the screen with another. An hour or so ago, she laid the table with knives and forks whose order on

the mat reminds us how to eat dinner. A decade ago, she arranged the furniture for entertaining, and she hasn't moved it since. The mantelpiece is hung with images of her ancestors, who have been dead for generations: it's exactly how her own grandmother would have arranged it, a century ago, and her grandmother before her.

Interiors do not just remind us who we are, where we're from, or how to behave. They remind us to remember. In fact, the story of memory always begins with a room, or at least it begins with the end of one.

One night, long ago, somewhere in ancient Greece, the poet Simonides was invited to dine at the house of Scopas the boxer. Simonides composed epitaphs for the dead, and verses to commemorate the deeds of great heroes. He'd composed one such verse for Scopas; but since half the poem was filled with praises for Castor and Polydeuces, Scopas had not paid him fully for it. He'd suggested, instead, that the poet might like to apply to the heavenly twins themselves for the balance.

It must have been an awkward meal. Then, halfway through dinner, a slave whispered in Simonides' ear: 'There are two men outside, waiting for you.' He got up to go to meet them, and went outside. 'You will have your payment', they told him, 'but do not return to dinner just yet.' And before he could turn around to bid the heavenly twins goodbye, the Hall of Scopas collapsed behind him, killing everyone inside it. So terrible was the wreckage that no-one could identify the bodies of those who had died.

No-one, that is, except for Simonides, who, being an epic poet in an age before pen and paper, had a prodigious recollection. Having committed the place of every guest at the table to his mind, he was able to reunite grieving relatives with the remains of their loved ones. Simonides was therefore credited with the invention of the art of memory, for he had been able to identify the dead bodies because he remembered *where* those guests had been sitting and when they were alive.

In ancient times, orators who had to learn long passages of speech by heart, believed that they could remember them better by assigning reminders of small parts of them to imaginary places. When the time came to speak they would take an imaginary stroll from place to place, encountering reminders along the way, in the correct order.

They called their constellations of reminders and places 'memory palaces', and they recommended that orators base them on real palaces and places. Their design was precisely prescribed. Colonnades, for example, were not to be recommended because the places between the columns were too repetitive to stimulate specific memories. The treatise *Ad Herennium* offers the following advice:

> ... backgrounds differing in form and nature must be secured, so that, thus distinguished, they may be clearly visible ... And these backgrounds ought to be of moderate size and medium extent ... [they] ought to be neither too bright nor too dim, so that the shadows may not obscure the images nor the lustre make them glitter.[6]

It could almost come from some treatise on interior design; and it is the contention of this book that all interiors are memory palaces: constellations of places in which reminders are encountered in the correct order, so as to remind us of what to do, where we've come from, and who we are.

So the history of the interior is also, therefore, a history of the art of memory. It's something of which Mario Praz was well aware, for, as he said, a room forms 'a museum of the soul, an archive of its experiences; it reads in them its own history'.[7] In 1958 he published *La Casa della Vita*, 'The House of Life', which was written both as his autobiography and also as a walk from room to room in his home. He ends the book staring at a mirror surrounded by his possessions, with the reflection:

this book that I have written is like a conspectus, in a convex mirror, of a life and of a house ... I see myself as having become an object and an imagined museum piece among museum pieces.[8]

Two years after Praz's elegy was translated into English, Frances Yates, a scholar at the Warburg Institute in London, began her classic *The Art of Memory* with the story of Simonides and the banquet. She ended it two millennia later with Leibniz, arguing that the memory palace, as it developed through classical times, the Middle Ages, the Renaissance, and the early modern era, led to the foundations of modern systems of knowledge:

> The art of memory is a clear case of a marginal subject, not recognized as belonging to any of the normal disciplines, having been omitted because it was no one's business. And yet it has turned out to be, in a sense, everyone's business. The history of the organisation of memory touches at vital points on the history of religion and ethics, of philosophy and psychology, of art and literature, of scientific method.[9]

Much the same could be said of the rooms in which we live – so ubiquitous, so protean, so taken for granted that they have traditionally been everyone's and no-one's business. This book will show how the order of things in the interior has developed in tandem with the art of memory, from its origins in rote learning and ritual repetition, to the artificial memory of the digital age, of which Frances Yates, writing in 1966, could only dimly have been aware.

This book has been designed as a memory palace, in which fragmentary reminders have been arranged in an order to recollect things from the past,

the present, and the future. It is a memory palace of several layers: six corners of my grandmother's sitting room bring to mind six palaces, each of which contained, once upon a time, a number of rooms now lost. Glancing from my grandmother's fireplace to her card table, her cabinet, her curtains, the broom cupboard, and the television, the mind wanders from room to room, from the cave in which we began to the cloud we inhabit today, each one of which represents a different mode of memory.

* * *

The memory palace was, in origin, a rhetorical device; and modest as they might be, the sitting rooms we sit in are as rhetorical as any speech. Mario Praz imagined the interior as the 'museum of the soul', and being the romantic he was, he assumed that that soul was solitary.

But rooms aren't just places we go to be alone. They are where we meet one another, and where we live together, not just as friends and intimates, but in wider society too. All of the interiors in this book are public rooms rather than private ones. In fact, they all inhabited palaces, once upon a time.

There are rooms from the palaces on the Palatine in Rome, of the medieval kings of England and the Holy Roman Emperors of Renaissance Bohemia, from Versailles, the Crystal Palace, and the picture palaces of the silver screen. Suites of five interiors tell the story of the structures of power and propriety that brought each palace into being, and the revolutions, evolutions, or ruinations that brought the order of things that made them to an end.

If it already seems like a foolish enterprise to make a memory palace of lost interiors, it must seem even stranger still, a little camp, perhaps, to devote so many words to such an anachronistic subject. Palaces have little place, it might seem, in much of the modern world, other than as relics of

less enlightened ages. At a time in which the revolutionaries of the Arab world have desecrated the leopard-skin Louis Quinze of their oppressors, palaces, and all they stand for, are surely out of step with contemporary life.

They always have been. Anyone who ever saw Louis XIV at the *levées* of Versailles, or the Vestal Virgins tending their sacred hearth in ancient Rome, or King Arthur's round table, would know that in palaces, bedrooms are never just bedrooms, fireplaces just fireplaces, or tables tables. Palaces are not just dwellings. Like the Doll's House that models them in miniature, they are the performance, the model, the monument, and therefore the memorial of dwelling. Palaces are, of their nature, memory palaces, designed to remember how they were lived in.

Most interiors disappear and are forgotten because no-one notices them. Rooms in palaces are, on the other hand, self-conscious creations, the imagined dwellings of whole societies, articulating their values in cushions and curtains rather than in laws and words. The right to wear the imperial diadem of Rome was vested in a purple room in the imperial palace. The hidden cameras of the Big Brother house arouse moral panic in a society that knows that everyone is on CCTV, all the time.

And while most interiors are everyone's, and therefore no-one's business, rooms in palaces have crowds of witnesses to remember them, armies of servants to maintain them, and schools of archivists to record their contents. Daybooks still survive at Versailles that record exactly what furniture was used in which room every day until the Revolution; and their evidence is corroborated in catalogues drawn up afterwards, to sell it on. Thousands of the six million who visited the Crystal Palace for the Great Exhibition in 1851 wrote down their conflicting impressions of what they saw.

Palaces remind us that interiors can be airships, superclubs, film sets,

shops, museums, hotel lobbies, restaurants, hospital wards, public toilets, and nuclear bunkers, for all their ancestors are to be found in the palaces of the past. The ancient houses on the Palatine in Rome give us our very word for palace; and the medieval furnishings of Westminster were the germ of the institutions of modern democracy. Museums were born in cabinets of curiosity; and the decorative language of Versailles is still used when a sense of occasion is required in cafes, hotels, and even in my grandmother's sitting room. The Crystal Palace is the prototype of the mall; and soundstages of Hollywood the multimedia environments of the nightclub and the teenage bedroom.

The story of the interior, from Mrs Beeton's *Household Management* on, has been told again and again as a bourgeois tale of homely comfort and display. It's an approach shared by the interiors sections of most bookshops, the magazine racks of newsagents, and countless makeover shows on TV, which all retail aspirational advice on shopping, homemaking, and living in the country. It's an assumption that makes interiors seem comforting, domestic, private, and ultimately trivial.

This memory palace of lost interiors has been remembered to challenge this perception. Interiors aren't trivial. They're certainly not reassuring. They can – and should – be as beautiful and as sublime as any art, for the order of their things is the Order of Things.

But this memory palace has started, and will end, like all books about interiors, in a middle-class sitting room. It could be yours, or mine, but as it happens, it belongs to my grandmother. It is a treasury amassed over nearly a century; and each of the treasures assembled there has a story to tell, for it has been taken from other interiors, long lost. Granny's sitting room has been created, like the memory palaces of antiquity, to bring tales of the past to mind, and here it recalls all the interiors that, inadvertently or deliberately, have inspired and shaped it. It might appear, at first

glance, like a little doll's house, a harmless home, an anachronism; but in fact it is an antechamber — to room after room of an endless, vanished palace.

ARCHITECTURE

A HEARTH *AND A* HOME.
The Aedes Vestae *of Ancient Rome.*

Focus

THE APPARENT FOCUS OF GRANNY'S SITTING ROOM IS SOMETHING that resembles a fireplace. I say it resembles a fireplace, for despite the collection of pokers and tongs, a fireguard, a blackened grate, a vaguely classical mantel, despite the basket of logs, this fireplace hasn't been used for years. Instead, an electric heater placed on the hearthstone provides instant hot air at the flick of a switch.

The columns and cornice of the mantelpiece form an aedicule: a miniature shrine, or temple. Of this my grandmother must be subliminally aware, since she has adorned it not only with the sacrificial instruments of fire making, but with her own household spirits. The mantel supports two crystal candlesticks that frame these like icons on an altar.

There are photographs taken of my mother and my aunt when they were little girls. They look adorable in their white dresses and curls – curls which were achieved, my mother recalls, using tongs so hot that, when tested on a piece of newspaper, they set it alight. There are snaps of my cousin and her boyfriend, skiing, and my niece and nephew, dressed as

shepherds in the nativity play. There are cards from absent friends, and invitations to parties that have already happened.

And either side of this altar, in little oval frames, hang departed shades. To the right there are Grandpa and Granny Eve, from whose home at Cranham Hall most of the furniture in this room once came. Granny can recall sitting in the same chair I'm in now as a little girl, with Granny Eve by her own fireplace. She was a countrywoman, Granny says, attuned to the moon; and she taught her everything.

And opposite Granny and Grandpa Eve, two matching cameos of Napoleon and Josephine have also been slipped in, although I'm pretty sure they aren't relations. Grandpa Eve picked them up in Italy on his honeymoon, Granny says, and they must have hung by Granny Eve's fireplace just as they hang here now. Her own grandmother would have been old enough to have remembered them while they were alive.

Console tables support further household gods: to the left, silver-framed photographs of my aunt, my uncle and my mother are styled in the manner of some solemn Garbo or Bacall. To the right, pictures of my grandfather are accompanied by the little silver tankard in which, my mother recalls, Granny used to take flowers to him when he was dying.

'Hearth and Home' we say. The two are inextricably linked, for fireplaces are usually one of the longest-lived parts of any interior, and the least negotiable. Fire is dangerous, and usually, therefore, encased in masonry. Long after its utility has passed away, the location of the fireplace can still dictate the layout of a room.

Like an appendix or a wisdom tooth, therefore, fireplaces are anachronistic relics; but it wasn't always that way. Once upon a time, fire provided light, heat and food. It was home, and people would huddle around it to while away long dark evenings. Stories were told by the fireside, and silent

hours were spent staring into the flames, remembering others who used to do the same.

Fire is also transient, and, unwatched, will go out. Like a myth that will die unless it is constantly retold, or a memory that will fade without remembering, fire requires repeated remaking; and that means it will always change. While it may flicker in the same hearth, no fire is identical to its predecessor.

The earliest forms of memory are like fire. An anonymous fragment of text from around 400 BC, the *Dialexeis*, comments:

> A great and beautiful thing is memory, always useful for both learning and life ... if you pay attention the judgement will better perceive the things going through it ... repeat again and again what you hear; for by often hearing and saying the same things, what you have learned comes complete into your memory ... what you hear, place on what you know. For example, 'Chrysippus' is to be remembered; we place it on chrysos [gold] and hippos [horse].[1]

It's what we do when we make fire, for fire requires constant attention, and must be repeatedly relit. It is, as the *Dialexeis* recommends, the placing of something new on what we already know – the creation of a new fire in an old hearth. The *Dialexeis* described what we might now call rote learning, or learning by heart: the product of a threefold process of concentration, repetition, and building slowly on what we know. It's how many learn to remember – and how many learn to learn – as children.

It is how the seers who sang the Lays of Ancient Rome remembered what they had to say as they stood by fires of their own, ready to repeat the stories of their own origins. They lived long before oratory and memory palaces, and had to work with simpler techniques.

Their myths and legends all began on the Palatine Hill. It's a park now. It's been a garden since the sixteenth century; and before that, part of the wilderness that surrounded the decrepit village of medieval Rome.

But once upon a time the Palatine was a matrix of magnificent atria that grew over the centuries, as each emperor took advantage of his moment between election and assassination to make his mark on the hill. Each of them built his own palace on top of that of his predecessor, and so as we dig down through the marble, brick, concrete, and rock we make our way backwards, interior by buried interior, through palace after palace, story after story, to the origin of them all, the original palace, and the original room, and the original story.

It is a curiosity that any remains of it have survived at all. It must have been a basic affair: a blackened hut, at whose centre burned a fire, above which a hole in the roof admitted light and allowed smoke to escape. It was where the Romans began, or so they believed.

The Romans used the word 'focus' to describe the hearths of their houses, and even in my grandmother's centrally heated sitting room, the fireplace exercises a power out of proportion to its efficacy, or its scale. It is no accident that she has arranged pictures of her ancestors around her memory of a fireplace. Both of them, fire and family, remind her repeatedly of where she has come from, and of who, once upon a time, she was.

Porphyrogenitos

ONCE UPON A TIME, LONG BEFORE YOUR GRANDMOTHER WAS BORN, an old woman sat down in a room to tell her story. She decided to begin at the very beginning.

'I have been conversant with dangers ever since my birth', she wrote, 'and fortune has certainly not been kind to me.'[1] Right from the start, it hadn't been easy. Her father had been away at war when the labour pains began; but her mother made the sign of the cross on her belly, and told the child to be still until he returned. 'How do you know whether he will come within a month?' the midwives scolded her. 'And how will you be able to bear the pains so long?'[2] But the child waited until her father was home before emerging, howling and purple, from the womb.

She had always been conversant with danger, she thought, and then she stopped, and remembered: '... unless you were to count it a smile of kind fortune ... allowing me to be born in the purple room'.[3]

Few of us can remember the room in which we were born; but she did, with uncanny accuracy. 'It was shaped', she wrote, 'as a complete

square from its base to the spring of the roof, which ended in a pyramid; it looked out upon the sea and the harbour where the stone oxen and lions stand.'[4]

She had only been there for a moment. Her father placed a diadem upon her tiny head, and picked her up, and took her to the door, where he showed her to the people waiting outside, who cried:

'God send bright days to the Augustai and Porphyrogenitai!' ...
'God grant them victory!' ...
'God give bright days and birthdays to the Porphyrogenita you
 have made!'
'Holy Spirit, protect the Augustai!' ...
'Mother of our God, keep the race of the Porphyrogenitai!' ...[5]

For Anna Comnena was no ordinary child. She was *porphyrogenita*. That is to say, she had been born in the Purple Room. It still embittered her, as she sat confined in her cell. Things could have been so different, had the promise of that room been fulfilled.

* * *

The room was a room, nothing more; but it granted all the *porphyrogenitoi* and *porphyrogenitai* that were born in it a special privilege, for it was they, and only they, that were entitled to the titles of Caesar, Augustus, and to wear the diadem of the Emperors of Rome.

The promise of the Purple Room was jealously guarded, for it bestowed upon those who received it an almost supernatural splendour, and it always had. One hundred and fifty years before Anna had been born, an ambassador described meeting the Emperor in another room in the imperial palace:

A certain tree, bronze but covered over with gold stood in front of the emperor's throne. And birds of various types, likewise made of gilded bronze, filled its branches and uttered the cries of birds, each according to its species. The emperor's throne was constructed in such a way that at one moment it appeared to be very low, then higher, and at another moment it seemed very lofty. The throne was of immense size, made either of bronze or of wood. Lions covered with gold stood as if guarding it, and beating the ground with their tails, they produced a roar with mouths open and tongues moving ... I was moved by neither terror nor admiration, since I had learned much about these things from men who knew them well.[6]

Liutprand had come in 968 to demand a *porphyrogenita* for the King of Italy. He thought he had a good hand to play: his master had occupied many of the Emperor's lands, and he had promised to return them in exchange for the marriage – but the Emperor said nothing directly to him and instead sent him away with a curious gift: the right to buy as much purple cloth as he desired.

When Liutprand returned some years later to ask for a more definite answer, he found that the Emperor Constantine had been replaced by Nicephorus, who was less diplomatic than his predecessor. 'It is an unheard of thing', said his courtiers, 'that a daughter born in the purple of an emperor born in the purple should be joined in marriage with strange nations.'[7] They then stripped him of his purple stuffs and sent him home.

It was a precise insult. Purple was extracted from murex shells, and they were so rare that to wear cloth dyed in the colour signified great status. Alexander the Great wore it in imitation of the Great King of Persia; and the patricians of the Roman Republic distinguished themselves

from the plebeians by wearing a purple stripe that ran down their togas. The right to wear purple was an honour bestowed on only the most favoured of courtiers, and then, only by the Emperor.

Purple clothing was the outward sign of imperial splendour, but the right to wear it was vested in a room. It was a simple device – a way of ensuring that the imperial crown would remain attached both to the buildings and the bureaucracies of *Megale Palation*, the great palace that contained the little Purple Room.

And devotion to the great palace of Rome was the *sine qua non* of the good Emperor. 'Constantine was a mild man', wrote Liutprand, 'who always stayed in his palace, and by such means as this made the natives friendly to him; but', he observed of his successor, 'Nicephorus, a man given to war, abhors the palace as if it were the plague.'[8]

The *Megale Palation* was certainly a place to whose countless rooms one could devote a lifetime of exploration. There was the *Chrysotriklinos* – the Golden Dining Room – in whose gilded forests Liutprand encountered Constantine; the *Lausakios*; the *Triconchos* – a grotto containing fountains of fruit juices and wine; the *Sigma*; the Hall of the Nineteen Couches; the *Heröon* – in which the emperors were buried along with relics of the Apostles; and of course the *Porphyra* – the Purple Room itself. Constantine knew them all, for he had been born in one of them. One day, he hoped, he would be buried in another.

And he knew precisely how every one of them should be used. The *De Ceremoniis* of Constantine Porphyrogenitos runs into over eighty chapters, describing protocols for the kiss of peace between the Emperor and the Patriarch on Maundy Thursday, and instructions for the Emperor's dress in processions. There were forms of words to be uttered when an emperor was buried, or on his birthday, instructions for the holding of ballets, and for the staging of dinners in the Triconchos when the weather was inclement.

There was advice about what to do when a *spatharocandidatos* was about to become a *protospatharios*, how to play the Gothic Game in the Hall of the Nineteen Couches, how to follow the races of the Lupercal, or indeed, what to say when a child was born in the Purple Room.

The *De Ceremoniis* described the daily life of a house and its inhabitants, the life of an emperor from birth in the Purple Room to enthronement in the *Chrysotriklinos* and burial in the *Heröon*; and in doing so, it described the life of an empire. The Emperor wrote it as an act of memory. 'Many things disappear of their nature over time and are exhausted through use', he wrote, 'and among them is the great and precious performance and codification of imperial ceremonial. Because it has been neglected, and is, as it were, dead, the Empire is unadorned and without beauty. It has become like a body badly constituted, whose members are met pell-mell, without order.'[9] For Constantine, the rooms and the rituals of the *Megale Palation* weren't just a habitation and its habits, they *were* the Empire. He could not have thought anything else. Constantine was, as all the Emperors of Rome were meant to be, *porphyrogenitos*. He had been born in the palace, and he rarely left it. It was his world.

Constantine hoped that the *De Ceremoniis* would be 'like a mirror, clear and razor perfect, that we shall place at the centre of the palace'. It was a magic mirror, in whose silvery reflection empty halls and chambers composed themselves into solemn rituals, noisy parties, and glittering spectacles.

But while the mirror of the *De Ceremoniis* reflects bewildering multitudes of words, garments, and gestures, it says almost nothing about the appearance of the rooms themselves. The Gothic Game is played in a hall containing nineteen couches. Over the door of the *Chrysotriklinos*, there is a veil. That is all.

It could not have been any other way. Constantine was *porphyrogenitos*,

and he rarely left his palace. It would have been so familiar to him that it would not have occurred to him to describe what it looked like. That required no memory, for, unlike the rituals it had once housed, the palace was still there.

So the only people who ever directly described any of the interiors of the *Megale Palation* were outsiders: amazed barbarians, Liutprand the ambassador, impressed despite himself, and, a century or so later, the only person who ever described the Purple Room: Anna Comnena.

* * *

She only remembered it because she'd forfeited the right to inhabit it. Anna might have been *porphyrogenita*, but she never became the empress she had hoped to be. Although her mother supported her claim as the first born, although she married a Caesar, her younger brother John slipped the ring from his dying father's finger and claimed the imperial crown for himself; and of course, since he was a man, everyone let it happen. Anna, outraged, tried to murder him, and when she failed, she was exiled to a nunnery to repent at leisure.

'Fortune has certainly not been kind to me', she remembered from her cell, 'unless you were to count it a smile of kind fortune ... allowing me to be born in the purple room,'[10] and she brought it to mind again.

'The floor of this room was paved with marble and the walls were panelled with it ... and this marble is, roughly speaking, purple all over except for spots like white sand sprinkled over it.'[11] Porphyry, the stone was called, and it was a rare and precious gem. The icons of the ancient Pharaohs were carved in porphyry, and so were the tombs of the Emperors of Rome, and so was the room in which they were born.

Porphyry came from a mountain in the upper reaches of the Nile. It had been on the southern marches of the Empire, once upon a time, but that

was centuries ago by the time that Anna Comnena described the room.

And so the room, like the Empire itself, was centuries old. Anna was *porphyrogenita*, and so was Constantine, two centuries before her. The first *porphyrogenitos* had been the Emperor Leo, who had been born 250 years before that, so the room must have been older than he was.

Anna Comnena remembered the room in which she had begun, but she could only guess at its own beginning, for it had been there so long that no-one could remember when or how it had been born, other than from a scrap of a story: 'Earlier Emperors had carried [it] away from Rome,'[12] she wrote. That was all.

For while Anna, and Constantine, and Nicephorus, and Leo, and all the rest of them had been born into the purple, and were Caesars and Augusti and Emperors of Rome, they had never been there, and never would. The *Megale Palation* wasn't on the Palatine Hill, although, like all palaces, it was named after it. It was in Constantinople, the city that had supplanted Rome as the capital of the Empire in the fourth century AD.

The *porphyrogenitoi* might have been born in the purple, but they were Emperors of an ersatz, diminished *imperium*, whose provinces had been lost to barbarians, whose ceremonies had fallen into desuetude and whose authority was borrowed from somewhere else. Even the Purple Room at its heart had been cobbled together from fragments of some other one: long ago, the legend ran, sheets of porphyry had been prised from walls in ancient Rome, carried across the sea, and re-erected in a new room, in a new palace, in a new Rome.

It wasn't just the rarity of porphyry that lent the Purple Room its imperial promise. It wasn't just that it was hidden in the heart of the palace; and it wasn't just the resonance of the colour purple. Anna Comnena had no idea whether it had come from Rome or not, but she hoped that it had. The Purple Room was a memory, a relic of another

faraway place that represented to the Romans of Constantinople where they had begun, and who, therefore, they were.

It reminded Anna Comnena of who she had been at least, as she sat in her cell, deprived of her purple finery, meditating on the wrecked promise of her birth; and as she wrote, she imagined that ruined room, in a ruined palace, in ruined Rome, from which, once upon a time, her own beginnings had begun.

Domus Aurea

NO-ONE IN ROME KNEW WHERE THAT ORIGINAL ROOM HAD GONE; and when, in 1504, Felice de Fredis started digging his vineyard, he didn't expect much, other than vines, not in the beginning. It was in the *desabitato*, the wasteland between the village of Rome and its ancient walls, and the nuns next door told him they barred their doors every night against the creatures that lurked among the ruins. The soil was peppered with chips of marble and brick, they said, that made it difficult to work. He certainly didn't imagine it would produce wonders of nature.

But on 14 January 1506 his labourers dug up a creature so strange that de Fredis felt obliged to contact the Papal authorities; and in the following weeks his house was filled with all the grandees of Rome who came to see it. It was a marble monster, so tightly coiled in the embrace of a serpent that it was almost impossible to tell where the man stopped and the snake began. It was horrible, they murmured, but they were fascinated all the same.

The Pope had the monster taken away to the Vatican — it is still there

— but even after the Laocoön sculpture had left, people would still turn up to root around, for they were convinced that if De Fredis' vines had turned up one monster, it must hide others. Raffaello de Santi and Giovanni da Udine were painters, they said; but they were scholars too. They had come to explore the remains of the palace of the Emperor Titus in which, they told de Fredis, the Laocoön had lurked in ancient times.

He showed them where to go, and the two lowered themselves into the darkness with ropes, clutching firebrands. They emerged hours later talking of beasts and men intertwined, of impossible architectures, furniture that grew leaves, fish that belched feathers and goats with the faces of sphinxes. *Grotteschi*, they called them, because they had found them painted onto the walls of grottoes. The colours were still bright, they said, for, as Vasari later wrote, they 'had not been open or exposed to the air, which is wont in time, through the changes of the seasons, to consume all things'.[1]

There was cave after cave, they said, a troglodyte palace, and at its heart an octagonal chamber, sheltered by a dome, at whose apex an eye must once have opened to the sky. On each side, a recess opened into a vaulted niche that obtained its own light and air from an ingenious system of ducts and chutes. A rill ran through the middle of the room from a rocky nymphaeum on one side, to a great door on the other. It must have been wonderful once, they said, but now, in the darkness, the door was blocked, the fountain dry, and the eye was closed.

Raffaello de Santi and Giovanni da Udine knew what they'd found. They were scholars as well as artists, and they'd read their classics. The ancient biographer Suetonius had described this place in his *Lives of the Twelve Caesars*. It was a breathless, tantalizing scrap of ancient gossip, nothing more, written half a century after the room had disappeared, but they remembered it all the same. He'd talked of a dining room, lined 'with fretted ceils of ivory, whose panels could turn and shower down flowers and

were fitted with pipes for sprinkling the guests with perfumes. The main banquet hall was circular and constantly revolved day and night, like the heavens.'[2]

That room was the stuff of legend: the first word in imperial splendour, and an inspiration to generations of despots. The Holy Roman Empress possessed a chamber laced with secret ducts for perfume, and the Emir of Granada a harem in which the sunlight passed over the fretted vaults, making their stalactites shine like stars. Charlemagne's throne room at Aachen was surmounted with an octagonal golden dome; and Chosroes I, the King of Persia, reclined under one that revolved day and night, and was covered with the patterns of the constellations. The room had inspired the emperor Elagabalus to scatter rose petals on his guests – in such quantities that he suffocated them. It was the prototype of the *Chrysotriklinos*, the Golden Dining Room in the *Megale Palation*, for that room, too, was surmounted by a heavenly dome and filled with impossible monsters.

* * *

The room they had found was the progenitor of them all; but it didn't belong, the painters realized with a delightful shiver, to the palace of the virtuous Emperor Titus. It was the lair of a monster more grotesque, more terrifying even than the Laocoön: one whose name had, in the centuries since this room had been buried, become a byword for imperial decadence.

He wasn't born a monster. When he was young, the people loved him; he was exactly what an emperor born in the purple ought to be, and he lived in the atria of his forefathers.

But in AD 65, a disastrous fire swept through the centre of Rome. It lasted for nine days, and it was only brought to an end by the demolition of all the houses at the foot of the Forum, in the valley between the Palatine and Esquiline hills. After he had quenched the flames, the Emperor

threw open his palace to house the homeless, and gave corn to the people. But the people were not as grateful to their Emperor as they should have been, and some ugly rumours started to circulate. The demolitions at the foot of the forum, it was whispered, and even the fire itself, had been the Emperor's work.

He certainly took advantage of the destruction wrought by the fire. Where the demolitions had taken place, he built himself a new palace. It was a very conventional sort of house at first, fashioned from the foundations of the houses that had been burned down before it. A colonnaded courtyard, the *atrium*, formed the entrance to the palace. It was rectangular, and the end of it opened into a large niche, the *tablinum*, where, according to ancient tradition, the Emperor would sit to receive his visitors.

But soon enough, something in the man began to change, and so did his house. 'He thought', Tacitus later wrote in his *Annals*, 'that there was no other way of enjoying riches and money than by riotous extravagance.'[3] As Suetonius observed, he loved spending money on nothing more than building, and a rhyme started doing the rounds of the city:

> *The palace is spreading and swallowing Rome*
> *Let us all flee to Veii and make it our home.*
> *Yet the palace is growing so damnably fast*
> *That it threatens to gobble up Veii at last.*[4]

The palace grew so wonderful that, soon enough, it acquired a nickname: 'the Golden House'. But it was much more than a house, even a golden one: built right in the middle of Rome, it was a new Rome, a miniature empire, an imaginary world. There was a sea that was surrounded, Tacitus wrote, 'with buildings to represent cities, besides tracts of country, varied by

tilled fields, vineyards, pastures and woods, with great numbers of wild and domestic animals'. Like the Empire it represented, it was filled with all sorts of marvels. The walls were lined with porphyry, and set with precious stones, or painted by the master Amulius, in the latest and most imaginative style. There was a colossus of the Emperor; and a temple of Fortune made of a rare stone from Asia, translucent so that even when the doors of the temple were closed, the interior was still suffused with light. At the heart of this world, the architects Severus and Celer made their extraordinary dining room.

Tacitus was of course appalled by the luxury of this palace, but he also levelled a subtler charge against it:

> Its wonders were not so much customary and commonplace luxuries like gold and jewels but lawns and lakes and faked rusticity — woods here, open spaces and views there. With their cunning, impudent artificialities, Severus and Celer did not baulk at effects that nature herself had ruled out as impossible.[5]

For the Emperor had turned the city into the countryside. He had built a temple to Fortune that never experienced the misfortune of darkness. He dined in a dining room that not only magically excreted food, flowers, perfume, and music, but also revolved like the heavens. The old *tablinum* was transformed into a vaulted nymphaeum, in which the Emperor could recline like a river god rather than sit enthroned like his ancestors.

He had been born a man, he had become an emperor, but in his new house he was reborn a colossus, a god. It is ironic that when he moved in, he is reputed to have said 'now I can live like a man,'[6] for in fact his Golden House was designed to liberate him from his humanity.

When the palace was ready, the Emperor decided to throw it open to

the people, to forgive them for their rumour-mongering. He was blameless, he claimed. The great fire of Rome had been set by a sect called the Christians, he said, and he would punish them for their crimes, in the sight of all.

He invited the people to a party, and in order to illuminate and entertain them, he carried out his vengeance:

> Mockery of every sort was added to their deaths. Covered with the skins of beasts, they were torn by dogs and perished, or were nailed to crosses, or were doomed to the flames and burnt, to serve as a nightly illumination, when daylight had expired.[7]

And that was just the start. Once the people were gone, and the Emperor was in private, amid the splendour of his gilded halls, or perhaps in some artfully rusticated spot in the gardens, he 'devised a kind of game, in which, covered with the skin of some wild animal, he was let loose from a cage and attacked the private parts of men and women, who were bound to stakes'. 'When he had sated his mad lust', wrote Suetonius, 'they were dispatched.'[8]

'Now at last I can live like a man,' he'd said, but the illusion of absolute power that his Golden House gave him turned someone who had once been a man into the Emperor Nero – 'the black', the nickname meant – a human being into a beast, who couldn't help but torture even those he loved. 'He castrated the boy Sporus', wrote Suetonius, 'and actually tried to make a woman of him; and he married him with all the usual ceremonies, including a dowry and a bridal veil, took him to his house attended by a great throng, and treated him as his wife.'[9] One can imagine the grotesque wedding breakfast in the domed dining room, with rose petals showering down like blood on the wounded boy.

Nero committed suicide four years later, lying on a straw mattress in the suburbs as Sporus wailed beside him. If he hadn't killed himself, someone else would have done the job for him. They placed the Emperor's ashes in a porphyry urn, and his mutilated bride was handed over to the next Emperor, a brutish soldier, as a catamite.

Nero's successors decided that the best thing to do with the Golden House was to bury it. It was an ancient punishment: *damnatio memoriae*, reserved for the most egregious of criminals. Titus built his palace over the top of the octagonal room; Domitian and Trajan built public baths over the nymphaeum, and Vespasian constructed an amphitheatre over the inland sea – the Colosseum – named after the colossus that Nero had placed there. Martial wrote an epigram to celebrate:

> *Here where the heavenly colossus has a close view of the stars*
> *And high structures rise on the lofty road*
> *There once shone the hated hall of the cruel king*
> *And one house took up the whole of Rome*
> *Here where rises the huge mass of the awesome amphitheatre*
> *In sight of all was Nero's pool*
> *Here where we admire the baths built so quickly for our benefit*
> *A proud park deprived the poor of their houses*
> *Where the Claudian temple spreads it wide shade*
> *Stood the last part of the palace*
> *Rome is returned to herself under your rule, Caesar*
> *The delights of their master have become those of the people*[10]

But the Emperors who buried the 'hall of the hated king' under their public works guaranteed its survival, for it was the complete isolation of its chambers from light and air that, as Vasari observed 1,400 years

later, preserved the vividness of the grotesques that had been painted on them.

Raffaello de Santi and Giovanni da Udine called them grotesques because they found them in rooms that had been turned into caves; but they were also grotesque in the manner in which we understand the word today, for those strange creatures that still dance over the plaster of the *Domus Aurea* are unnatural metamorphoses. Like the Laocoön that once lurked among them, like the Emperor at whose command they were made, like his Golden House, they are monsters, abominations, and crimes against nature.

They are still digging them up today, for the Golden House was so extensive that no-one knows where, under what used to be the vineyard of Felice de Fredis, it begins and ends. A circular column was found in 2009, which cored some thirteen metres down through the foundations of the palaces on the Palatine Hill. It might have been the axle around which, once upon a time, Nero and his dining room revolved. It might even have been the progenitor of the purple room.

But we shall never know; others argue that the room was an occasion, rather than a place: a pavilion erected in the gardens for a delightful day or two, and then packed away leaving no trace at all. Perhaps, like all monsters, this porphyry was only ever a fiction. All the room has really left behind is a rumour, repeated by a gossip decades later, and then only to damn the memory of the man who lived in it.

Domus Augusti

IT TOOK ARCHAEOLOGISTS MONTHS OF DIGGING TO FIND THE
original prototype of Nero's house, so completely was it buried under the
Napoleonic park, the terraced vineyards of the pontifical gardens, the
fortifications, temples, pleasure domes, and palace after imperial palace;
but when he unearthed it in the 1960s, it wasn't palatial magnificence that
convinced Gianfilippo Carettoni that he had found the home of the first
emperor of them all.

Carettoni didn't dig up a building. He found, instead, an interior: a
colonnaded court, an atrium, lined with painted rooms, their colours,
restrained and delicate, preserved by centuries in the basement darkness of
other palaces. The front door the *fauces*, was on the south side of the court
and on the other side, opposite the door, a niche known as the *tablinum* was
flanked by symmetrical rooms and painted, as far as the scanty remains
could indicate, slightly more richly than any other room.

There was no porphyry here. Indeed it was the very modesty of this
house that convinced Carettoni of what he had found, for the house he

dug up was the only house, on this most palatine of hills, that wasn't a palace.

* * *

It's what Suetonius had said all along. Augustus' house on the Palatine was 'remarkable neither for size nor elegance', he wrote, 'having but short colonnades with columns of Alban stone and rooms without any marble decorations or handsome pavements'.[1] Suetonius saw the furniture it had once contained; and he commented that it was so mean that it might have belonged to a private citizen.

The manners of Augustus, too, were as modest as his domestic tastes, for, being the first emperor, he hadn't been born into the purple. 'His morning salutations were open to all,' wrote Suetonius, 'including even the commons, and he met the requests of those who approached him with great affability, jocosely reproving one man because he presented a petition to him with as much hesitation "as he would a penny to an elephant".'[2]

Those salutations were, after all, nothing more than what any patrician of the Roman republic would have done. For centuries, at the first hour of the morning, the doors of every house of the Palatine would be thrown open, and every *paterfamilias* would enthrone himself in his *tablinum* to receive his guests and to make offerings to the gods of the hearth and the home.

When they were born, every one of them was carried out into the *atrium* and sacrifices were made to the gods. When they were married, their wives paused at the front door and decorated it with wool they had spun with their own hands. When they died, they were laid out in the *atrium* for all their clients to see. Gazing at them from the *tablinum* walls were the death masks of all their ancestors who had sat in the same place before them.

It had always been that way. In his histories, Livy told the Emperor that when the Gauls had sacked Rome four centuries before, the fathers of the nation did not flee the city, but opened the doors to their houses at the first hour, as they had always done. They sat down in their *tablina*, at the heart and the hearth of their homes, surrounded by their ancestors and their pathetic household gods, and waited for the Gauls to salute them with swords. They would rather die than leave their homes, for it was the home, the seat of the family, both living and dead, that made them Roman.

Augustus hadn't been born in the purple, and he didn't live in a palace. Like the senatorial toga that he wore, Augustus' home was just right: 'neither close nor full, his purple stripe neither narrow nor broad'.[3] 'When the people did their best to force the dictatorship upon him,' wrote Suetonius:

> he knelt down, threw off his toga from his shoulders and with bare
> breast begged them not to insist. He always shrank from the title
> of Lord as reproachful and insulting ... he would not suffer himself
> to be called Sire even by his children or his grandchildren either in
> jest or in earnest, and he forbade them to use such flattering terms
> even among themselves.[4]

And he refused all titles other than *Pater Patriae*: father of the fatherland.

But Suetonius, while he might have noted approvingly the cut of the man's cloak, couldn't resist poking fun at his footwear – Augustus wore high heels, he said, to make himself look taller. His public image might have been one of republican austerity; but he was a subtle and ambitious operator, and the traditional simplicity of his home and habit was a matter of policy.

His house itself, with all its republican simplicity, had itself been

acquired by political sleight of hand. It had been confiscated from the Senator Hortensius, who had been foolish enough to take the republican side in the civil wars. The man has disappeared from history, for the appropriation of his house was an act of *damnatio memoriae*.

And soon after Augustus had moved into his house, it was struck by lightning. When it happened, Augustus took it as an omen. His home should be devoted to the *res publicae*, he said, the public good, and he remade it just as Vitruvius, whose treatise on architecture was dedicated to him, had prescribed:

> for men of rank who, from holding offices and magistracies, have social obligations to their fellow citizens, lofty entrance courts in regal style, and most spacious atriums ... appropriate to their dignity. They need also libraries, picture galleries, and basilicas, finished in a style similar to that of great public buildings, since public councils as well as private law suits and hearings before arbitrators are very often held in the houses of such men ...[5]

At the first hour, the doors of the *atrium* would open and the subjects of the Emperor would come to visit their patron, waiting to see him standing or sitting around the edges of the court. He, seated in the niche opposite the front door, the *tablinum*, would see them all: embassies, dignitaries, and common men, dispensing largesse and justice to his subjects. Augustus would have the senate meet in his house, and it contained libraries of laws and histories, both Latin and Greek.

When they were rebuilding his house after the lightning strike, the workmen found all sorts of remains hidden underneath the ground: broken pots, charred bones, and primitive weapons. Augustus had them brought into his house and set up in the *atrium*. They belonged to Romulus, he said,

the original father of the nation, and he put them among the masks of his ancestors and the household gods in his *atrium*. He knew his visitors would make the connection.

And he didn't stop there. Right on top of his house Augustus built a temple to Phoebus, the god of the sun, who had given him victory over Anthony and Cleopatra at Actium, bringing a century of civil war to an end, and establishing the Empire.

In the temple, alongside the golden image of Phoebus, Augustus placed the Palladium, an ancient image of Athene. Under the temple, Augustus placed the Sibylline books, in which the words of long-dead prophetesses foretold the splendour of the Empire.

And in the hearth of his home burned the eternal flame he had taken from the House of Vesta. 'Phoebus owns part of the house;' wrote Ovid, 'another part has been given up to Vesta; what remains is occupied by Caesar himself. Long live the laurels of the Palatine! Long live the house wreathed with oaken boughs! A single house holds three eternal gods.'[6]

'The imperial residence', wrote the historian Dio Cassius, 'is called Palatium, not because there was ever a decree to this effect, but because Caesar lived on the Palatine and had his headquarters there ... for this reason, even if the Emperor is lodging somewhere else, his temporary residence keeps the title of Palatium.'[7] Centuries later, Augustus' distant successors were born into the purple in the *Megale Palation* of Constantinople; and 'palace' is still the name we give the homes of the august, from Kaisers to Czars, Emperors, High Priests and fathers of their country. It's for no other reason than, once upon a time, their prototype Augustus, Caesar, Imperator, Pontifex Maximus, Pater Patriae, once lived in a house on the Palatine Hill.

The *atrium* of Augustus had been well and truly buried by the time they took Suetonius to see it, but unlike the interment of Nero's *Domus*

Aurea, this had been an act of pious commemoration rather than *damnatio memoriae*, a monument to the beginning of empire, preserved at its zenith.

But there's always a beginning before the beginning, and there's something else they told Suetonius, as they were showing him round. They used to tell a story out in the village of Velitrae, they said, about a little room, where, the locals claimed, the first emperor had entered the world. It wasn't much to look at — it was just a pantry, in a farmhouse, in an obscure village; but once upon a time, the owner of the house decided to spend the night in it. He didn't last long: a great force ejected him from the room, and he found himself lying on the floor of the *atrium*, bedclothes and all, half dead. He sold the place soon enough. He obviously didn't deserve to live there.

Augustus had come into the world not in a purple room, but in a country pantry. He hadn't been born in the purple, and his house didn't start out as a palace; but he became the first emperor, and his humble and inconvenient home ended up buried under a temple dedicated to his own worship. It was the germ of all the palaces that followed it.

The *Domus Augusti* was like its *paterfamilias*, like the pantry in Velitrae, like any palace, like all of our homes, a paradox, both domestic and divine.

Regia

THE YEAR 1546 PROVIDED A GOOD HARVEST IN THE *CAMPO VACCINO*.
Pope Paul III had issued an edict permitting the quarrymen to excavate the
cow field at the foot of the Palatine Hill for marble, and over a couple of
months the soil yielded up countless fragments, some of which were re-cut
by the masons for use in new buildings, and others of which were burned
for lime.

There was a little farmhouse in the field that had been there since time
out of mind; and in the soil around this farmhouse the workmen found
thirty pieces of marble that they did not pass on – not to the masons or
the limekilns anyway. Alessandro Farnese, the Pope's grandson, acquired
them, and took them up to the villa he had built among the ruined palaces
on the hill above.

His librarians, Onofrio Panvinio and Pirro Ligorio, fitted the pieces
together, and to their astonishment, they discovered that they comprised
Fasti, a list of all the consuls and all the triumphs of Rome, year by year,
all the way backwards from the time of Julius Caesar to the foundation of

the city. They had it restored and displayed in the Palazzo dei Conservatori on the Capitol, where it may be seen to this day.

And then they knocked the farmhouse down, since underneath it, they suspected, there might be more marble for the masons.

It was only much later, as they dug further down through the human compost of mud, coins, shattered stones and broken brick, that anyone realized that the little farmhouse had been rebuilt again and again, on exactly the same foundations, all the way back, so it seemed, to the foundation of the city itself. For more than two millennia, there had always been a walled courtyard; and there had always been a building on the southern side of the courtyard, containing three rooms: a vestibule containing a hearth, and two others, one on each side.

The quarrymen who harvested the little house in 1546 wouldn't have known it: its modesty wouldn't have given them any clue. It wasn't until 1566, when a marble plan of the city was unearthed, and much, much later when they pieced the fragments together, that they realized what they had destroyed. There was a word inscribed into the marble next to the plan of the house. '*Regia*', it said, the house of the King.

It was a mystery, for the plan dated from the third century AD, by which time the Romans hadn't had a king for centuries. They'd thrown the last one out in 509 BC, and at the time, they'd vowed they would never have one again. Not even Nero, in all his pride, dared to call himself a king; and Augustus made a policy of refusing any title that had a monarchial ring to it. Even the word emperor – *imperator* – was a way of avoiding the crown, being an honour originally conferred temporarily on victorious generals rather than permanently on absolute rulers.

But all the while, even as they decried the very institution it represented, the Romans kept the little house that represented it. It was as much a mystery to them as it is to us. In the time of Augustus, Livy heard

the Salii, the priests of the *Regia*, singing hymns in a Latin so archaic that he could not understand what it meant. When he asked the priests, they didn't know either.

King Numa had built the *Regia*, they told him, and he didn't even want to be king. He was not even a Roman. As a young man, wrote Plutarch, he lived among the Sabines, 'forsaking the ways of city folk, determined to live for the most part in country places, and to wander there alone, passing his days in groves of the gods, sacred meadows, and solitudes'.[1]

When the people of Rome asked Numa to be their king he declined; but the Romans persisted, and in the end Numa relented, and to give himself somewhere to live, he built himself a house in the groves at the foot of the Palatine Hill, from which he 'banished all luxury and extravagance'[2] and in which 'he passed most of his time ... engaged in the quiet contemplation of divine things'.[3] It doesn't sound much like a palace.

Next door to his simple house, Numa built another, even simpler one. Ovid wrote that it was made of wattle and thatch, and was circular in form. Inside it, he made a fire, and instructed his women to tend it. Under the fire, he made a pit in the ground. And in a cupboard, in the darkness behind the fire, he placed an earthenware jar. That was all.

We have no idea what it contained, since no-one ever dared write it down. Plutarch, writing at the height of empire, had little notion of its existence. 'Some', he wrote, 'are of the opinion that nothing but this perpetual fire is guarded by the sacred virgins; while some say that certain sacred objects, which none others may behold, are kept in concealment by them.'[4]

Some believed the jar contained a rude wooden image of a woman. The Palladium, they called it. It had been brought to Italy by Aeneas, they said, who had escaped the destruction of Troy long ago, and had taken to the seas to find a new city to found. We have no idea what it looked like.

Its existence, let alone its provenance, was the stuff of legend. No man ever saw what was inside the hut, or at least no man saw it and kept his sight. Even when the High Priest rushed in to save the jar when the hut was on fire in 241 BC, he was struck blind for seeing things the eyes of men should not see.

The duties of the women of the hut were so serious, the Romans believed, that in order to carry them out, they were enjoined to virginity. It was ordained that if any one of them forsook her vows, or revealed her secrets, she would have to be buried alive. A little room was prepared for her in the city wall, furnished like a bedroom, with a cot, and food, and water, and she was led to it with solemn ceremony, before being built into the fabric of Rome itself.

Their duties were also bizarre, and barbaric. At harvest time horse races would be held in the field of Mars, and when the race was over, the winning horse would be sacrificed. The women would cut off its head, and garland it with loaves of bread, and march back through the city to hang it in the *Regia*. Then they would cut off its tail and race back through the streets to be in time to sprinkle the blood that was still spurting from it onto the hearth in the hut. And then the Virgins would mix the harvest grain with the blood of the horse, and pour it into the pit below the fire.

Or that's what was rumoured. All anyone knew for certain was that there was a fire.

The Romans believed that King Numa had learned his wisdom at the feet of Pythagoras, and Plutarch explained the form of the hut in the following way:

it is said that Numa built the temple of Vesta, where the perpet-
ual fire was kept, of a circular form, not in imitation of the shape

of the earth, believing Vesta to be the earth, but of the entire universe, at the centre of which the Pythagoreans place the element of fire, and call it Vesta.[5]

And he explained how the fire should be kept alight. It was no simple matter: 'it must not be kindled again from other fire, but made fresh and new, by lighting a pure and unpolluted flame from the rays of the sun.'[6] The fire of Vesta was an original fire, which could only be kindled from the original source of all fire, at the centre of the universe.

Like the centre of a circle, like the Palladium that Aeneas had brought from Troy, the fire in the hut was the place and the thing – the womb – from which the Romans had come, or so they believed. At the very beginning of his treatise on architecture, Vitruvius told a story about the origins of building:

> The men of old were born like the wild beasts, in woods, caves, and groves, and lived on savage fare. As time went on, the thickly crowded trees ... caught fire ... After it subsided, they drew near, and observing that they were very comfortable standing before the warm fire, they put on logs and, while thus keeping it alive, brought up other people to it, showing them by signs how much comfort they got from it ... Therefore it was the discovery of fire that originally gave rise to the coming together of men ... And so, as they kept coming together in greater numbers into one place ... they began in that first assembly to construct shelters. Some made them of green boughs, others dug caves on mountain sides, and some, in imitation of the nests of swallows and the way they built, made places of refuge out of mud and twigs. Next, by observing the shelters of others and adding new details to their own

inceptions, they constructed better and better kinds of huts as time went on.[7]

The men of old were born like wild beasts, he thought, until they gathered together in a circle, around a fire, and started to talk to one another. The little round outhouse at the foot of the Palatine Hill was a hearth, a home and like all homes and all hearths it represented a beginning, the place from which the Romans had emerged into the world.

Once upon a time, the word *atrium* meant 'blackened', for once upon a time that hole in the roof that opened the *atrium* to the sky was designed to allow smoke to escape rather than rain to enter. Once upon a time, as all good Romans knew, their homes had been thatched huts built around a smouldering fire. Once upon a time, the *paterfamilias* would have squatted on the floor as the women raked the ashes. Once upon a time, they had been savages, gathered in a circle round flames in the forest. Every Roman father knew that at the first hour of the day, as he sat down among his ancestors in the *tablinum* and looked out into the *atrium*, he was the same as all those who had gone before him.

Numa remembered it when he built the *Regia*. He made the courtyard his *atrium*, and the room opening off it the *tablinum* in which he could perform his morning salutations. They kept a hearthstone in it right until the end of the Empire.

When he died, they buried his books with him. He'd asked them to do it – not because he didn't want them to know his secrets, but because he wanted the Romans to pass their knowledge down to one another in their rituals and stories rather than to have them wither and die, pressed between the pages of a book.

And pass them down they did. Even after the Romans had expelled their kings and established a republic, they still kept the *Regia*. They still

kept a king too – the *Rex Sacrorum*, the 'king of the sacred things' – for while they might have wished to build their state anew, they had no intention of doing so without remembering where they had come from.

So they rebuilt the little house, again and again, on the same foundations. It was burned down, so Livy thought, when the Gauls sacked the city in 390 BC, and built again by Domitius Calvinus, the Governor of Spain in the time of Augustus. It was rebuilt in the time of Trajan and then again by Septimius Severus in the second century AD. The little circular hut was rebuilt in marble, its wattle walls replaced with grilles of gilded bronze.

At the same time, the house suffered blasphemies that only underlined its sanctity: Augustus had the Palladium and the sacred flame taken up to his new palace on the Palatine; Elagabalus had the image transferred to his own temple in the third century AD; and in the end, Constantine took it away to found the Nova Roma of Constantinople, just as Aeneas had once taken it from Troy.

Long before anyone thought of an empire, ever since the foundation of the Republic, the *Regia* had been an anachronism. Like all palaces, it was not just a hearth, but the representation of one, the memory of a home. It is no coincidence that the Romans chose the *Regia* as the place to keep their chronicles. When Domitius Calvinus restored the *Regia* in 36 BC, he had the *Fasti* affixed to the walls, remembering all the consuls and triumphs, from Julius Caesar's all the way back to the time of the foundation of Rome.

The original walls and roofs and doors and windows might have been replaced countless times; but built in the same place, in the same form, the house of the King and the hut of the women outlived their perishing. They outlived the Empire in the end. The last rebuilding of the *Regia*, undertaken sometime in the eighth century, involved its conversion back to its original function: a farmhouse, in a field.

The house whose walls remembered their foundation, whose rooms contained the *mementi* of ancient rituals, whose rituals were themselves the enaction of remembrance, was a remembered palace, and, what is more, a memory palace. It is ironic that when they found the *Fasti* at harvest time in 1546, they did not know why they were there, built into the foundations of a modest farmhouse. The building itself, the original palace, had returned after centuries to its original state, and in the process it had forgotten its own beginning.

Lupercal

THERE'S A PROBLEM WITH BEGINNINGS. THE ROOM IN ROME WHERE Anna Comnena was born was the ruin of another room, in another Rome; the room that Nero built in order to live like a man turned him into a monster; and the atrium in which the first Emperor made his morning salutations had been confiscated from an older order. Even the hearth of Vesta was the memory of something else – of a circle of savages, as they stood around their fire in the forest, in the beginning.

There's always a beginning before the beginning, something from which it came. There's a problem with memory, for if we could remember what was there before the beginning, how would it be the beginning?

Even after the Empire had departed for Constantinople, its beginning still remained in Rome. It long outlived the Golden House of Nero, and the House of Augustus, under whose palatine ruins it still lurked in the time of Byzantium. It was older, even, than the *Regia*. It was the ancestor of them all: a darkened circular room, in which a flame flickered from time to time.

It had been there all along: a little thatched hut, so low it was almost impossible to stand up in it, oval in form, with a steep roof. The interior was blackened with centuries of the smoke that curled up from the fireplace and filtered through the small aperture at the apex of the steep roof. On the floor, around the fire, a group of old men would sit raking the ashes, seeking in the glowing embers the auguries of their ancestors.

It was the original house, they said, the original room. *Tugurium Romuli*, they called it, the hut of Romulus. And that was why they remade it again and again, every time a spark from the fire flew into the thatch and burned it down. It was the house of the ancestor of them all, the palace of their first king, their founder. It's still there – or, at least, the spot is marked by little holes in the bedrock hollowed out to take the posts that held it up.

But there's a problem with beginnings. There's always a beginning before the beginning. Romulus didn't appear from nowhere, and underneath the bedrock underneath his hut, there always was, and still is, another room, and another story.

* * *

The only thing we know for sure is how it ended. In AD 494, Pope Gelasius wrote a letter to Andromachus, an elder of the venerable senate of Rome, concerning a rite known as the Lupercalia. 'If you believe this rite has salutary force,' he thundered, 'celebrate it yourselves in the ancestral fashion. Run naked yourselves that you may carry out the mockery.'[1]

That silenced them. The Lupercalia was a ridiculous superstition, and the senators were pagan fools for believing in it. It was certainly not the sort of ritual the Pope thought compatible with the dignity of Rome.

There was no point telling him that it wasn't just the rabble who ran naked through what was left of the city. He had read his Plutarch: 'many

of the noble youths and of the magistrates run up and down through the city naked, for sport and laughter, striking those they meet with shaggy thongs.'[2]

Had not, he reminded them, that renowned voluptuary Mark Anthony joined the running? Had he not barged his way onto the rostra, and proposed that Julius Caesar be crowned king? Hadn't Cicero been horrified at the sight of a senior statesman 'nudus, unctus, ebrius' (naked, smeared with oil, and drunk) despoiling the dignity of the Forum?

Hadn't Augustus banned young men from running to protect their virtue? 'Many women of rank', wrote Plutarch, 'purposely get in their way, and like children at school present their hands to be struck'[3] with thongs made from goatskin. 'Be patient under the blows of a fruitful hand', Ovid had advised the ladies, and 'soon will your husband's sire enjoy the wished for name of grandsire.'[4]

For the Pope and the senators knew perfectly well what the Lupercalia was all about. The dirty billy goats had what dirty billy goats always have on their minds: filthy, savage, speedy sex, and, even worse, so did the ladies. Hadn't Livy written that they joined in on the orders of the pagan goddess Juno?

No wonder the Pope was so keen to bring the Lupercalia to an end; and however hard the senators tried to argue for its preservation, they couldn't succeed, for by the fifth century no-one could remember when, how, or why it had begun.

In actual fact, no-one had ever been able to remember. That's the problem with beginnings. In his dictionary of the Latin language, when he should have known better, Terentius Varro – writing 600 years closer to the age of Romulus than Pope Gelasius – was strangely circular:

The Luperci are so called because at the Lupercalia they sacrifice at

> the Lupercal ... the Lupercalia are so called because [that is when]
> – the Luperci sacrifice at the Lupercal.[5]

And that was all anyone knew: it all began at the Lupercal, and the Lupercal was to be found at the base of the Palatine Hill, under the *Tugurium Romuli*, under the *Domus Augusti*, and under, eventually, all the other palaces that were built on top of it.

That was all anyone knew, and when the poet Ovid tried to explain the origins of the rite to Augustus, he found himself recounting story after story, each one of which contradicted the last.

He started with a goat, roasting on willow spits over a fire, and two naked boys, running around the plain. Suddenly they heard a shout: 'Romulus, Remus! Thieves are driving the bullocks off through the wasteland!'

'It would have taken too long to arm', wrote Ovid, and the two boys ran off naked, in opposite directions to chase the cattle thieves. Remus was the first to return, and hungered by the chase, he fell on the meat as it sizzled on the fire, and shared it with his friends, the Fabii. Romulus returned too late, and had to do without:

> Thither came Romulus foiled, and saw the empty tables and bare
> bones. He laughed, and grieved that Remus and the Fabii could
> have conquered when his own Quintilii could not.[6]

Since time out of mind the Luperci had been divided into two opposing teams: the Fabii, and the Quintilii. The Quintilii ran in honour of Romulus and the Fabii ran in honour of Remus. They ran naked to remember the time that Romulus and Remus were surprised exercising in the circus. They began their race at the Lupercal, where they would sacrifice a goat.

But that wasn't the beginning, and so Ovid told another story. On the Ides of February, he noted, the naked Luperci sacrificed their goat at the Lupercal, and ran their course around the base of the Palatine Hill to the tomb of Romulus in the forum. Their race ran the bounds of the Palatine to remember, he wrote, that once upon a time this Palatine had been the whole of Rome.

It wasn't called Rome then. The villagers called their village Pallantion, after the place in Arcadia from which they had come, once upon a time; and in a cave they found in the base of the hill, they left offerings for a wolf-god they'd brought with them, whom they called Lykaios. The Romans, mishearing them, called the cave the Lupercal, and the hill the Palatine.

Pallantion, if ever it existed, has disappeared, leaving nothing other than the sound, if not the meaning, of its name. There was a Palatine before the Palatine, just as, centuries later, there was a Rome before Rome. There is always a beginning before the beginning, and Ovid tried to imagine it:

> The Arcadians are said to have possessed their land before the birth of Jove, and that folk is older than the moon. Their life was like that of beasts, unprofitably spent; artless as yet and raw was the common corn: water scooped up in two hollows of the hands to them was nectar. No bull panted under the weight of the bent ploughshare: no land was under the dominion of the husbandman: there was as yet no use for horses, every man carried his own weight: the sheep went clothed in its own wool. Under the open sky they lived and went about naked, inured to heavy showers and rainy winds.[7]

But that wasn't the beginning either, and in his third story, the poet tried to remember what happened inside the Lupercal. He wasn't sure what it was: there was no written rite to read in the darkness; only, he'd heard, the scream of a goat, a spattering of blood, and a peal of laughter. All he knew was that the Fabii and the Quintilii entered the cave in their patrician togas, and left it '*nudus, unctus, ebrius*': naked, smeared, and drunk.

They did it to commemorate the oldest fable of them all about Romulus and Remus; but Ovid and his contemporaries, accustomed to the imperial greatness and the high civilization of Rome, couldn't make sense of it.

Romulus and Remus must have been descended from great Aeneas of Troy, they said. The mother of the twins must have been a princess, or at least a Vestal Virgin, who had been ravished, of course (how else could a virgin fall pregnant?) by Mars (or that's what she said). The *lupa* was a prostitute, they said, and she hadn't brought the boys up to maturity. Rather, they had been found by a wandering shepherd, who took them in and didn't realize who they were. Their royal bearing revealed them as they grew, they said, and they rejoined the noble house from which they had come.

But the stubborn nub of the story remained: once upon a time, the founder of Rome had suckled at the teats of a she-wolf and had lived in her lair.

No-one could remember why. No-one could remember how. That's the problem with beginnings. Infants and animals, like myths and caves, have no memory. At least, they have no memory they can pass on.

The Lupercal was the first room in Rome, and the Romans remembered it for more than 1,000 years. Every year, on the Ides of February, they would return to their point of origin, and start again. Every year they would emerge from the cave into a new city – whether its thatched temples

had been torched by the Gauls, or turned from brick into marble by an Augustus, appropriated as a palace by a Nero, or broken up and shipped east by Constantine to a new Rome elsewhere.

No wonder Pope Gelasius had the rite stopped in AD 495, for he did not want the Christians of his new Rome to remember that they had been animals once. The Lupercalia was replaced with the festival of the Purification of the Virgin and an annual day at the races in Constantinople, and the cave, its memory damned, was blocked up and buried.

Then, in 2006, an archaeological team came across a domed cavity, hidden deep underneath the palaces on the Palatine Hill. Of course, they claimed it was the Lupercal.

But they couldn't get in, and it is very unlikely that they will be able to any time soon. The cave is not only filled with rubble, but buried under so many other ancient buildings that it would be impossible to excavate it, without removing thirty centuries of memory. So far, the only knowledge we have of the Lupercal is through the soundings, endoscopes, and x-rays that we use to explore our own interiors. No-one will enter the Lupercal, and until they do – and it is by no means certain that anyone ever will – no-one will know if that is what this cave ever was, or indeed, if ever there was a Lupercal, a Romulus, or a wolf.

The cave is the original interior. It is where we begin, or cease, to be human. It is the beginning before which there can be no beginning, a place where memory is stopped up in the dark, a place to enter in reverential dread, and from which to be reborn muddied, bloodied, howling and purple.

FURNITURE

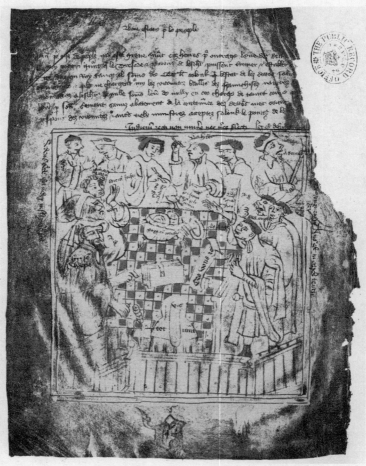

A TABLE FOR GAMES.

An exchequer in the fifteenth century.

A Table for Games

ONCE A MONTH OR SO, GRANNY LIKES TO HOLD A BRIDGE PARTY. IT'S the last sport left to a woman who used to run the tennis club, play golf three times a week, and was captain, so she tells me, of the hockey team at school. Now bridge keeps her mind alert, she says, and her memory in trim.

Preparations begin a week in advance, when she must remember to ask her man-who-does, William, to take the card table and the four director's chairs out from behind the sofa. He will unfold their legs, and set them out in the middle of the floor: a little encampment amid the more fixed furnishings arrayed around the perimeter of the room.

Then Granny and her friends will sit down to their abstruse ritual: the simulation of a court, whose kings and queens are attended by entourages liveried in scarlet and black, hearts and diamonds, spades and clubs. They only place small bets – next to the brightly coloured cards, they pile up portcullises made of little stacks of pennies.

When I ask Granny why she does things this way, she's not sure: 'It's just done that way, darling,' she says – she is something of an instinctive

conservative. But when pressed, she goes a little further: 'otherwise, I'd have to use the dining table.' What she means is that it will already have been laid for lunch, and it is the wrong shape for bridge. Besides, it is just too high – by a fraction of an inch.

Granny points to another card table. It belonged to her mother-in-law, she says, and she wrecked it. Once upon a time, shifting furniture around might have been a servant's job; but in my great-grandmother's dotage after the War, there weren't any. To make moving it about easier, she had the clawed feet of the table sawn off and replaced with castors. The table ended up too high for cards, and now stands, uselessly, against the wall.

The sitting room is full of such tables, each one designed with some specific pastime in mind. There's a tiny one studded with drawers that was made for sewing, and a larger, lower one covered in glossy magazines, whose sides fold up to turn it into a tray. There's one, upholstered in a piece of old carpet, that hovers somewhere between being a table and a stool. The early Georgian legs are quite valuable, but the rest of it isn't: my grandfather painted the underside with an amateurish copy of Goya's *Duke of Wellington*. It was too low, he imagined, for anyone ever to see it – but the valuer did, when he picked it up to check for makers' marks.

The card table Granny uses for her bridge parties is everything that her fireplace is not. It is, on the one hand, absolutely specific to its function, and on the other light, flexible and mobile. The French word for furniture, *meuble*, describes it much better than the English. Its verbal inverse, the word *immeuble* means not just 'immoveable' but is also the word for a dwelling. We are stuck with buildings, fixed as they are for the long game. We move furniture around inside them to fit them to our more ephemeral pastimes.

The verbal distinction between *meuble* and *immeuble* dates back to the Middle Ages, when kings and lords lived on the road, moving every few

months to another castle or hall in search of food, game, or military advantage. They'd take their family, and their servants, and their clothes; but they'd also take all their furniture. Sometimes they even took their windows: the glass in them was so precious that, often, they could only afford one set. They'd arrive at some fortress or other, their upholsterers would get to work with poles and tapestries, benches and tables, and soon enough, a bare stone shell would have been transformed into a luxurious habitation. When the lord left, his interiors would disappear along with him.

The *immeuble* architecture of a medieval hall was generic; and it fell to the *meubles* temporarily arranged within it to articulate the intricacies of household politics. Medieval depictions of palaces, of parliaments, courts, and banquets almost never include architecture: the interiors in which they take place are defined by furniture alone.

The Houses of Parliament in London were such a palace once, of which nothing is left other than the great hall. It was, and is, a generic shed, and it's almost impossible now to imagine how it was ever lived in. Instead, its long-lost lives are remembered in the *meubles* with which it was inhabited. Once upon a time King Edward actually sat in King Edward's chair. His courtiers sat around him at the King's Bench; and they laid out the chequered tablecloth on his table to count his money.

They called it the exchequer, and like many of the *meubles* of the medieval court, the word has outlived the piece of furniture from which it originated. The King's Bench turned into the highest court in the land; and King Edward's chair into the seat of empire. The British constitution, such as there is one, is not an abstraction but an imagined hall, furnished with chairs and tables. To rearrange them is, as we shall see, to tamper with the integrity of the state.

The *meubles* of Westminster made memory palaces, in which imagined

objects were set out in specific places to stimulate the memory; but unlike the memory palaces of classical times, they were designed to remember the immediate present rather than some mythical past. They laid out the rules of a game, reminding everyone, from the common plaintiff standing at the door to the King sitting on his chair, of their place, both in the hall and in the chain of being.

While to classical orators the memory palace was a morally neutral mnemonic device, to the medieval mind it was laden with divine and moral significance. The *Rationale Divinorum Officiorum*, written by the theologian Durandus in the thirteenth century is, on the face of it, a description of the liturgy, furnishings and architecture of a cathedral; but it is in fact a memory palace, in which every window, retable, and gesture of the church temporal remembers some aspect of its spiritual counterpart.

Thomas Aquinas wrote: 'The *ars memorandi* ... is the best, particularly for the things to be remembered pertaining to life and judgement.'[1] And our lives and judgement lead, of course, to our ultimate destinies. Aquinas' contemporary Boncompagno da Signa reminded his scholastic readers of what it was that we should strive to remember: 'the invisible joys of para-dise and the eternal torments of hell'[2] for these are, of course, the ultimate prize or price of our judgements.

And while the memory palaces of the ancients were as fixed as their furniture, those of the Middle Ages were more contingent. The joys of heaven might have been eternal, *immeuble*, but the ways to attain them in the *meuble* mutable world were not. In several woodcuts made to illus-trate the *Ars Magna*, the 'Great Art' of knowledge of Ramon Lull, the fourteenth-century mystic, wisdom is represented as a fortified stone tower. The art of learning by which it might be attained is drawn as a wooden ladder, leant temporarily against the stone and secured by the trembling hands of angels.

Meubles turn *immeubles* into ephemeral ladders leading to eternal wisdom, or games played after lunch with liveried kings and queens. Once the game is over, the objective achieved, everything is cleared away, or the arrangement rearranged for the next activity. It is what happened at Westminster; and it is what happens in my grandmother's sitting room. My grandmother will never play cards at a permanent table, sitting on a proper chair. She would rather, like some medieval lady on progress, have William unfold her table and chairs and place them in the middle of the room, returning to take them away once her archaic ritual is over.

A Chair

EVEN BY BRITISH STANDARDS, THE PROCESSION THAT MADE ITS WAY up the Royal Mile in Edinburgh in November 1996 was an odd one. All the usual suspects were there: the heralds with their tabards and trumpets, the guardsmen in bearskins, the chamberlain, and a prince in a horse-drawn carriage. There was a twenty-one-gun salute and a Tornado flypast as they approached the castle.

But last in the procession, in the place of honour, in a shiny black limousine, mounted on a velvet cushion, there was a stone. As it passed by, murmurs passed through the crowd; and they weren't friendly. A couple of eggs were thrown, and jeers and hissing accompanied the procession: the fighter planes and the guard weren't just there for display.

By the 1990s calls for self-determination in Scotland had become so deafening that they could be heard even in the halls of Westminster. The government of the United Kingdom of Great Britain, certain that they had no friends north of the border left to lose, had no intention of satisfying them.

Rather than granting Scots the parliament they had asked for, they had decided to send them a stone. Perhaps the Scots should have been grateful; but as the procession trundled up the Royal Mile in November 1996, they looked for their sovereignty, and all they could see was a lump of rock. No wonder they were jeering.

The English weren't happy either. The Dean of Westminster Abbey felt 'bereaved', he said, to see the stone go. It had to be taken away in the dead of night, under strict guard; and the Prime Minister was forced to reassure the country that it was only a temporary measure, for like the British constitution itself, it was supposed, rocks should not move.

* * *

This one hadn't, for a long time. The stone had only been to Scotland once before in seven centuries, and then it was only because it had been stolen. On Christmas morning 1950, four students from Glasgow University made away with it. It was an absurd and wonderful prank: the stone had broken into two pieces when they'd taken it, and they'd had to drive them round the country concealed under the seat of their (inappropriately named) Ford Anglia, hiding them in all sorts of odd places, from a gypsy encampment to a builder's yard, avoiding all the roadblocks that had been set up along the A1 to stop the prize from making it up to Scotland.

But they gave it back in the end, for the students' intention had never been to keep it for ever, not then. Even as they parked their car at the border, and lifted up the leatherette to anoint the stone with a dram, one of the gang, Ian Hamilton, had mixed feelings:

> The block of stone upon which I was now sitting ... was not an end
> in itself. Had it been an end in itself, I could have persuaded the
> other two to get out the car, then driven off and dumped the stone

somewhere it could never be found, and that would have been the end of it, stone, problem, and all. It would have stayed in Scotland for ever, as part of the subsoil. That would have been no solution at all. The dream had been to wake Scotland up, and in that we had succeeded. It was the idea that mattered, not the corporeal thing. And the stone was now very much a thing.[1]

* * *

For centuries the stone had been very much more than a thing; and while the passions of some might be stirred by its relationship with Scotland, for others, they pertain to the piece of furniture in Westminster Abbey from which the students stole it in 1950.

It's no ordinary piece of furniture. Throne and stone have spent seven centuries together, give or take a theft or two, in exactly the same place, in the inner sanctum of Westminster Abbey. It has always been the same. Queen Elizabeth II was crowned on the chair in 1953, and so was her father, and his, and his. Queen Victoria sat on King Edward's chair to become Queen of Great Britain and Ireland in 1837, and again for her coronation as Empress of India in 1876. During her reign, therefore, it became the seat not just of British kingship, but, in the words of the Royal Commission for Ancient and Historic Monuments, a 'strange palladium of Empire'.[2]

It has always been the same, almost. At the coronation of William and Mary in 1689, the only one at which two co-equal monarchs were crowned at the same time, a precise duplicate of the throne had to be made. At the same occasion the Queen's sister, the then Princess Anne,

> displayed her knowledge of the minute laws of royal etiquette. The attendants had placed her tabouret too near the royal chairs, so that it was partly overshadowed by the canopy of state. The

princess Anne would not seat herself under it, until it was removed to a correct distance.[3]

Acutely aware of the fragility of her own fortunes at court, she had no desire to appear too eager to occupy the throne itself.

It has always been the same: thrones do not move, and have therefore always been used to signify their occupants in absentia. Elizabeth I would flank her own throne with empty chairs – one for the King of Scotland, should he choose to attend her (which he never did) and one for her heir, should she ever have one (which she never did). The throne was dressed as magnificently as the person for whom it was intended; and for Elizabeth's coronation, the chair was wrapped in eighteen yards of 'cloth of silver incarnate'.[4]

It is always the same. Ordinarily, the throne is kept in St Edward's Chapel in Westminster Abbey; but on coronation days, and coronation days only, it is moved. It is taken out and placed on a dais in the choir, facing the high altar. Sitting on the right chair, in the correct spot, a human being becomes God's chosen. In that moment, like it or not, believe it or not, a temporary interior – an *immeuble* building married to a *meuble* chair – comes into being to connect Heaven and Earth.

It was meant to be made of solid bronze at first – King Edward I's commission to Adam the goldsmith survives from 1297 – but although some pieces were cast, his work had to be abandoned almost immediately, it is thought, on grounds of cost; and instead a certain Walter of Durham was paid 100 shillings to carve the chair in oak in 1301.

Walter made his chair like a little building: the backrest is surmounted by a pinnacled gable like the west end of some vaulted cathedral; the arms are traceried like tall gothic windows; and at coronations, the throne occupies its dais like a chapel perilous, perched on top of a holy mountain.

Like a shrine, the chair was designed to sanctify what it contained. In the Middle Ages, chairs were very rare; and ordinary people squatted on the floor, or jostled on benches when they sat down. Chairs were signals of high status not because they were more comfortable, but because their miniature architecture framed the person that sat in them, like the wings of an altarpiece. In his portrait that still hangs in Westminster Abbey, Richard II, framed by the great chair, floating in a gilded empyrean, has all the impassive solemnity of an icon.

* * *

And hidden in the heart of it all along, beneath the elaborate ritual and the silver incarnate and the oak and the gilding, has always been the stone. There are all sorts of stories about it, and they started telling them almost as soon as it had been put there.

King Edward I called the stone the Petra Scociae, for he had found it at the Abbey of Scone, in Perthshire on 8 August 1296. He took it from the Scots among the spoils of war, for quite apart from the political concessions he had hammered out of them, it was the stone that represented his sovereignty over their country for, he had heard, it was the very stone upon which the kings of Scotland had been anointed. It was only natural that he would have his own throne built to contain it, ensuring that he and all his descendants would be seated on the thrones of both England and Scotland at their coronations.

He left behind him a country that had, for the time being, ceased to be; and to make sure of it, he destroyed or stole the archives and records of Scotland, hoping that the Scots would never again be able to tell their own tales about their land and their people.

But, at the nadir of their fortunes, they told them anyway. They remembered the inauguration of King Alexander III, their last king, at

Scone in 1249. The stone had been taken out from the abbey, they said, and wrapped in woollens, and carried to the summit of the Moot Hill, just outside. There, the King sat on it and took his vows, and was acclaimed by the nobles who stood in a circle around him. Then a *scotus montanus*, a highlander, swathed in scarlet plaids, approached the stone and uttered a blessing in the Gaelic tongue. It is a ritual that still has echoes in the coronations of Westminster, where the same stone is taken out of the inner sanctum of the abbey, and placed on a little hill of steps, and the peers of the realm acclaim their lord, standing around robed in furs and crimson.

But the account of Alexander's inauguration was the only historic text the Scots had managed to save. All the other stories they told about the stone were just that, stories; but they did agree on one thing: the stone, they told one another, hadn't always been at Scone.

Some believed that it was none other than the Lia Fáil, the sacred stone upon which the Gaelic kings of Ireland were inaugurated in ancient times on the hill of Tara. They said that when the King touched the Lia Fáil, the bowels of the earth would open up to proclaim him. Tara was certainly the site of outlandish rituals: Giraldus Cambrensis' *Topography of Ireland* of 1188 described one coronation in which the King would fornicate with a mare, which was then sacrificed and turned into a broth. The King would bathe in the broth, and when it was saturated with his humours, his people would drink it.

A romance they wrote, *The Piere D'Escoce*, told an older tale:

> *In Egypt, Moses preached to the people*
> *Scota, pharaoh's daughter listened well*
> *For he said in the spirit: 'whoso shall possess this stone,*
> *Shall be conqueror of a far off land.'*

> *Gaidelon and Scota brought this stone*
> *When they passed from the land of Egypt to Scotland.*
> *Not far from Scone, when they arrived*
> *They named the land Scotland from Scota's name.*[5]

And Thomas Fordun's *Chronicle of the Scottish People*, written nearly a century later, elaborated on the idea, for he believed that Pharaoh's daughter had taken the stone to the Scots not of Scotland, but of Galicia in Spain. It was taken on from there to Ireland by a certain Simon Brecc, and then centuries later, King Fergus had brought it to Scone.

But it was the English who repeated the most ancient story about the stone. In 1327 William Rishanger wrote in his chronicle that it was the stone upon which the patriarch Jacob had laid his head to dream his dream of the angelic ladder from earth to heaven. Perhaps they hoped that the stone still bore traces of that sacred sleep, and that angels would descend upon the King when he sat on it, making him, like Jacob, the father of a chosen people.

In the summer of 1296, the Scots lost a stone and a story that went all the way to the beginning of time. In the process, they lost their kingdom. They couldn't quite believe it, and they repeated the same lines, again and again for centuries. Fordun was the first to write them down:

> *If destiny deceives not, the Scots will reign, tis said*
> *In that same place where the stone has been laid*[6]

And half a millennium later, Walter Scott was still repeating them:

> *Unless the fates are faithless found*
> *And prophet's voice be vain*

Where'er this monument is found
The Scottish race shall reign[7]

It had already come to pass by then, in a manner of speaking. In 1603 King James VI of Scotland was crowned James I of the United Kingdom of Great Britain on the throne of England and the ancient stone of his native land. He soon forgot about the country that both he and the stone had come from, and Scotland became a colony like any other, for the chair was the germ of an empire upon which, soon enough, the sun would never set.

That sun is setting now; and in 1996, when the stone returned to Scotland, the imperial spell of the throne was broken. In a few years' time, perhaps, Scotland and England will have reverted to their separate status; and then, perhaps, all there will be in Westminster will be an empty chair, in an empty room, for without the stone to lend it legitimacy, that is all the immoveable seat of the United Kingdom can be.

* * *

It is ironic that this symbol of British stability came from somewhere else. No-one knows for sure where, and it is unlikely that anyone ever will; but there is a new story that is, on the face of it, less outlandish than the tales of Jacob's pillow or Pharaoh's daughter, or the Lia Fáil.

It has been suggested that the stone was once a part of a building, and was made to seal a subterranean interior. It is made of the same sandstone as the ruins of the Abbey of Scone. It is flattish like a paving stone, and slightly canted to allow for ease of removal: two iron rings have been cast into it to enable it to be lifted. The chronicles all agree that it was kept inside the Abbey of Scone, and in his history of the stone, Nicholas Aitchison has proposed that it was used to seal the crypt below the altar.

We shall never know if it happened: Edward I razed the abbey centuries

ago; but we can imagine the scene. The stone would be lifted from the vault of the crypt, and carried to the top of the hill. The King would sit on it, and the spirits of his ancestors, temporarily released from interior confinement, would swirl around him in the fresh highland air. For a moment, a territory would become a nation, a landscape a room, a man a king, and a piece of an immoveable building, for a moment, a piece of furniture.

A Table

FROM THE MOMENT OF THEIR CORONATION, IT IS THEIR DUTY, AND it always has been. The kings and queens of England must always show charity to those less fortunate than themselves; and on Maundy Thursday in 1979, the day of the institution of the Holy Grail, the Queen went to give alms to the poor in her ancient capital at Winchester. Afterwards she progressed to the Great Hall in the castle there. At the upper end of the room, a round table had been hung with white damask, strewn with flowers, and laid with cutlery for lunch.

On the wall above this round table there hung another one, eighteen feet in diameter. Around the rim of the table ran a series of names densely written in gothic miniscule. In the centre of the table was painted a rose, red and white, and wrapped around the rose was another inscription: 'This is the rownde table of kyng Arthur w[ith] XXIIII of his namyde knyattes',[1] it read, and above the rose perched a painting of the once and future king himself.

In a photograph of the occasion, the Queen is laughing. It was clearly

absurd, the stuff of sentimental music theatre; but the mythical table of Camelot was palpably there, right behind her, with the names of Lancelot and Gawain and all the rest of them written upon it.

And unlike the makeshift table at which she sat, it had been there as long as anyone could remember – longer, in fact – for, despite a major investigation only three years before, no-one could tell the Queen where, for sure, the table had come from, for whom it had been made, or when. All they could do was regale her with stories.

One of the knights at the table told the Queen that it had been painted in 1793. It was a pretty piece of Georgian Gothic carried out by William Cave, a local decorator.

But someone else at the table interjected with another story. The table might have been painted in 1793, but it had been there long before; and it had been used for target practice by republican soldiers during the English Civil War in 1648. They had aimed their muskets, he said, right at the head of the legendary monarch. The recent restoration had found the bullet holes underneath the paint.

Another person reminded the party that the table had been there a century before that, at the wedding of Philip of Spain to Bloody Mary. The knights at the round table on that day told the groom that King Arthur haunted the ramparts of the castle enchanted as a raven; and Philip, in the first flush of wedded bliss, somewhat incautiously declared that were Arthur to return to human form, he would hand the crown of England to him at once.

And another said that it had been there twenty years before that, in 1522, when Philip's father, the Holy Roman Emperor Charles V, had come to England to negotiate the wedding. Henry VIII had the table painted especially for the occasion, and added the cabbage-like Tudor Rose to the middle of it. Charles's cosmopolitan courtiers were not impressed

by Henry's vulgar restoration. Paolo Giovio, an Italian connoisseur, later
wrote:

> The table is still reverently preserved in the town of Winchester, a
> notable witness of admirable valour, and is shown to distinguished
> visitors, as recently to the emperor Charles. But the names of the
> knights around the edge, which had been badly eaten away by
> decay, were then renewed by unskilled hands so insensitively and
> with such damage to its ancient grandeur that the table looks like
> a fake, and has lost much of its credibility.[2]

The table might have looked like a fake, but Giovio didn't suggest that it
actually was one; and another guest reminded everyone that Henry had
been particularly keen for Charles to see it for old times' sake, to remind
him of the friendship between their own fathers.

In 1506, Philip the Fair had been shipwrecked off the coast of England;
and young prince Henry had been dispatched to meet him. He escorted
him to Windsor, stopping at Winchester along the way, and showing him
magnificent hospitality everywhere. After the usual chivalrous courtesies
had been exchanged, Henry's father treated Philip to a feast, and the King
reminded his guest of what he had seen:

> Hung up in the church [*sic*] at Winchester you saw the round table
> about which so much has been said and written: I hope that in time
> people will speak of the table at which we sit here, and that long
> after our passing they will say that it was at this table that true
> and lasting friendship was made between the Holy Roman Empire
> and ... the kingdom of England. I promise you that this table
> will be put where it will be able to be seen and that the date and

the names of the noble company who dined at it will be written upon it...[3]

He didn't keep his promise; but Arthur continued to haunt the young prince. His elder brother had been given the name by their Welsh father, and when he died Henry inherited his wife, the crown, and the chivalric aspirations of his ancient race.

It was something all the Kings of England had shared, once upon a time, they told one another; for two centuries before, in 1344, King Edward III announced his intention to 'found a round table in the same form and manner as the Lord Arthur once king of England had established it'.[4]

His chancellor of the exchequer, William Edington, was commanded to organize the construction of a hall for the round table at Windsor; and it is tempting to imagine that Edward intended his order of knights to sit around the table that now hangs in Winchester. The hall he projected for them was round; and the round table was clearly a table, once upon a time: the framing for the twelve legs can still be seen on what was once the underside.

But Edward abandoned plans for his chivalrous order almost immediately, and Edington went on to become Bishop of Winchester, where he ordered repairs to the hall in 1348. One might imagine, therefore, that the table had been made for Windsor, and had been taken to Winchester in Edington's caravan as a memento.

But the evidence suggests the very opposite: in 1344, orders were given to spread heather and sand on the bridges leading *to* Windsor 'lest they be broken by the great cart bearing the round table'.[5] The table was to be taken towards, rather than away from, the castle and therefore it must already have existed: somewhere else.

The move never took place, as far as we know. The round table is so large that to move it would have involved dismantling either the table itself (for which there is no physical evidence), or a large part of the building that contained it (for which there is no evidence either). If the table was in the hall at Winchester now, it must always have been there, and must, perhaps, have been built there.

When, no-one knew.

And then another knight at the table reminded his fellows of a poem, written by a certain Lodewijk van Velthem, about a feast held, once upon a time, by King Edward I:

> *The king sat down to table,*
> *And at the same time he had*
> *The lords of the round table*
> *Seated with him in chairs*
> *Just as king Arthur had done*
> *When he held a feast, as we*
> *Have often read.*[6]

Lodewijk attributed the occasion to Edward's wedding to Eleanor of Castile, which happened in London sixty years before he wrote his poem, but it could have happened at any time during Edward's reign, anywhere. Some have suggested the date of 20 April 1290, when it is known that Edward held a tournament at Winchester; but the evidence was so circumstantial that at this point the round table of Winchester, and whoever made it, and when, passed out of historical record into myth.

No-one around the table knew whether what hung behind them on the wall was the real round table, or, indeed, whether there ever had been one. There are other candidates, to be sure: the most outlandish, perhaps,

being the old Roman amphitheatre at Caerleon in the Welsh Marches. One can imagine a band of warriors gathering on the crumbling seats, in the twilight of the Empire. But Caerleon is a building rather than, as the legend prescribes, a piece of furniture, and must consequently be discounted in favour of the table at Winchester.

It is an irony, for the occasion described by Lodewijk van Velthem, indistinct as it is, was the only time in its written history that the round table of Winchester was ever used as one.

It had not occurred to anyone, until that point in the meal, to question why a table should hang on the wall rather than stand on the floor.

Then another guest, who had remained silent throughout the meal, read to the Queen the first words that were ever written about the round table, by the poet Wace of Jersey:

> *Pur les nobles baruns qu'il out*
> *Dunt chescuns mieldre ester quidout*
> *Chescuns se teneit al miellur*
> *Ne nuls n'en saveit le peiur*
> *Fist Arthur la rounde table*
> *Dunt Bretun dient mainte fable*
> *Illuec seeient li vassal*
> *Tui chevalment e tuit egal*
> *A la table egalment seeient*
> *E egalement servi esteient*
> *Nul d'els ne se poieit vanter*
> *Qu'il seiust plau halt de sun per*
> *Tuit esteient assis meain*
> *Ne n'I aveit nul de forain.*[7]

A round table, providing no place for a head or a foot, making an equal of everyone, was always a subversive and paradoxical idea. No wonder they hung it on the wall behind the King's head as soon as they could. No wonder Edward III discontinued his plans to sit at it. No wonder Henry VIII tried to turn it into a lush Tudor rose. No wonder the revolutionary roundheads took pot-shots at the king that Henry had painted on it, and no wonder, in 1793, in the aftermath of the French Revolution, such care was taken to cover the bullet holes up under an antiquarian paint job.

If King Edward's chair turned the person who sat in it into God's representative on earth, then King Arthur's round table made the monarch the first among equals. It is ironic that when they hung it up they masked – or duplicated – a wheel of fortune that was once painted on the wall in the same place, behind the King's ancient seat of judgement. Once upon a time it could have reminded everyone that the high (even the King) could be bought low, and the table did the same. It is an image that haunted King Arthur as he approached his own unlucky end. In an old French retelling of this tale, the *Morte D'Arthur*, King Arthur has a dream. He is in the dark, alone, old, in distress, when he hears the voice of a woman he does not know:

'Arthur, where are you?'
'My lady,' he replied, 'I am on a high wheel, but I do not know what
 kind of a wheel it is.'
''Tis the wheel of fortune,' she replied.[8]

The Queen, dining with her knights at a round table under the round table in her ancient capital of Winchester in 1979, should not, perhaps, have been laughing, for it was not just some picturesque and ancient tradition. It was a warning.

A Cloth

ONCE THE MONARCH HAS BEEN CROWNED, AND THEY HAVE DISBURSED their obligations to their subjects, the time comes for their subjects to render their obligations to the Crown. It takes place at Easter; New Year by the Julian reckoning. Her Majesty the Queen is the first person to be shown the contents of Number 11's suitcase. The second is Number 10. Only then it is shown to another place, and only then do we find out what's going on.

In other nations, things are what they are. There is a minister of finance and a budget and that is that. In Britain, nothing is what it seems; and it will not assist you to know that the other name for Number 11 translates from the Latin as the doorman of the chessboard.

No-one has ever understood what was going on, for, in Britain, nothing ever changes.

One afternoon 800 years ago, in the twenty-third year of the reign of King Henry II, a wise man is meditating at a window in a tower by the Abbey in Westminster. Outside, the dark waters of the River Thames slide slowly by.

His reverie is interrupted by an impertinent servant: 'Sir,' cries the boy, 'haven't you read that both knowledge and treasure, if hidden, are useless? ... Then why don't you teach to others the vast knowledge ... which people say you have?' The sage sighs, but he doesn't ignore the youth: 'Come here' he says, 'and sit here, across from me, and ask me questions'[1] and thus begins the *Dialogus de Scaccario*, 'The Dialogue of the Exchequer'.

'What is the exchequer?' asks the servant, and the master sighs again, because he knows that he already knows the answer. Everyone does – the exchequer is a table:

> a rectangular board, about ten feet long and five feet wide, which those sitting around it use like a table. It has a raised edge about four finger widths high, so that nothing placed upon it can fall off. Over this aforementioned exchequer is placed a cloth ... not an ordinary cloth, but black, marked with lines a foot or a spread hands width apart.[2]

Everyone knows that, but the boy is not satisfied, for he is sure that the exchequer is much more than a piece of furniture; and he asks what happens at the table. The elder describes the scene to him. One man is standing at the table halfway down one side:

> everyone can see him and ... his busy hands ... move freely in their task. At his right hand, in the space [between the lines] furthest away from him, he places the pile of pence, eleven or fewer. In the next space, counters for shillings, nineteen or fewer. In the third space, counters for pounds, and this space should be directly in front of him, because it is the one most used in the ordinary

account ... In the fourth space is the pile of twenties, in the fifth, of hundreds; in the sixth, of thousands, and in the seventh, which is rarely used, of tens of thousands of pounds ... he must be careful not to let his hand get ahead of his tongue, or vice versa, but to place the counters and say the numbers aloud as he is thinking them, lest there be an error ...[3]

Everyone knows that, but the youth is still not satisfied, for he knows that the exchequer is not just a counting table, and he asks the old man who sits at it. Their positions are, he explains, precisely prescribed. 'At the head of the exchequer table,' he says, 'on one of the short sides, in the middle of the table (but not the middle of the bench) is the place of the president.'[4] To his left sit the Chancellor, the constable, and two chamberlains 'with the elder and more venerable one first';[5] and after these, the marshal. To his right sits the Bishop of Winchester. On the bench to the right of the table sits the treasurer, his clerk, the writer of the treasury roll, the scribe of the chancery roll, the chancellor's clerk, and the clerk of the constabulary. And on the bench to the left sits the chamberlain's clerk, and other officials, and in the middle of the bench a man known by his office as the calculator. And on the bottom bench, facing the president, is the sheriff of the shire. It must always be so, for the exchequer is not just a table and a cloth. It is the place in which the people of England render their obligations to their King.

Everyone knows that; but still the servant is not satisfied, and he asks the master how the people are made aware of their obligations, and where they come from. They are to be found, the old man says, in an ancient book that is kept by the side of the table. It contains 'a careful survey ... of the whole land, of woods and pastures and meadows',[6] indeed of all the riches of England, and therefore, of the King.

'The natives call the book Domesday,' says the sage, 'that is, the day of judgement ... for just as no judgement of that final severe and terrible trial can be evaded by any subterfuge, so ... its word cannot be denied or set aside without penalty.'[7]

But the boy does not understand, for from what the old man has told him, it is not woods and pastures and meadows that are counted out on the exchequer table. The book was written in the time of the King's grandfather, says the sage, but in those days 'kings did not receive any quantities of gold or silver from their estates, but only victuals, from which the daily needs of the royal household were met'.[8] As the kingdom grew, however, the people complained that it was impossible to bring their geese and corn to the King, and the King realized that if he wished to wage his wars in France, coined money would be more useful to him than ducks and cattle and wool. So King Henry I sent his barons out into the kingdom to convert the value of each estate from pigs and barley into money; and now the kingdom's obligations to the King are rendered in pennies and pounds.

Everyone knows that; but it is no simple matter, for in the twenty-third year of King Henry II's reign, money is still a novelty whose currency is not to be trusted. When the sheriff of each shire brings his coinage to the treasury, pennies and pounds are spilled out onto the floor, melted down and assayed for weight and quality against a standard pound weight that is kept in the treasury. When it has been assayed, it is recounted, and when it has been recounted, the sheriff is led up to the exchequer and takes his seat at the foot, to face the worthies of the kingdom who will judge what he has brought them.

It is no simple matter, for while the Domesday Book might contain final judgement in all matters, it is, by the twenty-third year of the reign of Henry II, an anachronism. The fire of the smelter and the hands of the calculator, rapidly negotiating the scored cloth spread on the table are, in

that year, the new exegesis of an ancient testament and the midwife of the new monetary economy.

It is an economy that still looks to its members like a strange new game, for money is quite unlike the pigs and geese and corn and barley it has replaced and represents. 'Why is the exchequer so called?' asks the servant; and the master replies, 'The best explanation I can think of at the moment is that it looks like an exchequer, or a chessboard.' Everyone knows that, but nothing is simple to the boy any more. 'Do you think that is the only reason our wise ancestors gave it that name?' he asks. 'Because they could just have well called it a checkerboard [tabularium]', and the old man sighs and tells him:

> There is another, less obvious, reason. For just as in a chess game the pieces have a certain order, and move or stand still according to certain laws and within certain parameters, some ranking higher and some leading the way, in the same way at the exchequer, some preside and others have seats because of their official positions, and no-one is free to act outside the established rules ... also, just as, in chess, battle is joined between the kings, so at the exchequer there is basically a competition and a struggle between two individuals, namely the treasurer and the sheriff who makes his account to the others sitting there as arbiters, so that they may see and judge.[9]

The exchequer is a game, played on a table covered in a cloth, with counters that move up and down the table; and he observes that 'by this system of reckoning, the same penny, used as a counter can represent a shilling, a pound, a hundred pounds, or a thousand.' And the sage continues his chain of thought: '... and as the calculator wishes, the conditions change, and

a counter that represents a thousand can be made to descend through the ranks until it represents just one'.

Inured to the assumption that a penny can only ever be a penny, a sovereign a sovereign (and a servant a servant), the servant cannot resist inferring:

> Similarly, any common man, who is a human being and cannot be anything else can, when worldly honours are heaped upon him … rise from the depths to the highest position, and, then, because fortune's law holds true, he is thrust back to the bottom, and remains what he was, even though it seemed that dignity and status had transformed him.[10]

'It is a worthy thing to seek flowers of mystic meaning among the thistles of worldly matters,' replies his master, but he does not wish to continue the conversation, for he knows that to take it any further would be to take it too far; and the dialogue of the exchequer comes to an end as the importunate servant and the patient statesman depart from their window, in the tower, by the River Thames.

As they take their leave, the old man makes a prophecy:

> At your urging, I have laid my axe to wild and untouched woodland, cutting timber for royal buildings, to be planed by more skilful builders. And when a royal palace arises from that wood, he who started shall deserve, if not the greatest thanks, then the first.[11]

His prophecy has come true, for 800 years later, the exchequer is a vast palace by the Thames, several palaces in fact, with hundreds of towers and

thousands of windows, filled with millions of virtual pounds and pence, and hundreds of servants more civil than the one who interrupted the sage so long ago. Their practices are just as arcane as they have ever been.

But while the river flows on, the window and the tower and the sage and servant have all passed away. The exchequer is also lost, or at least, if it exists, no-one can find it, for while the sage and servant discussed almost every aspect of its arrangement in minute detail, while the dialogue explains exactly how to assay the silver, and count it on tallies, to pursue debts and also to forgive them, they never once mentioned where it was.

In those days there was a tower in Westminster, to be sure, but it was only one among many, and only sporadically occupied, for the King and his court lived on the move. The mobility of medieval governments was driven less by the contingencies of politics and war than by the eternal law of supply and demand. No one place was fertile enough to provide enough food to sustain the thousands of people; and sleeping and living as they all did in one room, disease rapidly spread among them if they stayed in one place for too long.

In consequence, the court, hundreds and thousands of knights, moved constantly from place to place, sometimes daily. It was a terrifying spectacle. Eadmer, the Anglo-Saxon chronicler, wrote that when the Royal Household approached, the common people would 'hide in the woods, terrified of a band of knights and Barons like ravening wolves, and the insatiable demands of court which could strip the land like a swarm of locusts'.

That was the origin of the kingdom's obligations to the King, and their codification in the Domesday Book and the exchequer, which were designed to soften and regularize the rapacious exactings of the Royal Household upon the people. Like the Round Table, the exchequer represents a contract negotiated between ruler and ruled rather than an edict imposed by imperial will.

The exchequer was, like all the machinery of the medieval state, an occasion rather than a place, an event that followed the King on endless progresses. Henry II was not just King of England, but also lord of Normandy, Anjou, and Maine; and everywhere he went, his government was obliged to follow him. In the latter years of his reign, the treasury moved between Winchester, Westminster, and Salisbury on average once every six months in order to provide the King with ready money.

One can imagine the carts lumbering through the spring rain down the ruins of the Roman roads, laden with chambers and courts that had been packed away, stumbling slowly from hall to *immeuble* hall. No wonder the exchequer itself was so simple: a game of judgement, a magnificent court that, once it had adjourned and the kingdom's obligations to the King had been met, became a piece of cloth that could quite simply be taken off the table, folded up, and carried away.

A Hall

FIVE HUNDRED AND FORTY-SEVEN YEARS AFTER THE PATIENT STATES-
man and the impertinent servant had held their discourse in their tower,
the King was shown into his hall at Westminster. The royal standards had
been hung from the rafters, the mace had been brought, the room was
packed, and the court was ready to sit.

But when he came in, he was not impressed:

> After a stern looking upon the court, and the people in the galleries
> on each side of him he placed himself in the chair, not removing
> his hat, or otherwise showing the least respect to the court, but
> presently riseth up again and turned about looking downwards
> upon the guards placed on the left side and on the multitude of
> spectators on the right side of the said hall.[1]

Presently, he spoke. 'I would know by what power I am brought hither,'[2]
he asked; but he already knew the answer:

Charles Edward Stuart, King of England, the Commons of England, assembled in Parliament, being sensible of the evils and calamities that have been brought upon this nation and of the inno-cent blood that hath been shed in it, which is fixed upon you as the principal author of it, have resolved to make inquisition for this blood, and according to the debt they owe to God, Justice, the Kingdom and themselves, and according to that fundamental power that is vested, and trust reposed in them by the People (other means failing through your default) have resolved to bring you to trial and judgement, and have therefore constituted this high court of justice before which you are now brought.[3]

As the solicitor for the Commonwealth read out the charge, the King leaned forward in his crimson chair and tapped him on the shoulder with his cane. 'Hold', he said, but Mr Cook did not turn or pause; and as the King withdrew his cane, the silver top fell off. No-one moved, and after a while the King had to stoop to the floor and pick it up himself. It was not an auspicious beginning:

When I know a lawful authority, then I will answer … Remember, I am your King, your lawful King … I have a trust committed to me by God, by old and lawful descent; I will not betray it to answer a new and unlawful authority; therefore resolve me that and you shall hear more of me.[4]

The judge sighed and adjourned the court. He had been expecting this, and there was no point continuing, for the principle upon which the King of England was standing was the reason that everyone was there. There had been civil wars before, kings had been deposed and murdered before,

but never like this, not with the full panoply of state. The trial of King Charles I was the first in British history in which not just the practice, but the very principle of the monarchy had been put in the dock.

* * *

It could not have taken place anywhere else.

Once upon a time, long before the exchequer, and the round table, and the throne, Westminster had been a sandbank by the Thames; and once upon a time his thegns had brought King Canute there to flatter him. 'You are so powerful', they said to him, 'that even the sea will obey you.' But Canute smiled; and he told them to bring his chair to the water's edge. He sat down and commanded the rising tide to fall, but soon enough he and his thegns were wading through the murky water, laughing, with the throne on their backs. Later, Canute built a wooden hall there to remind them all that while the king might hold sway over the affairs of men, he had no power over nature.

That hall has long perished away, and in the absence of any historical record, we can reconstruct it, and halls like it, only through the songs and poems that used to be sung in them. They tell of Wotan drinking wine with his warriors in Valhalla, and Beowulf, drinking beer on the benches of Heorot, with his knights and barons. 'Time and time again, when the goblets passed and seasoned fighters got flushed with beer, they would pledge themselves to protect Heorot', sang – or rather shouted – the bard over the din of hundreds of men, bloodied from battle, muddied from hunting, flecked with boar flesh, dribbling with drink. They'd pass out eventually, of course, and bed down together on the floor, to wait for the monsters that might come for them in the night.

It was a far cry from the cold clatter of Charles's cane, as it fell to the floor, in the same place, in 1649.

Canute's hall is long buried under the many halls that his successors built over it, each one grander than the last. Edward the Confessor built himself one in stone, and in 1099 William Rufus erected another hall to the north of it, whose foundations still describe the extent of the room Charles I walked into in 1649. It was so vast that no timbers could be found long enough to span the roof, and it had to be divided in two by an arcade. Three centuries later the builder Hugh Herland made a new roof for this hall at the behest of King Richard II. Ingeniously framed like the keel of an upturned boat, it covered the enormous width of the hall in one span, seemingly supported on the wings of angels.

In 1244 Henry III fed 10,000 people in Westminster Hall at one sitting; but he didn't actually eat with them, and neither did Canute, let alone Wotan. Instead, they would preside over the revelry from the end of the room, opposite the door, seated at a high table, on a high chair.

And the high chair was a place so sacred that not even Grendel, the nightmarish monster that terrorised Heorot, dared approach it: 'He haunted the glittering hall after dark', sang the scyld, 'but the throne itself, the treasure seat, he was kept from approaching; he was the Lord's out-cast.' It was where Beowulf hung his bloodied arm after he'd ripped it off.

When Wotan sat on his chair in Valhalla, they sang:

The ravens sit on his shoulders and say into his ear all the tidings which they see or hear; they are called thus: Huginn and Muninn. He sends them at day-break to fly about all the world, and they come back at undern-meal; thus he is acquainted with many tidings.[5]

For the table and the chair at the end of the hall – the King's Bench – was the seat of divine knowledge, and vengeful justice.

That justice was never dispensed evenly, even in the earliest times; for while thegns and erls brought their cases to the King's Bench directly, those of lowly birth were stopped by the door at the other end of the hall, where officials were delegated to hear their common pleas without disturbing the King's feasting.

And that was when the King happened to be in Westminster. When he was away at war, or on progress, he would delegate his justice to others. In 1178 Henry II decreed that five judges could sit at the King's Bench in order to pass judgement in his name. His authority was devolved upon King's Bench itself; and, reinforced by its new dignity, that piece of furniture began to change. The chair was remade in marble in 1245; and in 1308, around the same time that the roof was rebuilt and the hall turned into one large space, a marble table was made to stand in front of it. It was some nineteen feet long and three feet wide, supported on three stone arches. The central section was made so that it could be removed, allowing the king to be enthroned in all his majesty in the sight of his people. Quite unlike the rough timber benches and boards that filled the rest of the hall, the King's Bench was fixed, and this was so unusual that it acquired a courtly term all of its own: a 'table dormant'.

* * *

No wonder the Commissioners of the Commonwealth were so keen to bring King Charles to trial in Westminster Hall, for if justice were to be done to the King, it was as well to do it at the King's Bench, where the authority they sought over him was embodied, they (and he) believed, in a table and a chair.

But the King's Bench would have been hard to spot in January 1649, for it lay dormant under the labyrinth of partitions, screens, tables, chairs, benches, and other excrescences that had, over time, filled Westminster Hall.

By 1320, two timber benches had been made to stand in front of the King's Bench. Both twenty-seven feet long, one was allotted to the judges themselves, and the other to their clerks. By the late sixteenth century, the original bench had been buried under a timber dais; and this dais was itself partitioned on the right hand into the court of King's Bench, and on the left the Court of Chancery. The Court of Common Pleas had undergone a similar transformation – partitioned off from the body of the hall, it was dominated by a sort of wooden tower from whose eminence the judge would peer down at the lowly folk who brought their civil cases to it. The rest of the hall was lined with booths in which tradespeople sought to profit from the process of the law, selling books and pamphlets, scribes, and even witnesses for hire. In order to provide places for spectators, the private citizens who owned the houses next door broke in through the windows and made wooden balconies, for which they would sell tickets at their own front doors.

These excrescences, elaborate and probably ancient as some of them were, were thrown together from timber, for no-one knew when the King might desire to return to his hall. When that happened, the whole apparatus would have to be dismantled, the King's Bench would awaken from sleep, and become the chair and the table of the King once more, and he would sit at them, and eat, and drink and judge, just as, once upon a time, William Rufus, or Canute, or, once upon a time, Wotan had done.

And thus it came to pass in 1649. On the 9 January a herald rode into Westminster Hall with six trumpets and two troops of horse to announce the return of King Charles I to his hall at Westminster. This started a frantic eleven days of activity, for by 20 January, the *meubles* of Westminster Hall needed to be moved into positions for which, while they were dressed in the scarlet and ermine of ancient tradition there was, in fact, no precedent.

On the one hand, the place needed to be made large enough to accommodate the considerable interest the case would cause. In addition, the court consisted of a president, several clerks and 135 commissioners; and in order to make space for them, the partition that divided Chancery from the King's Bench was pulled down to make a large single space.

But such was the fear of assassination or assault that there was no question of opening the whole of Westminster Hall to the public. Instead, the outer walls of the courts of King's Bench and Chancery were reinforced with two security barriers. The whole ground floor of the hall was reserved solely for the members of the court and a military guard; while spectators were restricted to the galleries above.

And so when King Charles was led to his seat on 20 January 1649, he stood for a while, staring around him, at an interior which, although it belonged to him, had been made completely unfamiliar.

The hall had been decked with the royal standards, but they had been hung there by his subjects not in his honour, but because they had been taken from him at the battle of Naseby. The King was taken not to the King's Bench, but to a chair set facing it, in the place of the accused. In front of him they had placed the mace and sword of justice they had stolen from him; and in the place of his bench, or burying it under their nervous sweating buttocks, there were no longer judges appointed to their station by the King, but three rows of commissioners elected by the Commons of England. The furniture of the hall had been turned back to front, and as a consequence, the world had been turned upside down. No wonder Charles wanted to know by what authority he had been called thither.

It broke him. When, a week later, they sentenced him, he finally decided to speak, but it was too late: 'I may speak after the sentence—', he babbled, 'by your favour, Sir, I may speak after the sentence ever. By your favour – hold – the sentence, Sir – I say, Sir, I do—'[6]

They executed him three days later.

And when he was gone they started to clear the court – it disappeared in a day or two – and as they did so, the King's Bench came to light underneath centuries of accretions. They had it broken up, for they had no intention of allowing a King to sit at it ever again.

They broke it up, but they didn't throw it away. Fragments of the King's Bench were rediscovered during repairs to Westminster Hall in 2005, buried under the floor. The broken pieces are now kept in storage rather than in their proper place, at the head of the room, for it is no longer the seat of royal justice, and neither, after Charles I's trial, can the crown be the fount of an absolute authority. A brass plaque mounted in the floor marks where it stood. And another one shows where King Charles sat down to receive its justice.

Without the King's Bench Westminster Hall has gone, in the end, the way of all halls – yours, and mine: it's an entrance lobby. Only from time to time is a table or a seat moved into the correct position, at the end of the hall opposite the main door, and only then does anyone remember that once upon a time, it was this place that was the seat of power at Westminster. Now, it's another.

A Palace

'WE AT NO TIME STAND SO HIGHLY IN OUR ESTATE ROYAL AS IN TIME of parliament,' Henry VIII once said, and it's still true. It has always been the same.

The Royal Opening of Parliament is as repetitive, and enchanting, as a fairy tale. Once a year the Queen puts on her crown, and climbs into a glass carriage, and rides to the turrets and pinnacles of the Palace of Westminster. Sitting on a golden throne, swathed in velvet and ermine, flanked by princesses in tiaras, lords spiritual and temporal and judicial in mitres and coronets and powdered wigs, overlooked by lions rampant and chivalrous knights, the monarch in parliament presents the immoveable image of majesty.

It has always been the same; and when everyone is assembled, the Gentleman Usher of the Black Rod is dispatched from the royal presence to another place, bearing the ebony cane topped with a silver lion that he has borne for time out of mind.

But as he approaches the doors of the other place, they are slammed

shut in his face. Only after he has rapped on them three times with his cane do the people inside let him in, and when they finally do, they don't stand up to hear his royal summons. Instead, they loll around their benches and they laugh at him.

It is not a mistake, for everything has always been the same.

The Palace of Westminster is best known now as the Houses of Parliament; and although the word refers to the practice of conversation, the two houses that it contains speak to, and about, one another as little as they can. The House of Commons is only ever referred to by the denizens of the House of Lords as 'another place'; and by comparison with the Lords, it is a dull cuckoo ensconced in a gilded nest. The architecture critic Robert Lutyens described it as 'without distinction ... a rather ugly galleried box' that would have been better 'without the Gothicism that renders its appearance so ridiculous'.[1]

And unlike the studied splendour of the rest of the palace, the Commons is always noisy and overcrowded. There are not enough seats for everyone, and the Government and the Opposition face one another on rows of benches separated by the length of two swords, drawn in anger. The 'mother of all parliaments' encloses fractious twins, who, while their names might change from Whig and Tory to Labour and Conservative, will never permanently establish ascendancy over one another, but will never cooperate, either. It is ironic that this room was built to enshrine principles of democracy for which its form makes it so incommodious.

It is not a mistake, for despite its medieval appearance, the House of Commons is only sixty years old. The occasion of its construction was the destruction of its predecessor by a wartime bomb in 1941. It might not have been meant that way, but the bomb provided the House with the opportunity to build itself a new house, perfectly suited to modern democracy; and

the debate that accompanied its creation was lengthy, detailed, and considered. Nancy Astor, the first woman to sit in the House of Commons, stood up to speak in that historic debate and she complained that:

> I have often felt it would be better if ministers and ex-ministers did
> not have to sit and look at each other, almost like dogs on a leash,
> and that controversy would not be so violent. I do not think there
> is any merit in violent controversies, and I do not believe that the
> fights in the House of Commons helped democracy.[2]

She, along with other members, proposed that a new house should be rebuilt along the rational lines of the assemblies of other nations, in the form of a semicircular theatre.

But Winston Churchill argued that the inconveniences of the previous chamber should be retained. 'Its shape should be oblong and not semicircular,' he argued, and 'it should not be big enough to contain all its members without overcrowding.'[3] He carried the House with him, and the committee who met to discuss the new proposals were, they claimed:

> unanimous in their opinion that the sense of intimacy and almost
> conversational form of debate encouraged by the dimensions of the
> old chamber should be maintained. They believe that the present
> intimate and traditional style of discussion is firmly fixed and
> established in the customs and affections of the nation.[4]

An intimate and traditional style of discussion – or what Nancy Astor, with American directness, rather than feminine delicacy, called 'violent controversies' – was what distinguished British politics from those of the nations with whom they were at war, they argued; and classical theatres,

however rationally planned, had, in the opinion of one MP, been 'the death warrant of democracy on the continent'.[5]

The House commissioned their house from Giles Gilbert Scott, creator of those icons of Britishness, the red phone box and Battersea Power Station. He rejected any calls to continental avant-gardism, writing that 'I should feel happier about the future of architecture had the best ideas of modernism been grafted upon the best traditions of the past, in other words, if modernism had come about by evolution rather than revolution.'[6]

It was a sentiment with which most Britons, as they stood alone against European totalitarianism in 1941, would readily agree; and if Scott used architectural style to political ends Churchill, introducing the debate, made the converse point. 'We shape our buildings', he said, 'and afterwards our buildings shape us.' That shaping was, in Britain, notable for evolutionary slowness rather than revolutionary radicalism.

It had all happened before, for in British politics, as both Scott and Churchill had observed, nothing and everything changes. Just as a bomb provided the mother of parliaments the opportunity to be reborn in 1941, so a century before, another conflagration had done the same.

It began on 16 October 1834, in a stove overloaded with old tally sticks. They had been used to count the revenues of the exchequer once upon a time, but had become useless in a more numerate age, and had been cast on the flames. The heat of their burning set fire to the palace chimneys, and by morning most of the Palace of Westminster had been gutted.

The debates about reconstruction were just the same as they were to be in 1941. There were those who proposed the creation of a new House of Commons on classical continental lines, but those who insisted on evolution rather than revolution, of course, won the day.

Charles Barry and Augustus Welby Pugin's design for the replacement

palace was the model of medieval splendour, but that didn't stop the sniping:

> No doubt Mr Barry's plan was a fine picture, well calculated to deceive one young and inexperienced in architecture, but it ought not to have imposed upon such old, tried, and practised artists as the Commissioners ... Was it in any way conformable to the instructions given for selecting no plan which did not afford sufficient accommodation? ... with respect to that House [of Commons], it was required, that the body of it should contain 460 Members. By the plan it would, he believed, contain only 326'[7]

Fifteen years later, as the House approached completion, its Speaker was forced to announce that 'the arrangement of the seats in six rows, on either side of the House, as originally intended, would not afford the necessary degree of accommodation to Hon. Members.'[8] 'It was an eternal disgrace to the House and to the country', commented one member, 'that they had expended so much money on a place so ill-suited to carry on the business of the country.'[9]

But they moved in anyway. It was, after all, an ill suitedness that, within a century or so, became the object of fond nostalgia; and it was an ill suitedness up with which the House of Commons had put for centuries already. An engraving made of the old House in 1834, the year of its incineration, shows that it had always been too small and too confrontationally arranged for reasoned, democratic, debate.

It was a problem that the finest architects in the land had repeatedly tried to address. The Act of Union with Ireland in 1799 had added 100 new members to the House, and in order to accommodate them James Wyatt had been forced to make large openings in the existing outer walls

to create more space for benches down either side. Ninety years before, Sir Christopher Wren, who was himself a member, had been called upon to make new galleries for the forty-five new MPs conjured up by the Act of Union with Scotland.

He was obliged to wreck his own work in order to do so, for he had designed the interior of the House only twenty years before. It had been a serene, classical space, reminiscent of his city churches, lined with two opposing rows of benches, and dominated by the Speaker's throne under two windows, round-headed like the tablets of the law. Its lowered ceiling and intimate scale made it easy for members to engage in 'intimate and traditional' debate.

Or that's what the members chose to remember in 1941 and 1834. The truth is that the House of Commons had always been a ramshackle room, never quite big enough to contain all its members, and furnished to provoke furious argument rather than reasoned debate. The truth is, the room had never been built to house a parliament in the first place.

Once upon a time, Westminster Palace really had been a palace, and the King had really lived there. King Edward III endowed a college of priests to pray there for his soul, and he built them a chapel dedicated to St Stephen. When they sang the hours, they would range themselves facing one another, along the choir stalls that lined the side walls, and divide into the two parts of the antiphony – *decani* and *cantoris* – and then they would sing, each side answering to each, the eternal praises:

> *O Lord Save the King*
> > *And mercifully hear us, when we call upon Thee*
> *O Lord save Thy people*
> > *And bless Thine inheritance*

But the Lord, while he saved the King, didn't mercifully hear them; and their hour came in 1547, when Henry VIII dissolved the religious colleges. He had no use for a chapel in Westminster anyway, for he had moved out of its draughty halls thirty years before, after another fire. The room lay empty for three years, until the Protestant advisors of Edward VI decided to turn it over to secular uses. It was granted to the Commons so that they could sit in it on the occasions that they happened to be in session.

Until that time, the Commons had no fixed home, for they played little part in the day-to-day business of government and were summoned only when the King needed them to raise subsidies. When he called them, parliaments would come to wherever the King was on his progresses – in Winchester, York, or Oxford – only occasionally in Westminster. Sometimes they met in the King's bedroom, sometimes in his Great Hall, and sometimes in the chapter house they would borrow from the monks in the abbey next door.

The old chapel of St Stephen in Westminster Palace was the first room that the House of Commons could call its own; but it was still, in essence, a chapel. The members would file in and take their places in the stalls, facing one another like a monastic choir, and when they were ready, their Speaker would take his place like the priests before him, in a chair in front of the old altar, which, although it was obsolete, nobody dared to remove.

Instead, the increasingly Protestant membership of the Commons did everything they could to bury the idolatrous chapel. They whitewashed the wall paintings of the saints and covered the carvings in sober panelling. Wren's classical interior, built inside the old chapel in the aftermath of the Glorious Revolution, was a classical mask, designed to hide the medieval, sacral origins of the room for ever.

It was only the fire of 1834 that brought the old chapel to light, and then only for a moment. As the charred fragments of Wren's wainscoting

fell away, solemn saints and angelic traceries were revealed; but the ancient walls had been so shattered by the heat that they had to be demolished immediately.

They didn't rebuild the House of Commons on the same spot, and the mother of the mother of all parliaments now exists only in the footprint of a corridor. Look carefully at the tiles on the floor, and you'll see a brass plaque that marks the place where once the Speaker used to sit, and before him, the cantor of the chapel choir.

Once upon a time, the Commons were guests in the palace of the King; but once he had given them a room of their own, they started to act like they owned the place. When, in 1642, King Charles I tried to enter their house, they refused to speak to him. The Speaker cowered on the floor with hands over his eyes, muttering: 'May it please your majesty, I have neither eyes to see nor tongue to speak in this place, but as the House is pleased to direct me, whose servant I am here,' and the King was sent away unsatisfied.

Nothing has changed, and when the monarch sends for the House of Commons at the state opening of parliament, the door is still slammed in the royal face. It is an act of memory, for the mother of parliaments, the ugly, fractious cockpit of democracy, has proved remarkably reluctant to forget the room that mothered her. That room has perished time after time; but the arrangement of the furniture within it has outlived fire, revolution, and war. The yahoos and catcalls of Prime Minister's Question Time are, in origin, antiphonal singing, as eternal, as changeless, and also as mutable as the palace, the hall, the table and the crown, and the throne.

OBJECTS

THE CATALOGUE OF AN UNKNOWN COLLECTION.
The Liechtenstein inventory of the Kunstkammer of Rudolf II, 1607.

A Cabinet of Curiosities

IN MY GRANDMOTHER'S SITTING ROOM THERE IS A CABINET OF curiosity. She had it specially made, she proudly reminds me; and it's certainly grand enough. Framed by pilasters and cornices, set with hidden lights, the front of the cabinet has been designed to look like a miniature palace, or a museum.

On one shelf stand ivory elephants, and willowy mandarins carved in jade. Another supports gilded icons from Bulgaria and a soapstone Madonna from Kenya. A pair of porcelain parrots might, Granny tells me, be very valuable. There is a collection of glass paperweights: complex coralline worlds that entranced us all as children; and two saucers and a teapot are all that remains of a floral tea service. My mother tells me she was allowed to use the brass bell in the shape of a crinolined infanta if she was ill, to summons orange juice to her bedroom. It was once a set of four, and I remember playing dollies with them as a child. On one shelf there stands a set of goblets carved in Bohemian crystal; and on another, a Chinese bowl, once one of a pair.

This bowl is filled with matchbooks, taken from all the hotels my grandmother has ever stayed in. They are worthless, Granny admits, but she keeps them all the same. They remind her of being a teenager before the War, taking the train with her parents down to the Hotel Bristol in Vienna, and driving on to the Bodensee. And they remind her of being a working widow, much later, driving rich, impatient Americans from *schloss* to *schloss* on culture trips. She met so many interesting people, then, she tells me, and learned so many interesting things. So many interesting things, she gestures, vaguely, towards her cabinet.

On their own, unlabelled, without the Chinese bowl (and its missing twin), the matchbooks are worthless pieces of card. Since Granny stopped smoking, they aren't even useful for lighting up. But gathered together in a bowl and placed upon a shelf, they form a collection, for the cabinet turns the things it contains into curiosities. Its shelves and lights and symme-tries create groups and complete, by implication, incomplete sets. In the relationships it creates, provenances are explained, reciprocities illumi-nated, and stories told. The cabinet turns mute things into reminders that, arranged in specific places, stimulate the mind to recollection. It is a memory palace.

Collecting is, of its nature, an act of memory. The bowls and cups that are arranged in Granny's cabinet are not for eating off, or drinking from. They are little memorials to eating and drinking, the collection of an incomplete set of which presupposes the recollection of a complete one, in the mind, if nowhere else. The insistence on authenticity and provenance privileges knowledge over sense, and the past over the present. The desire to catalogue and to arrange things is the desire to reproduce, in miniature, a memory of the world from which they have been taken.

Now she doesn't get out much, Granny sits in her chair, and gazes at her cabinet to remember, in microcosm, a world she visits less and less.

Collecting is a contemplative, solitary activity, in which we remove things from their natural or social contexts to make them our own. Nowadays, we use the word 'cabinet' most often to speak of cupboards like my grandmother's, but originally it meant 'little cabin'; and the word still bears traces of retreat.

Cabinets acquired a special significance in the Renaissance, when even the privileged were still obliged to camp out in communal halls. Cabinets were places in which to be alone; and being the only private rooms in otherwise public palaces, they were used to store all sorts of precious curiosities: private possessions, private letters, and private thoughts. The palaces of Vienna, Munich, Dresden, and most famously Prague all contained such cabinets; and in them the princelings of the Holy Roman Empire collected all sorts of curiosities. *Wunderkammer*, they called them.

And chambers of wonder they were, for the curiosities they contained were, to modern eyes, hopelessly eclectic and were arranged in ways that seem, to the modern eye, bizarre. The treasures in the cabinet of the castle at Ambras were grouped by colour. At the Residenz in Munich they were composed on tables by size. In Prague they were laid out on a long green table that ran down the middle of the room, leading from wonders of nature at one end, through models of artifice, to instruments of science at the other. None of these was a classificatory system we would recognize as scientific today.

And that is an irony, for the *Wunderkammer* of the late Renaissance were the crucible of the scientific revolution. The instruments they contained were collected to measure the heavens; the objects of artifice to try the human mind and hand; and the wonders of nature to archive the earth. The curators and scholars who were collected in these rooms used the things they contained to revolutionize our understanding of the world, and their findings led directly to the discoveries of Galileo and Newton.

They were also the germ of that great public interior of the scientific age, the museum. Relics of the *Wunderkammer* of Prague form the core of museums as diverse as the Kunsthistorisches Museum in Vienna, the Národní Museum in Prague, the national museums of Denmark and Sweden, and the Metropolitan Museum in New York. All the paraphernalia of modern museology: the catalogue, the curator, the gallery, and, of course, the cabinet, find their origin in the *Wunderkammer*.

But none of that had happened at the time. Science did not mean what it means today; and the cabinets of the Renaissance possessed nothing of the rigour of the modern museum. They were created in an age in which mandrakes and the Holy Grail were no more or less scientific (or fantastic) than the moons of Jupiter. They were collected piecemeal, the indulgence of private caprice, and the world they recollected was not like our own, not, at least, to the people who lived in it.

The things these wonderful memory palaces were made to recall must therefore remain a mystery, known only to their collectors, the princes and the magi whose private motives have passed away with them. Without them, they remain inscrutable cabinets that inspire curiosity rather than instruments of transparent science.

It's the same in the Doll's House. Animated by my grandmother, her cabinet is a miniature museum, a memory palace. On its little shelves, china and brass, orange juice and saltpetre, parrots and crinolined ladies have been collected to tell the story of a life, a world, and a system of knowledge. Without my grandmother to recollect their stories, they would be useless trinkets, and the cabinet would be just an empty cupboard. One day, this is what will happen.

A Catalogue

HERE FOLLOWS A CATALOGUE, FROM THE YEAR 1607, OF WHAT WAS found in the room known as the *Kunstkammer*:[1]

> One hundred and one cabinets, among them
>> A cabinet lacquered red and painted gold
>> A cabinet of silver
>> A cabinet of ivory and ebony
>> A cabinet set with two mirrors
>>> And in them,
>>>> coins, rings, and a giant opal carved into the form of a mountain
>>>> Miniatures and landscapes
>>>> Books on the proportions of men
>>>> Histories
>>>> Astronomies
>>>> A great red leather book, containing all sorts of creatures

Geometrical and Astronomical Instruments
> A heavenly globe borne between the wings of Pegasus
> An earthly globe whose hours are struck by the figure of Astrology
> A perspective instrument
> A music box, surmounted by the triumph of Bacchus
> And a bell for summoning the dead

A book of pageants
Medals of the Emperors of Rome
And little animals, cast in silver from life
Fortuna, Venus and Cupid, carved in ivory
The Triumph of the Emperor Maximilian, carved in stone
Matthias, the King of Hungary, and Beatrix of Aragon, his queen
An almirah, containing
> Venus
> Pallas
> And a dog

A bust of our lord Rudolf II
> And his triumphs, cast in bronze

Bezoar

Majolica

Vessels of Amethyst
Vessels of Chalcedony
Vessels of Jasper
Vessels of Marble

Vessels of Prasma

Vessels of Lapis Lazuli

Vessels of Heliotrope

And most beautiful, most costly, the largest: a vessel of Agate, in which the name
of Christ may be seen

Grecian urns

An ancient oil lamp

An Egyptian vase

Whistles

Persian armour

Indian daggers

Swords from Turkey

A goblet, wrought from the horn of a rhinoceros, the tusks of a warthog, and
the teeth of a shark

And another, turned on the lathe by the Emperor himself

Coconuts

A crab

Birds and fish

The teeth of a Hippopotamus

The beak of a Dodo

The skeleton of a Basilisk

One horn, very long

No-one had read the list through for years; and when the curator looked it up in his inventory, he found only the entry: 'Catalogue of the Unknown Collection'.[2] He should have known. He'd made that one up himself.

Two years before, in 1945, Dr Gustav Wilhelm had arrived at the mountain fastness of Vaduz in a bus packed with hundreds of boxes. There weren't enough of them, he knew, but there had been very little time. He had been driving for days: from Vienna to the mines of Lauffen where they'd salted away the paintings, to the monastery of Gaming where they'd shut up the sculpture, to the island of Reichenau on the Bodensee, where they'd taken the smaller decorative pieces. He'd dealt with air raids, snow, thaw, officious officials, and the prospect that he'd never see his family again; but he had, he knew, to get his boxes out of the Greater German Reich before anyone else got to them.

And then Dr Wilhelm locked himself and his boxes into a room in the castle where he knew no-one would find him; and he began to unpack. As books, cabinets, clocks, paintings, and vessels emerged from deal and cardboard, he made an inventory.

Or, rather, he made one up. He carefully removed the labels on every treasure, and applied a new one, attributing each one to a lesser artist, more recent times and cheaper materials. He turned one of the most significant art collections in Europe into a heap of junk. He knew it was the only way to save it.

When he was done, the German customs inspectors arrived to look at his collection. He'd had to agree to it: it was the only way he'd been able to persuade them to let him drive his bus over the border. The guards cast their inexpert eyes over the boxes, and since, as far as they could see, they contained nothing on the Reich List of Indispensable Art Objects, they allowed them to stay where they were.

And once the guards were gone, Dr Gustav Wilhelm began to sort

through what he had been able to rescue of the ancestral collection of the Princes of Liechtenstein.

Two years later in 1947, in the process of restoring his treasures to their former identities, Dr Wilhelm came across the Catalogue of the Unknown Collection. He opened it for a moment, and turned the pages, and found himself rummaging through a room that had been lost for 340 years. It was a chaotic, eclectic jumble, quite at odds with his own careful, curatorial instincts. He closed the book; and the door did not open on the *Kunstkammer* for another nine years.

But rumours about it circulated around the curators of Central Europe in the late 1940s. They were all, like Dr Wilhelm, in the process of recollecting their collections from the chaos of war; and Dr Erwin Neumann of the Kunsthistorisches Museum in Vienna took a particular interest, not least because many of the objects in the unknown collection were, he could tell, already in his own.

In 1956, Dr Neumann proposed a scientific edition of the inventory. It was no simple task; and when the study was finally published in 1976, it took up a whole volume of the *Yearbook of Viennese Art Collections*. Rotraud Bauer and Herbert Haupt, the scholars assigned to the task, found that their studies had taken them far outside the confines of their own museum.

They tracked down the vessel of heliotrope to the Louvre, and heard tell of one of agate, surmounted by an ivory swan, in the Husgeradskammaren in Stockholm. There was a bust of the Emperor Rudolf in the Národní Museum in Prague; and the goblet turned on the lathe by the Emperor himself was in the Koniglijk Kunstkammer in Copenhagen. The heavenly and the earthly globes were in the Metropolitan Museum in New York; and one of the 101 cabinets in a mansion in Los Angeles.

Wherever it was in 1607, whatever sort of room 'the room known as the *Kunstkammer*' had been, its contents had been dispersed; and they appeared

in the catalogues of all sorts of collections, drawn up both before and after 1607. Bauer and Haupt found themselves collecting an inventory of inventories, in whose dense cross references they were able to trace the evolution of the unknown collection.

There was a catalogue they found in Vienna for an auction that had been held in Prague Castle in 1782. Only 300 items were listed, and their sale raised, apparently, no more than 577 gold coins and 37 Kreuzers. No-one bid for the stuffed dodo, and it was thrown into the castle moat.

There was a clock that recurred in wills and bills of sale in nineteenth-century America, eighteenth-century France, and late seventeenth-century Rome. It was included in a catalogue written by a certain Pompeo Azzolino, the nephew of a Cardinal who had been the secret lover of Queen Christina of Sweden, after she had abdicated to Rome.

And the same clock reappeared in the royal library in Stockholm, in a list drawn up on the orders of the Swedish army in 1648, at the end of the Thirty Years War. They'd run amok in Prague, so the story ran, and found the keeper of the *Kunstkammer*, and threatened him with the rack, and forced him to hand over his keys. Then they'd stormed in, and packed thousands of crates, and carried them out of the room, down to the river, out to the Baltic, and into the harbour at Stockholm, where Queen Christina awaited them, impatient for the spoils of war to arrive before the ink was dry on the treaties for peace.

Another such inventory had appeared in 1913, in an antiquarian market in Silesia, as the Counts of Nostitz were clearing out their castle of Lobris. It had been drawn up, according to the epigraph, for the Directors of the Estates General of Bohemia in 1619. Almost contemporary to the Catalogue of the Unknown Collection, it was almost identical, but not quite. In this inventory, all of the objects in the *Kunstkammer* had been valued, and, what is more, their disposition in the room recorded. Neither

of these two categories of information had been entered in the inventory of 1607.

And so Bauer and Haupt were able to reconstruct the arrangement of an interior lost for three centuries. A long green table ran down the middle of the *Kunstkammer*, covered in clocks, globes, caskets, mirrors and musical instruments. The walls of the room were lined with twenty cases, and they were filled with books, animals, porcelain, crystal, ivory and astrolabes. Between them were squeezed 101 cabinets. A bust of the Emperor Charles V was placed above the first of them, and, on top of the last, one of his cousin, the Emperor Rudolf II.

They knew why this inventory had been written. In 1619 there had been a coup in Bohemia, which was at that time part of the Holy Roman Empire. The Estates General had thrown the agents of their Emperor Ferdinand out of a window in the castle in Prague, and elected a king of their own choosing. They knew that the Emperor would seek revenge, and that they would need a war chest to fight him; and so they decided to realize their assets to raise the necessary funds. The list that turned up at Lobris in 1913 had been drawn up for this very purpose.

It was a purpose that was never fulfilled. By 1621, the authority of the Emperor had been restored in Bohemia, and he ordered the Duke of Liechtenstein to draw up a new catalogue, in preparation for the removal of the most valuable items from the *Kunstkammer* to the security of Vienna. Perhaps it was then, rummaging through thousands of treasures, that the Duke found the Catalogue of the Unknown Collection. Perhaps it was then that he picked it out, and secreted it away to his own cabinets in Vaduz, where no-one would find it for hundreds of years.

There have been several attempts to recollect the unknown collection. An exhibition was staged in Prague in 1912; and the stables in the castle were converted into a little museum in 1965. In 1988 some of the treasures

of the *Kunstkammer* were displayed together for the first time in centuries; but since Prague was then outside the west, the collection was shown in Essen and Vienna.

A decade later, the iron curtain was drawn back to reveal a huge show, collected back in the place where, it was believed, the *Kunstkammer* had originally been found. The exhibition in the Hradcany Castle at Prague was an affair of fantastical logistical complexity, in which around three hundred different institutions from around the world lent several thousand objects.

But the show was doomed to hold the treasures of the *Kunstkammer* for just a month or two; and now it is remembered like its progenitor, only in the catalogue made of its contents. Its careful scholarship lacks the mysterious casualness of the original; but its very completeness reveals how little of it it had been possible to recollect. Of the thousands of treasures listed, only forty-five could be matched up with any certainty to items in the inventory of 1607. Some objects proved too precious or too fragile to move. In other instances, their current owners refused to lend them. The majority remained hidden, had been destroyed, or had just been forgotten.

We know how, because almost every time it happened, someone wrote it down. Catalogues, lists, and inventories are always attached to wills, bills, and sale catalogues, instructions for plunder, packing, unpacking, moving, and throwing away. That is why their contents are named, numbered, priced, located, and sized. Inventories are drawn up in the knowledge that any attempt to stop the hands of the clock and entropy of a collection is futile. They are named after acts of discovery; but they are always, in fact, acts of remembrance.

Or almost always. None of the contents of the Catalogue of the Unknown Collection was ever priced, and nor was the location of any curiosity in the cabinet ever specified. The catalogue fails even to describe the form or the location of the *Kunstkammer* itself. Even if one were able to

recollect the whole unknown collection, no-one would know where to put it. Here and there, the list has been amended in another hand; and some entries have been illustrated with little doodles: a flamingo, a pot, a horn, a woman whose hair grows down to the ground.

The Catalogue of the Unknown Collection is therefore quite unlike all its successors, for it appears to be a working list, compiled *while the unknown collection was being collected*. The collector did not need to know how much his possessions cost, since he already possessed them; and he did not need to know where he could find them, because they were there, with him, in the *Kunstkammer*. The list was repeatedly amended because collectors always collect more, and doodled upon because it was made for private reverie rather than public presentation.

The Catalogue of the Unknown Collection is no less curious than the cabinet it describes, for only very rarely do we commit to memory what we already know. It is a paradox, for while it might describe a private present it begins in a perfect, historic, tense with 'what *was* found in the room ...' Whoever rummaged through the *Kunstkammer* in 1607 was already trying to recollect the past, or was at least aware that the collector and his collection were about to enter it. Whatever and whoever was in the room known as the *Kunstkammer* in 1607 was in danger, and what is more, they knew it. Their fears were realized. Like the rooms that contain them, collections are moments in time that can never fully be recollected.

Despite decades of scholarship, the Catalogue of the Unknown Collection remains as unknown as it did when Dr Gustav Wilhelm found it, in a castle in the mountains. We still do not really know why it was written, or what, indeed, it was trying to record. The *Kunstkammer* remains what it was the day some unknown curator sat down to make a list of its contents: a cabinet of precious secrets, a constellation in perpetual motion, as elusive as the Holy Grail.

A Cabinet

A PALACE RESTS ON THE CLAWS OF FOUR LIONS. THE BASEMENT, which is of jasper, supports a portal of serpentine and ebony. The attic stories are panelled with porphyry, and the pyramid of the roof was once surmounted by a tiny gilded globe.

The windows of this palace should grant us glimpses of an interior, but, instead, they open onto views that could not possibly be inside. The central portal frames a portico in Venice, while to either side, cascades tumble through rough alpine valleys; two hooded monks pass through an arch of living rock on the way to the castle at Krumau. These scenes have the quality of miniatures illuminated with the softest of brushes, but they are in fact petrified in agate and onyx, marble, heliotrope, amber, topaz, and opal.

This palace contains a whole world, set in stone, ebony, and gold brought from all the corners of the world. Below, there is gold and jasper from the mine; in the middle, the world of men and creatures; above, a pyramid, symbol of heavenly fixity. It is tiny: so small in fact that once

upon a time, this, and a hundred other palaces, lined the written walls of the catalogue of the unknown collection and the stone walls of the *Kunstkammer*.

* * *

Not one of them attended its recollection in Prague in 1998. Or, at least, not one was shown that could be identified with any certainty as having been one of the hundred and one. Most of them had only been identified in the inventory by entries no more descriptive than the word '*kabinett*', and a number. Instead, a selection of cabinets from Florence were placed on display to show what the originals might have looked like, had anyone been able to find them; and not for the first time did a cabinet stand in as symbol for something else.

This cabinet wasn't available to go to Prague, since in 1998 its location was the subject of delicate negotiation. It is now at the V&A in London; but it shouldn't really be there. Arthur Gilbert, who once owned it, didn't think much of the place 'It's like a junk shop,'[1] he said: he had a habit of falling out with people.

Gilbert was born Arthur Bernstein in Golders Green in 1913. He could have followed his brothers into the family business in the East End, but instead he ran away with a dressmaker. Taking his wife's surname, he turned her business into a great success: so much of a success that by 1949, Arthur and Rosalinde retired to California, quite simply, they said, for the weather.

It was in order to furnish their mock Tudor manor house overlooking the Pacific Ocean that the Gilberts began what they admitted was a life of 'maniacal'[2] collecting. Things soon ran out of control; and by the time the collection left home, the walls of the private gym had been hung with a pair of gilded doors that Catherine the Great had once donated to a monastery in Kiev.

In 1975, the Gilberts loaned a proportion of their collection to the LA County Museum, but to Gilbert's chagrin he could see that they were only interested in contemporary art. His collection of *ancien régime* snuffboxes and *pietra dura* micromosaics was an acquired taste, he knew – he had an eye for gaps in the market – but it had become a priceless assemblage, and he had a host of other institutions vying for it. If the County Museum wasn't too bothered about his treasures, he would take them elsewhere.

It was through the offices of Lord Rothschild that the collection was returned to the land of Gilbert's birth; and it was the tortuous nature of the associated negotiations that prevented the cabinet from going to Prague in 1998. Arthur Gilbert was no disinterested scholar: at the opening of the collection in 2000, he turned to the Queen Mother and said: 'I am not an altruist. And when I die what I have will go to the people of the world, whether they like it or not.'[3]

His collection was placed on public display in Somerset House; but in return, Gilbert demanded that all the windows be blacked out, wrecking, in some opinions, the classical architecture of the building. Stranger still, he required that in the centre of the exhibition should be placed not some delicate treasure, but his own office. The room was duly shipped over from LA, complete with a waxwork of the man himself, phone in hand, sealed in a glass cabinet.

His effigy thus entombed, Gilbert died in 2001, the year after the collection opened to the public. It was moved to the V&A in 2008, long after he had any chance to object to the destruction of his own cabinet of curiosities. Along with hundreds of other strange objects, the cabinet was placed in a glass cabinet of its own, in a room filled with other cabinets.

It wasn't a major exhibit. It still isn't. Arthur Gilbert had picked it up in 1966 through a dealer he knew in New York. They told him that it had

been made around the first decade of the seventeenth century, in Prague. That was, more or less, all they knew about it.

* * *

In 1589, Ferdinando, the Grand Duke of Tuscany, sent a diplomatic mission to Rudolf, the Holy Roman Emperor. They had never met, but the duke had heard all the rumours. Most of the stories about the Emperor concerned his avarice, which was legendary. His niece, the Archduchess of Styria wrote: 'What he knows, he feels obliged to have',[4] and Rudolf possessed, or was possessed by, an unusually intense relationship with his possessions. After he'd met him, the ambassador of the Duke of Savoy wrote home to his master that the Emperor had spent 'two and a half hours sitting motionless, looking at the paintings of fruit and fish markets sent by your Highness'.[5]

Everyone knew that the only way to engage the Emperor, or to excite his favour, was to bring him gifts. Rudolf kept everything, and as a result, his collection grew so large that he was obliged to build a new wing, the *Gangbau*, on the western side of his castle, to house it. The Emperor had moved to the castle in Prague in 1584, and from that time onwards, the place was turned into a building site.

And so the Grand Duke of Tuscany sent a gift with his mission which, he hoped, would interest the Emperor, and take its place in the *Gangbau*. It was a table top of *pietra dura*, hard precious stones assembled into a mosaic, manufactured in his own workshops by a certain Cosimo Castrucci.

Rudolf was delighted with the gift, so delighted, in fact, that he ordered another one from the same workshop. This table, dubbed the 'eighth wonder of the world'[6] by one courtier, was no mere furnishing, for the circular top was made in the image of the whole universe, with the

Emperor in the guise of Jupiter at its heart, surrounded by the cycles of the heavens, and the earth beyond them.

The construction and the transportation of this table was itself something of an exercise in international relations. First, the Emperor sent stones mined in his own Holy Roman Empire to Florence. The transportation of these gems across the Alps and through the diplomatic minefield of the Italian princedoms was no mean feat, as was the transportation of the finished table back again. The whole process took nearly seven years. Cosimo Castrucci shuttled back and forth between Florence and Prague, carrying jewels and drawings and furnishings, and as he did so, he found that he was becoming something of a diplomat himself.

As Rudolf got to know him better, the more he wished to possess not just the mosaics themselves, but also the man who made them. Negotiations were delicate, for Castrucci was a prized asset in Tuscany; but in 1596 he arrived in Prague, just ahead of his table, and his son Giovanni followed him two years later. They found that the Emperor had furnished them with a workshop, all the precious stones they could use, and, most importantly, his imperial favour. In 1610, Giovanni was appointed *Kammeredelsteinschneider*, 'court jeweller'.

They weren't the only ones gathered there. From Milan, the Emperor had brought another dynasty of stonecutters, the Miseroni, who turned hard mountain rocks into precious vessels, finding in the grain of the stone forms so smooth that they felt as though they could have been moulded from wax. Jan Vermeyen and Adriaen de Vries set these vessels in precious mounts, and alchemists toiled in the cellars, trying to make more gold to supply their art. There were clockmakers and glassblowers, taxidermists and painters, philosophers and magi. The Castrucci worked with them all to make the 101 cabinets for the Emperor's cabinet.

And the scenes Cosimo and Giovanni devised to ornament the imagi-

nary windows of these cabinets began to resemble the paintings that hung on the walls of the Emperor's own cabinet, and the drawings whose folios filled its chests. The Castrucci formed an especially close relationship with the painter Roeland Savery. In the summer, the Emperor would send Savery up into the mountains, where he would draw the tumbling rocks, the rushing cascades and the broken trees he could never have seen in his native Netherlands; and in the winter, the Castrucci would reconstruct these scenes in stones that had emerged from the same mountains.

When the grand duke tried to tempt him back to Tuscany in 1611, Giovanni Castrucci refused. Instead, he sent the grand duke a cabinet he had made, a little palace surmounted by a belvedere, from whose imaginary eminence the duke could contemplate what he had been forced to give away.

* * *

There is no single text to identify the cabinet collected by Arthur Gilbert in 1966 with any one of the entries in the Catalogue of the Unknown Collection; but its strict Florentine architecture, framing bohemian scenes set in Bohemian stones, identifies it with some certainty to the workshops of the *Kunstkammer* of Rudolf II, if not to the room itself.

Then again, nothing of that room survives in anything like its original form; and when they looked for a place in the castle in which to recollect the Emperor's collection in 1998, there was none to be found. The *Gangbau* now houses state apartments refurbished in the 1930s. Their smart deco emptiness possesses nothing of the strange profusion of the *Kunstkammer* that had once been there.

The only drawings we have of it in its original state were made in 1723 by a certain Johann Heinrich Dienieber, and they are now kept in the castle archives. They are inscribed with the words: 'from the beginning of August 1723, stamped by the office of new works,' indicating that the drawings had

been made in preparation for renovations. Like an inventory, Dienieber's drawings were made not to document the *Kunstkammer*, but to destroy it.

Sure enough, the interiors of the *Gangbau* were swept away in renovations carried out on behalf of the Empress Maria Theresa. Even the floors and ceilings were moved, so that the proportions of the rooms are impossible to reconstruct. A few blocks of masonry remain, but the urbane stucco facades we see today hide more than they reveal about what they used to contain.

Once upon a time, Rudolf triangulated the movements of the heavenly spheres with his astronomers from the roof of the *Gangbau*. On the walls below hung paintings of cities, mountains, and castles. A grand portal, framed by Doric columns and a pediment, opened into the *Kunstkammer* itself, the room in which the Emperor kept his most precious treasures; and below that, in the stone basement, artificers like the Castruccis worked away, producing even more of them.

Once upon a time, the *Gangbau* was a cabinet. Now it's just a building, and the *Kunstkammer* of Rudolf II exists only in miniature, as a model or synecdoche of itself: a little cabinet, made in a cabinet, for a cabinet. It's like the Catalogue of the Unknown Collection. One can imagine finding the inventory tucked into a drawer in the cabinet, and of course, the cabinet, hidden somewhere in the text of the inventory: they contain one another, just as once the *Kunstkammer* contained them both, and they contained the *Kunstkammer*.

Cabinet and catalogue were both made to organize a collection that had become unmanageably vast and various, and to fix it, somehow, as an image in the mind. By 1607, when the catalogue was written, and the cabinets were being made, the *Kunstkammer* was becoming not just a collection of objects, but a collection of such images – a collection, in essence, of collections.

But even in trying to fix his collection, the Emperor was adding to it. The one thing that is not listed in the inventory is its greatest treasure — the catalogue itself that rendered it comprehensible — and that is one clue to the meaning of those fateful first words of its first inventory: '... this is what *was* found in the room ...' Collections are never complete; and the pages of the Catalogue of the Unknown Collection are palimpsests that foreshadow their own obsolescence. What was found in the room in 1607 would not be the same in an hour, a week, let alone a year; and writing a list of all of its contents was always going to be a hopeless task.

The cabinet, on the other hand, is the image of fixity. It rests on the paws of four lions, and is fixed in jasper, serpentine, and ebony. The attic stories are panelled with porphyry, and the pyramid of the roof was once surmounted by a tiny gilded globe. It is the sum of all knowledge, organized and contained in a miniature palace. Turn the key, however, open the door, go inside, and you will find that, for all its order, or perhaps because of it, all its contents have disappeared.

A Clock

IT DOESN'T LOOK MUCH LIKE A CLOCK.

A golden sun traverses a silver globe. The globe turns in a cage of brass; and the cage balances between the wings of a horse that prances on the green empyrean of a table. At the poles, a dial tells the hours as they pass. Once every twenty-four of them the dial returns to its original position.

The clock is tiny, smaller even than the cabinet, but the interior it represents is far larger, for it is, in the words in the Catalogue of the Unknown Collection, the globe of the heavens, and larger than that, the eternity in which the heavens move.

It is signed by Gerhard Emmoser, who was brought to Vienna by Rudolf's father, the Emperor Maximilian; and he made it, it is thought, in 1584, the year in which Rudolf moved his court to Prague and started to build the *Kunstkammer*.

Emmoser has made many clocks for the Emperor, but they are not enough to sate his appetite for time; and in 1592, he has another artificer,

Jost Bürgi, make him a new one. Bürgi is summoned to Prague to meet Rudolf, for his clock contains a startling innovation. Bürgi's colleague, the mathematician Philip Rothman, tries to describe the motion of a new hand on its face:

> The duration of a second is not very short but resembles the length of the shortest note in a moderately slow song.[1]

And soon enough Bürgi, as well as his clock, are installed in the *Kunstkammer*, along with Emmoser, and his.

Others are not so lucky. In 1584, the Emperor purchases a clock from Georg Roll of Augsburg, but soon discovers that Roll has sold a similar one to his brother, the Archduke Ernst, for a higher price. Rather than being pleased at obtaining a bargain, Rudolf has Roll thrown into prison for treating him 'in a scurvy manner'.[2] In his opinion no-one should possess time more properly or spend more money on it than the Emperor, for time is, in his view, more precious, more mysterious, than any other commodity.

Every day, or when he can, the Emperor sits at his writing desk in the *Kunstkammer*, listening to the ticking of his clocks. He does not really need to know the time with any great accuracy. Out in the villages of his Empire, only the rising and the setting of the sun tell the peasants when to rise and make their way to the fields. Most of his subjects tell the time in the irregular guttering of a candle, or the passing of sand through a glass. Down in the Old Town Square, a mechanical knight strikes a bell to tell the markets to open and close. In a world where nothing changes fast, no more precise measure is required; but in the *Kunstkammer*, time is measured with obsessive pedantry.

* * *

The surface of the silver globe in Emmoser's clock is engraved with the constellations of the stars, the meaning of which is denoted by the creatures and the objects of the zodiac inscribed upon them. The globe itself denotes the crystal sphere of the heavens, in which the fiery stars are mounted, and at whose unseen centre hangs the earth and the seat of the Emperor. Everything in this little world is in its proper place. No wonder Rudolf nurses such a passion for cosmical clocks.

In 1600, the Danish astronomer Tycho Brahe pays court in Prague; and he later reports that:

> The Emperor wished to have the mechanical device on my carriage shown to him (for he had seen it from the window when I drove up to the castle). I therefore had my son fetch the mechanism from the carriage, gave it to Barwitz (the court secretary) and showed him how to explain its construction to the Emperor. When Barwitz had done this and returned to me, he said that the Emperor said he had one or two similar devices but none so large or made in exactly the same way. He did not want to accept mine from me but would have one made for himself by his astronomer from a pattern of mine.[3]

For, as in everything else, in matters of heavenly science, the Emperor is insatiable. He likes to collect not just clocks, but also astronomical instruments, and, indeed, astronomers.

Brahe is a nobleman of independent means who regularly falls out with his patrons, to some extent, perhaps, because he does not really need them. By the time he arrives in Prague he has been wandering around the Empire for years. He is tempted to stay only by the offer of a large castle where he can work undisturbed.

But the Emperor cannot resist disturbing Brahe whenever he can. He

enjoys conversation, to be sure, and astronomical speculation; but what the Emperor really wants to know is his horoscope. Only Brahe, with his knowledge of the heavenly bodies, can plot with any accuracy the life of the Emperor's earthly body.

Brahe, while he might be irritated by the disturbance, does not dismiss the Emperor's fascination. In fact, he is as sure as his master of the words of Oswald Croll, a magus of the court:

> Heaven and earth are man's parents, out of which man last of all was created; he that knows his parents, and can anatomise them, hath attained the true knowledge of their child man ... because all things of the whole universe meet in him as in the centre, and the anatomy of him in his nature is the anatomy of the whole world.[4]

Brahe and his master believe absolutely that the sky is not a void, but a crystal vault enclosing a crowded room, at the centre of which the Emperor sits at his desk, enacting the purposes of the stars.

He wants to know what those purposes are. 'When our arduous tasks of government permit,' writes the Emperor, 'we enjoy the subtle knowledge of natural and artificial things.'[5] And what he wishes to know is what Emmoser, Roll, and Bürgi have concealed in the interior of their tiny clocks. The Emperor wants to know what it is that causes the heavens, and all that is under them, to move. It is not, he is sure, a mindless force.

* * *

In Emmoser's little silver universe, it is not the earth that moves, but the golden sun, along a groove incised into the globe along the line of the ecliptic; and when the year is over, it returns to its original position. Like Mercury, Venus and Mars, Jupiter, Saturn, and the Moon, its movements

do not follow the fixed paths of the stars. This is why they are called 'planetes', or wanderers: sometimes they seem to be moving forwards, sometimes backwards, describing circles within circles as they wander through the sky. Emmoser's clock describes a clockwork universe, but he cannot model the wandering of the planets on his silver globe.

Brahe is joined, the year after his arrival, by an austere Protestant teacher of middling birth, Johannes Kepler. They don't expect to be friends, but the two of them soon find themselves together, watching the sky from the roof of the *Gangbau*. They borrow instruments from the chests in the room below, and use them to plot the exact location of the heavenly bodies in time. Their testament is the Rudolfine Tables, an almanac that plots the motions of the planets. Its accuracy and rigour is unprecedented, and Kepler writes of its compilation:

> If thou art bored with this wearisome method of calculation, take
> pity on me, who had to go through with at least seventy repetitions
> of it, at a very great loss of time.[6]

It is ironic that their findings disrupted the timeless order of Emmoser's precious cosmos. For making them – perhaps even using the clock – Kepler, at least, came to believe that it was not the sun that moved at all through the silver globe of the heavens, but the earth.

The idea was hardly new. The *De Revolutionibus* of Copernicus had been published half a century before; but Brahe and Kepler's observations lent empirical proof to what had been, until then, a theory. Copernicus argued that the wandering of the planets could be explained if both they and the earth were rotating around the sun at different speeds. Sometimes Mars, or Venus, might race ahead. Sometimes one of them might fall behind. Sometimes they might seem to conjoin. Kepler used the compilation of the

Rudolfine Tables to develop a refinement to Copernicus's scheme, for he deduced from his observations that the orbits of the planets around the sun must be elliptical, rather than circular, and furthermore that the speed of their motions were not regular.

Emmoser's clock had been built as microcosm, an interior, at whose centre sat the Holy Roman Emperor; but by the time Kepler and Brahe had finished with it, the globe of the heavens was a fragile, irregular egg, the earth an atom whirling around its periphery, the Empire a smudge somewhere upon its surface. No wonder they failed to convince the Emperor.

In 1604, a new star appeared in the sky. At first, even Kepler refused to believe it, for the idea of a new light to stud the crystal sphere of the heavens was more frightening even than the notion of a moving earth. If new stars could be born, and old ones die, then the boundaries of the world, and the Empire, and the *Kunstkammer*, and indeed of the objects collected inside it, were not fixed or certain, but contingencies, nothing more.

Emmoser's clock, and the *Kunstkammer* that contained it, had been collected by the Emperor as engines of science, of knowledge, in the expectation that such knowledge could be perfected. The clock and the room were created to be, like the cabinet and the catalogue, systems of order; but the new science born in the *Kunstkammer* did not, and could not, and never will generate certainty. Once upon a time, Copernicus had written:

So far as hypotheses are concerned, let no one expect anything certain from astronomy, which cannot furnish it, lest he accept as the truth ideas conceived for another purpose, and depart from this study a greater fool than when he entered it.[7]

Kepler merely echoed him in 1609:

> If I were concerned with results, I could have avoided all this work,
> being content with the vicarious hypothesis. Be it known, there-
> fore, that these errors are going to be our path to the truth.[8]

It must have been about the same time that the scribes of the *Kunstkammer*
started to amend the Catalogue of the Unknown Collection; and it must
have been then that they realized that its compilation was, like Kepler's
enquiries, that most wearisome thing: the pursuit of knowledge for its own
sake, the path to a truth at which they would never arrive.

* * *

Emmoser's clock was not in Prague for the recollection of 1998, but on the
other side of the world – in the Metropolitan Museum in New York, a city
that did not even exist in the time of the Emperor Rudolf, on the edge of
a New World whose form was barely understood.

It had taken 300 years to get there. The heavenly globe appears in the
collections of Queen Christina of Sweden in 1651, and then more than a
century after that in the sale of the possessions of the 'Avocat Fortier'
in Paris.

Some time in the late nineteenth century the clock appeared again in
the collections of John Pierpont Morgan, a collector whose encyclopaedic
avarice eclipsed even that of Rudolf II, let alone Arthur Gilbert. Morgan
made so much money out of railroads, telephones and electricity that he
was able to act, in the absence of a central bank, as financier to America,
underwriting European investment in the emerging technologies of that
still-new world.

He was no connoisseur, buying other collections en bloc, and soon
forgetting what he had bought. Once, on enquiring from his secretary
where his Michelangelo bust of Hercules was kept, his secretary was forced

to reply: 'this bronze bust is in your library, and faces you when sitting in your chair. It has been there about a year.'[9]

Morgan had helped to found the Metropolitan Museum in 1871. After he died in 1913, his son Jack lent the whole collection to the museum for a temporary exhibition. It had never been gathered in one place before. He did it to raise money; his father had left numerous cash bequests in his will, and the estate was subject to a vast inheritance-tax bill. After the show was over, Jack sold the Fragonards, the Chinese porcelain, and the Louis Quinze furniture to the Duveen Brothers. The Renaissance tapestries and bronzes, and the Raphael followed soon afterwards. The little globe took up permanent residence in the Metropolitan Museum in 1917, when Jack gave the museum some seven thousand objects.

There are two little inscriptions on the inside of the globe of Emmoser's clock. The first is dated 1650, and indicates that the clock was repaired at this date, presumably just after it arrived in Sweden. The other dates from 1781, and notes that the clock was repaired again at this date for a M. Delacroniere by the clocksmith Gautrin. It is thought that it was then that the original motion of the clock was replaced by the one that we see today.

The *primum mobile* of Gerhard Emmoser and the strange science of Rudolf II have been superseded as surely as the interior that once contained and produced them. Just as the cabinets are empty, and the inventory is obsolete, so the globe of the heavens has become an empty shell, an exhibit, nothing more: encased in a glass cabinet in a museum, it no longer moves.

A Bowl and a Horn

TWO OBJECTS FROM THE UNKNOWN COLLECTION NEVER MADE IT
back to Prague in 1998, although the old imperial treasury in Vienna was
happy to lend all sorts of other things of much greater artistic value.

Tour parties gather around and peer into the empty interior of the
bowl. They are trying to read a word. It only appears in the correct light,
to a chosen few, they are told; and when the guides tell them about the
horn, they just laugh.

Very little is known about them. A poem survives celebrating the gift
of a horn from King Sigismund of Poland to the Emperor Ferdinand in 1561;
but there is no record as to the acquisition of the bowl, and modern schol-
arship has revealed facts about the two objects that do little to dispel their
mystery.

Material analysis has revealed that the bowl is carved from a single
piece of agate, and it is the largest of its kind anywhere. A study of the
bowl made in 1951 suggested that it was probably made in the fourth
century AD, and was probably housed in the imperial treasury at Constan-

tinople. There is no record of it, but is thought likely that the bowl was taken from Constantinople in the sack of the Fourth Crusade in 1206. How it reached Vienna is unknown. Carved in tiny letters into a vein in the agate, is the word 'aristo' – the signature, it is thought, of the craftsman who had made it.

The horn is a simpler affair. It is clearly the grossly extended left incisor of a narwhal, a species of whale that inhabits the Arctic Ocean. These teeth were long collected along the northern coasts of Europe. In the sixteenth century the Danish throne was made entirely of them; and there is every likelihood that the King of Poland had a few, one of which he passed onto the Holy Roman Emperor in 1561.

The reason they never made it to Prague in 1998 is a quirk of the Austrian Constitution: it is impossible for the bowl and the horn to leave the country. It's a tradition that dates back to the death of the Emperor Ferdinand I in 1561. His heirs may not have found it easy to divide his Empire; but they could agree on one thing: that the bowl and the horn were so precious that they should belong to them all. In order to safeguard them, they entrusted them to the care of the most senior member of their family, who was forbidden to sell them or give them away. It's a duty of care that the Austrian state inherited – or appropriated – from the Hapsburgs as they fled from the wreck of their Empire in 1918.

They are prominently listed in the Catalogue of the Unknown Collection:

Entry 1: One horn, right long[1]

Entry 1350: Firstly, the most beautiful, most costly, the biggest of all the things in the treasury: an agate cup or vase with handles, in which may be seen the name of blessed Christ.[2]

The elders of the House of Austria had misread the writing in the bowl, you see. They thought the letters read 'XRISTO' rather than the 'aristo' that scholars see today — if they see anything at all. It was a cup belonging to Christ, they thought, and not only that, but the very Grail that caught the blood streaming from his side at the Crucifixion.

It is that word that the tourists are struggling to read, even now. Not all of them see it, for it may only be read in a certain light and from certain angles. Indeed, the imperial family used to say that the bowl would only reveal its true nature to those it chose, and to the rest it would remain nothing more than a bowl.

And as for the horn, the Habsburgs believed that it had been taken from the forehead of a unicorn. To obtain such a thing, they said, was no mean feat. Unicorns could be neither tamed nor hunted, and only an innocent, mild-mannered maid could pluck the precious horn from the head of the beast, and then, and only then, when the beast had suffered it to be so. No wonder the horns of unicorns were so rare.

But the horns of unicorns weren't precious just because they were rare. They were used to cure melancholy, and as a universal antidote to poison. One part of the Habsburg horn was made into a goblet, another, the hilt of a magical sword that would protect its wearer from all evil.

* * *

In 1596, his last uncle died and Rudolf became the eldest scion of the house of Habsburg. He made sure the bowl and the horn were brought to him as soon as possible, for he had always wondered at the supernatural. In the *Kunstkammer* he'd collected mandrakes, little humanoid roots that were said to utter a deafening scream as they were pulled from the ground. There were two devils trapped in a block of glass, and a bell that he could use to summon the dead. He owned countless bezoar, stones regurgitated from the

intestinal tracts of African antelopes, and used as medical prophylactics.

In 1584, he met the English magus, John Dee, who appeared at the castle, so he claimed, by angelic command, offering the Emperor a magic mirror that would show him his heart's desire. Rudolf sent Dee away, thinking him a madman, but his friend, a certain Edward Kelley, he asked to stay, for Kelley claimed to be able not just to show him but also to *give* him his heart's desire.

Kelley embarked on a turbulent relationship with the Emperor, who appointed him to make gold from base metals in 1588, and then imprisoned him for failing to do so in 1591. Rudolf wasn't completely disillusioned: Kelley was briefly released to try again in 1594, but, failing, was thrown back into gaol, and died there in 1597. All the same, he dedicated his work 'The Stone of the Philosophers' to the Emperor, in the hope of grateful, if posthumous, restitution.

He nearly got it, and there is no evidence that Kelley's inability to turn base metals into gold convinced the Emperor of the foolishness of the enterprise. It wasn't just that Rudolf was greedy for gold. Rather, the process of turning base things into precious ones was the source of endless fascination to him. He hoped that somewhere in his collection, somewhere in the drawers of one of the 101 cabinets, might lurk some fragment of the philosopher's stone that would make it possible.

The Emperor Rudolf was, for his age and his station, an unusually private, melancholic man. The English ambassador Philip Sidney described him as: 'few of words, sullein of disposition, very secrete and resolute ... extreemly spaniolated',[3] and Hieronimo Soranzo, the Venetian ambassador, observed that 'he behaved rather shyly, and took no part in the usual amusements; jokes pleased him not, and only rarely was he seen to laugh.'[4]

And in the first years of the seventeenth century, as he retreated further and further into his *Kunstkammer*, all sorts of rumours attended

him. It was already scandalous that an emperor should have deserted the imperial capital of Vienna for Prague, that he spent time with lowly artificers and scholars, that he had never married, and that he consorted with astronomers and Protestants. It was shameful enough that he never led his armies into battle.

But by 1606, it was rumoured that magic had turned the Emperor against the Christian religion. That year his closest relatives, the Arch-dukes Matthias, Albrecht, and Ferdinand met secretly in Vienna to discuss their brother. Matthias put before them a proposition:

> His Majesty is interested only in wizards, alchemists, Cabalists and the like, sparing no expense to find all kinds of treasures, learn secrets and use scandalous ways of harming his enemies ... he also has a whole library of magic books. He strives all the time to elim-inate God completely, so that he may in future serve a different master ...[5]

Something had to be done, and in the spring of 1607 Matthias started massing an army on the eastern marches of the Empire. It was in that year, as his own brother started to march against him, and he realized for the first time that he might lose it, that Rudolf commissioned the catalogue of the Unknown Collection.

And then he locked himself into his cabinet and placed his two most precious possessions, the bowl and the horn, on the floor. Then he drew a circle round himself, and sat down with them, convinced that no-one could touch him, that he could summon the dead from their graves, and that he could move the stars in the sky.

He created a tiny private room inside a room. It only took a moment, and no-one saw him do it.

Both of them, the circle on the floor and the scribbled list, were pathetic gestures, but that Rudolf ever believed in their efficacy – even if only for a moment – is a testament to the power of collecting. For the collector, things are never just things. The materials of which they are made are, like the horn of a unicorn, the agents of mysterious power. The many places they have occupied, the many hands that have held them, leave their own traces, even where those traces, like the writing in the bowl, cannot be seen.

But a collection is not made of things alone. Its chief constituent is the interior that contains them and creates relationships between them. Drawing the circle around the bowl, the horn, and himself, the Emperor made a little room, an imaginary treasury, a refuge, and a mystery. Like the clock, the cabinet, and the catalogue, the circle was a tiny world infused with wonder, a miniature memory palace, made of places and reminders just as the ancient orators had prescribed.

It was created to do more than just remind the Emperor of what he was about to lose. The magus Pico della Mirandola, whose books were, of course, contained in Rudolf's exhaustive library, had written: 'magic does not create miracles, but, as a kind of adoring servant, it calls up the living forces of nature. It studies the connection in the universe which the Greeks call sympathy.'[6]

To the Renaissance mind there was nothing more (or less) magical about magic than gravity, harmony, or, indeed, memory, for all of them were invisible sympathies between visible objects. The wandering of the planets through the fixity of the starry sphere dictated earthly fates below. The motor of their movement, the *primum mobile*, was the dictator of every fate, and the source of every sympathy. To understand the former was to perceive, however dimly, the existence of the latter.

Giordano Bruno, the errant Dominican friar who tarried in Rudolf's

Prague, wrote that magicians 'ascended to the height of the divinity by that same scale of nature by which the divinity descends to the smallest things'.[7] The purpose of magic was to control the motion of the heavenly bodies from below, to move the *primum mobile* through the agency of the stars, and so, at two removes, to control the source of destiny itself.

And so the purpose of a magical memory palace was to reverse the invisible sympathies of memory, so that rather than remembering the past, it could predict (and perhaps control) the future. Rudolf II was convinced that somewhere in his cabinets he would find the philosopher's stone that could turn the heavenly spheres at his command and furnish him with the foreknowledge of his own fate.

But the philosopher's stone was not in his collection. It *was* his collection, for a cabinet infuses the curiosities it contains with something numinous, removing from them the emptiness of base material. No wonder his brothers were so keen to lock the Emperor Rudolf in his cabinet. No wonder he was so keen to commit the memory of its contents to paper before they could take it away from him.

It didn't save him. By the summer of 1608, Matthias was encamped just outside Prague. Lacking an army of his own, or unable to lead one, Rudolf was forced to hand the crowns of Moravia, Austria, and Hungary over to his brother. Matthias tried to take the throne of Bohemia as well; but Rudolf refused, and to punish him, Matthias quartered his troops in the castle and held noisy court. It was only a matter of time before, in November 1611, the Estates General of Bohemia deposed Rudolf and elected Matthias as King in his stead.

And Rudolf was left with nothing but the grandiloquent, empty title of Holy Roman Emperor. He ended up a prisoner in his own castle, a curiosity in his own cabinet, surrounded by thousands of objects that, while they shimmered and glittered, clicked, whirred, scuttled, and

squawked, while they had been collected from all the four continents and corners of the world, while they represented the sum of all human knowledge, were, in the end, only things.

Without the magic circle that enclosed them, without sympathy, they were just objects: a list, a clock, a cabinet, a bowl, a horn, and a melancholic old man, sitting, alone, on the floor.

A Museum

IN JANUARY 1612, A LION DIED IN THE CASTLE MOAT IN PRAGUE. THE keeper reported the news to the Emperor, and when he heard it, he turned around and locked himself into his cabinet one last time. He refused meat, or drink, or medicine, and, just as his brothers had feared he would, the sacraments, and three days later, he, too, was dead.

As was customary, the body of the Holy Roman Emperor was laid out on a dais draped with the imperial flag. He lay enfolded in the arms of a double-headed eagle; but few were sorry to see him go. None of his Habsburg relatives attended the funeral. Rudolf never married, despite the presentation of endless child princesses at court. Instead, he had pursued a morganatic relationship with the daughter of his antiquary, and his eldest child went mad. When Giovanni was found in a room at the castle in Krumau, embracing the mutilated body of a village girl, they locked him in and he was never seen again. Rudolf died without issue, alone.

But the sterility of his life could not have been further from the profusion of his menagerie; and his castle moat had been prowled by, at various

times, no less than five lions. In 1596 he had two leopards brought to him from Venice, and in 1603 he acquired two more: he paid their keeper 450 florins a year to look after them. He was given one camel as a gift by the Archbishop of Naples in 1591. He already had two, captured from the Turks in the Hungarian marches. There were parakeets sent from Spain, and ostriches brought over the mountains from the Adriatic, a cassowary given by the Prince Bishop of Cologne, for which the Emperor had made a golden chain, and a dodo. The correspondence between the Emperor and his ambassador Khevenhüller in Madrid is filled with references to exotic creatures landed on the docks in Lisbon. There was an elephant, and a rhinoceros – great beasts so strange that every monarch in Europe wanted to have them.

Inside the *Kunstkammer* there were flamingos, harlequin monkeys from Cayenne, a scarlet ibis, flying fish, sawfish, walking fish, spiny blowfish, seahorses, and an octopus. There was a crab, a moose, and a hippopotamus. There were coconuts, warthogs, conches, tortoises, crabs, coral, thousands of antlers, the teeth of a tiger, the paw of a leopard, and the wings of butterflies.

There were birds of paradise, which, lacking feet, were unable to make their home on the earth, and had to return to heaven to sleep. There were the feathers of a phoenix, the skeleton of a basilisk, the dried skin of a dragon, and a mandrake root in the form of Christ from the Monastery of Eppendorf. It had been venerated there since 1482, when it had grown from a communion host that a peasant woman had buried under a cabbage plant. The cabbage itself, which grew to a miraculous size, had been eaten at the time. The museum contained the claws of a salamander and a grain of the soil from which God had created Adam.

Some of these wonders we might now explain away. The dragon was nothing more than a lizard, the skeleton concocted from those of a cat and

a bird. The birds of paradise had lost their feet on the long journey from the East Indies to Europe.

But all of them were wonderful to the Emperor, for, confined to his castle in Prague, alone, savannah or glacier, coral reef or alpine forest were quite as unlikely as the pyres of Heliopolis, or the gilded splendours of El Dorado. On the one hand, his mandrakes and dragons were hardly more imaginary than his subjects, who, while they might have been enjoined by custom to venerate the old man, no longer bothered. On the other, there was nothing less marvellous to Rudolf about a narwhal than a unicorn, an exotic bird than a phoenix. He wondered at them all.

But however wonderful they were, all of the contents of Rudolf's museum were dead. The creatures of the menagerie rarely survived the central European winter, and the most wonderful of them were killed by the journey to Prague. The elephant died on the march from Lisbon to Madrid, and the rhinoceros on a boat sailing from Barcelona to Genoa. They had arrived in Prague in 1603, but they were no more than skin and bones, and Rudolf had them dried and placed in chests in the *Kunstkammer*.

All the claws and feathers and scales and horns and teeth that the *Kunstkammer* contained were no longer for scratching, or flying, or biting. Locked into cabinets, they had long lost the sheen of life, just as the brilliant colours of fish fade when they are pulled from the water. Their death was the necessary consequence of their collection in an interior, their dusty pallor the price the Emperor paid for their stillness and confinement.

It had to be that way. Rudolf had tried to bring his royal beasts into the castle to live with him, but in 1581 one of his tigers maimed a small child. In the same year, he had been forced to pay his court barber compensation for an attack in which one of the lions had killed its keeper, and the court barber's wife. No wonder Rudolf was so devastated by the loss of his

last lion. He must have known that death could be the only consequence of his desire to possess the creature.

As his own life ebbed away, or aware that it soon would, Rudolf set about documenting the creation he knew he was bound to lose, or had, indeed, already lost. 'His Majesty's Book of animals with all manner of four footed beasts, all painted in oil after life by Dieterich Raffenstein, on vellum, bound in red leather'[1] was an inventory of the natural wonders that belonged to His Majesty; and it appears in the Catalogue of the Unknown Collection.

The Book of Animals is now known as *Museum Kaiser Rudolfs*, 'The Museum of the Emperor Rudolf', and, in the absence of the physical museum, it provides, by coincidence, the only visual record of the appearance of the original. The skin of the hippopotamus is painted hanging against a distempered wall. The horns of the rhinoceros and the unicorn are displayed on a table covered in green baize; and these painted scraps of baize and wall are all we know about the physical appearance of the *Kunstkammer*.

The inventory attributes His Majesty's Book to Dieterich Raffenstein, but it is too varied and vast a work to have been completed by one hand alone. We can still distinguish some of the others, centuries after they have withered away.

Many of these hands had already created other images of nature for the Emperor. Joris van Hoefnagel illuminated a folio entitled 'the Four Elements', among whose emblems caterpillars crawl, moths flit, and rose petals blow. Veins pulse through the wings of dragonflies, and a white bloom forms on the skin of a ripe plum. In the *Four Elements*, moments so short and phenomena so tiny as to be almost undetectable find their monuments in coloured water that dried on paper centuries ago.

A creature of the Emperor, the tools of his trade no more mysterious

than water and coloured powder, Hoefnagel was nevertheless able to capture something that his master could not. In his watercolours and drawings, petals, tiny insects and their wings, tremble, shimmer, blush, and bloom. They crack and break, and rot. They live and they die. They resist the deadness of the museum and the inventory.

Indeed, they respond to different principles altogether. Hoefnagel's miniatures are usually accompanied by inscriptions, and he had already illuminated several alphabets for the Emperor. A worm eats its way through a pear under the words 'Nasci pati Mori' (we are all born to suffer death), while a mantis prays under a rose whose petals are blown away with invisible breaths of air. 'Aeternum Florida Vertus' says the caption: 'virtue flowers for ever,' for the certain expectation of death is always accompanied by the promise of resurrection.

In the real museum, everything was dead, but in the *Museum*, through the agency of art, the lion stalks the open ground; birds perch on branches; and the insects and fish hover against azure skies and waters. None of them is yet imprisoned in the cabinets of a chamber in a castle.

Or so it might at first appear. Some of the less exotic creatures might have been sketched as they fluttered or crawled around the palace gardens. Others may have been painted as they cowered in their cages in the menagerie. Rare it is, however, for any creature to stay still long enough to be captured in oil on vellum; and the closer one looks, the clearer it becomes that the 'after life' from which the book had been painted was something of a loose term.

The hippopotamus that snarls on one page had to be resurrected from the skin that hung on the walls of the *Kunstkammer*. The rhinoceros whose formidable form stalked the pages of the *Museum* was copied from a drawing made in 1515, by Albrecht Dürer. He too had never seen the beast, which had landed in Lisbon and died on a ship sailing to Genoa the

following year, his own drawing being a copy of a copy of an anonymous original.

Some creatures found their way into the *Museum* through the force of logic alone. Folio ten shows a terrestrial unicorn, the living beast from which, the Emperor imagined, his precious horn had been obtained, and folio twelve shows a sea unicorn. It was not there, as one might suppose, because rumours of the existence of the narwhal had reached the *Kunstkammer* (although they had). In fact, the sea unicorns in the *Museum* of Rudolf II look nothing like narwhals; they are chimerae: horses with fishy tails. Rather, it was supposed, the sea unicorn must exist because every terrestrial creature must have a watery counterpart.

Many other animals were copied from the pages of another of Rudolf's books of *naturalia*. Now stored in the Oesterreichische Nationalbibiliothek and known only by its catalogue number, Codex Miniscule 42, this volume provided the lineaments of animals and plants that the Emperor's artists could never have seen. And neither had the Codex Miniscule 42 been taken from nature. It had been assembled from Rudolf's own collection of drawings, some of which, like that of a hoopoe, had already been drawn more than 100 years before.

No wonder the pages of His Majesty's book contained the feathers of a phoenix and demons imprisoned in a block of glass. It was not an encyclopaedia of all the wonders of nature, as they trembled and squawked and crawled outside the castle, the kingdom or the Empire. Rather, it was the imagination of everything that the Emperor had been able, or wished he had been able, to collect into his chambers inside. It was a collection not of nature, but of collections and inventories and other encyclopaedias.

'What he knows, he feels obliged to have' his niece had written, and *The Museum of Rudolf II* was a mechanism both for having, like the cabinet, and for knowing, like the globe. The museum turned into the *Museum*, the

room into the book, a matter of months before its progenitor also passed from physical presence into memory.

And in that process, the Emperor, his collection, and the room that contained it, suffered the same fate. By the time the *Museum* was complete, thousands of creatures had been hunted, captured, transported, skinned, stuffed, dried, plucked, dismembered, hung on the wall, mounted, placed on a table, and locked into a room that no-one could enter. There the Emperor sat alone, wondering how, now he possessed all the wonders of the world, now that he had documented them all, he might bring them back to life again.

Not his wealth, nor his subtle knowledge, nor his magic, could do it for him, and as soon as he was dead, the most precious contents of the *Kunstkammer* were removed. Within seven years, the Estates General of Bohemia had tried to sell the lot, and the armies that defeated them took wagonloads back to Saxony and Bavaria. Fragments of the *Kunstkammer* are now collected in collections from Sweden to America.

We only document the things we possess, or the interiors we inhabit, when we are about to lose them. Until then, animated as they are by the people who live in them, interiors are as protean as a bird of paradise that, having no feet, cannot land, or the bloom that ripens on the skin of an unplucked plum. They live and change and decay, and evade the grasp of knowledge. To know a room, to fix it in time, is to condemn it to the fixity of the cabinet and the dusty recesses of a museum.

DECOR

Seconde Journée
Theatre fait dans la même allée, sur lequel la Comédie, et le Ballet
de la Princesse d'Elide furent representéz

A Magic Mirror.
Louis XIV watches Les Plaisirs de l'Isle Enchantée.

French Grey

THE WALLS OF GRANNY'S SITTING ROOM ARE PAINTED GREY. IN FACT, the walls of all of Granny's sitting rooms have always been painted grey. French grey, she calls it, and it might be grey, but it's not a boring colour. Subtly infused with dusty pigments, it glows pink, green, blue, or violet, depending on who is looking at it, and when.

Her friend Betty introduced her to the colour. Betty did everything properly, Granny says. She helped my grandmother make her wedding dress, and advised her on the decoration of her first home. Betty would spend her summers touring the chateaux of the Loire with a stonemason and a pair of callipers. Her Gloucestershire manor breathed the impeccable élan of France, from the Louis Seize furniture in the grey-panelled salon, to the parterres outside the tall French windows. That grey, Betty used to say, was painstakingly applied in seven thin layers to give walls the sheen of a silken gown.

Not that Granny bothered: she has always been impatient when it comes to decorating, and the walls of the Doll's House are liberally

spattered with hastier attempts at marbling, rag rolling, scagliola, and all the other tricks with which plain walls are turned into the scenery of a more elegant life. The linings with which my grandmother has decorated her sitting room – grey plaster, long curtains of olive green and duck-egg blue, grisaille engravings, polished parquet, are statements of what she believes to be good taste.

It's a taste specific to a generation brought up on the guides to decor that proliferated at the turn of the twentieth century. Elsie de Wolfe, the self-proclaimed foundress of the profession of interior decoration, aimed *The House in Good Taste* squarely at women like my grandmother: wives and homemakers of the prosperous middle classes. She followed it with *Recipes for Successful Dining*, in which French cuisine was perfectly matched with elegant decor; and *After All*, her autobiography, described her journey from a bourgeois Brooklyn brownstone to a villa at Versailles.

'The story of the Villa Trianon is a fairy tale come true,' she wrote, 'we loved the place with its glamour of romance and history.' She bought it for a song and set about restoring its eighteenth-century splendour right away:

Our bedrooms are very simple, with their white panelings and chintz hangings. We have furnished them with graceful and feminine things, delicately carved mirror frames and inlaid tables, painted beds and chests of drawers of rosewood or satinwood. We feel that the ghosts of the fair ladies who live in the park must adore the bedrooms ...[1]

For Elsie de Wolfe, Betty, and even my grandmother have all sought, in paint and cushions and curtains, to enchant the ghosts of the fair ladies who haunt Versailles. Deprived of all its *meubles* by the Revolution of 1789,

the interiors of the palace are empty sets, preserved long after the play has come to an end. Its rich linings of mirror, gilded panel, marble mantel, and, of course, endless, elegant, grey have lent their definitive éclat to countless state occasions.

But in the main, the interiors of Versailles present the present with a problem, for they were made to glorify the very *Ancien Régime* that modernity was invented to destroy. Too splendid a work of art to discard, too loaded a symbol to revive, Versailles is the setting for a masque that cannot, and must not, be re-enacted, lest the Revolution revolve back upon itself and time begin again.

Versailles is a contradiction. It represents, on the one hand, standards of taste that are still employed whenever a sense of enchanted pleasure is required, from the opera house in Manaus to the *grands cafés* of Phnom Penh. On the other hand, it is the relic of pleasures so enchanting that they are, in modern democracies, best kept in histories and fictions.

They were never real in the first place. The interiors of Versailles were decorated in the late seventeenth century for Louis XIV as the setting for an entirely new mode of domestic and political life; but, a sort of permanent scenery, they originated in *fêtes champêtres* and masques staged in tents in the garden on a summer's evening.

The first of these performances was called *Les Plaisirs de l'Île Enchantée* – 'The Pleasures of the Enchanted Island'; and like the *Wunderkammer* of Rudolf II, the salons of Versailles were created to cast an alchemical spell. Unlike Rudolf, however, Louis XIV performed his magic, on stage, in front of an audience. Such performances were a long tradition in the royal court of France.

In 1530, Louis' predecessor François I spent many years in negotiations regarding the purchase of a room. The memory theatre of Giulio Camillo was small, but it was like the philosopher's stone, claimed its creator, for

it was the key to universal memory, knowledge, and power. In traditional theatres, the audience – more or less anonymous, indubitably mortal – occupied the seats and watched the gods and heroes as they enacted their dramas on the stage. In Camillo's theatre, however, the causal relationship was reversed, for the gods, the planets, and all the powers of creation would occupy the graded seats of the theatre; and its owner, performing on the stage, would control them.

Francis I never purchased Camillo's theatre. It has disappeared; but its memory haunts the sceneries of Versailles, in which the gods that decorate every ceiling, tapestry, panel, and door, were painted to watch the King strut and fret below, and to do, by implication, his bidding.

Decor is always a sort of alchemy, for combinations of colour, texture, and pattern bind together the elements of a room, and make them more than the sum of their parts. The root of the word is found in the Latin word 'decorum', which means appropriateness, in modes and manners. To decorate a room is to dress it up for a performance, and to enchant its occupants into behaving like actors in a play. Successful dining, as Elsie de Wolfe observed in her *Recipes for Successful Dining*, wasn't about the food on the plate, but the occasion of the meal, and the room in which it was eaten.

My grandmother would agree. When she is going to entertain, she sets her white hair in stiff curls, and powders her face until she resembles nothing so much as a ghostly courtier. She opens curtains usually drawn, and a pale, cool light washes over silk, gilt, and crystal. Just as the bell sounds, she checks herself, and the room that clothes her, in the mirror above the mantel. The scene is set.

An Enchanted Island

ON THE EVENING OF THE FIRST DAY, A YOUNG MAN RIDES INTO A clearing, in a forest, where four roads meet.

He is followed by three pages, brightly liveried; and then four trumpeters and two drummers, and the marshal of the camp, Guido the Savage, riding a white horse, and wearing 'a cuirass of silver cloth, covered with little scales of gold'.[1]

And then Roger rides in. 'His action and his whole bearing were worthy of his rank; his helmet, surmounted entirely by flame coloured plumes, looked incomparably beautiful; never did a more free or warlike air raise a mortal so much above other men.'[2]

And with him ride Ogier the Dane, Aquilant the Black, Gryphon the White, Rinaldo, Dudo, Astolpho, Brandimart, Richardetto, Oliviero, Ariondantes, Zerbino, Orlando, each wearing magnificent liveries, their horses caparisoned in colours appropriate to their names and their stations.

They ride around the clearing, and make their obeisance to the two queens, who, along with 600 members of the court, have so far sat silent,

in four tribunes made of topiary, festooned with gold, which have been erected over the places where the four roads enter the clearing.

And then Apollo enters on a chariot, followed by all the dimensions of time. The four ages of gold, silver, bronze, and iron sit at the wheels of the chariot; and they are followed by the twelve hours of the day, and the twelve months of the year. Dinner is borne in by the seasons. Spring, dressed in green and silver, rides a white charger, Summer an elephant, Autumn a camel. Spring gardeners, summer reapers, and autumn vine dressers carry in the fruits of their seasons, while a troupe of old men, dressed in skins and doubled up under the weight of huge dishes of ice, follow Winter, who rides a bear.

And then the court sits down to eat, and 'all the knights, with their helmets covered with plumes of tilting colours, and their tilting dresses, leaned on the barriers; and the great number of officers, richly clad, who waited at the table, enhanced its beauty, and rendered that ring an enchanted palace.'[3]

* * *

In the evening of the second day, the voice of the dawn sings an aria as the rays of the sun steal upon four huntsmen who are lying asleep on the grass. They too begin to sing, until one of them leaps up and shouts: 'What! Again! Was there ever such a passion for singing ... I shall go mad! ... Get up, get up, get up!'[4]

And so begins the comedy of *The Princess of Elis*. The Princess is too interested in the pleasures of the chase to concern herself with love, and it is a trial to her that her father has invited three of the finest princes of Greece to woo her: she shows them complete indifference.

At least, she would, but the Prince of Ithaca seems as little interested in her as she is in him. It irks her, then pricks her, and soon the pair find

themselves pursuing a romance couched solely in the language of disdain.

It all ends happily, of course, when Ithaca and Elis are united, and there rises from under the stage 'a great tree, on which were sixteen fauns, eight of whom were playing on the flute, and the others on the violin ... four shepherds and shepherdesses came and danced a very fine entrée, in which the fauns ... mingled from time to time'.[5]

The story has been enacted in the forest, but the whole clearing where the four roads meet has been 'covered with cloths, shaped like a dome, to protect against the wind the great number of flambeaux and wax lights which were to light up the theatre'.[6]

It is a very strange theatre, for it is the audience who occupy the richly-decorated scenery of the tent, while the Princess of Elis pursues her fictional amours in the unadorned landscape outside. Between the two, one of the topiary tribunes from the night before makes a proscenium arch.

The overture of *The Princess of Elis* interrupts song with speech. The story begins at dawn, but is played at sunset. The fiction takes place in reality. Everyone is aware of the artifice of the situation; and they all laugh when Monsieur Molière, who has written the play, appears in it as the fool, Moron, dispensing unwelcome advice to his high-born protagonists.

The courtiers remember his *Impromptu de Versailles*, played the year before, in which Molière and his players play themselves, summoned at short notice to perform before the King. They have not rehearsed anything, they have forgotten their lines, and every time they try to recall them, they are interrupted. The play finishes as the curtain rises behind them on their impromptu *Impromptu*.

And the story of the Princess of Elis is about two people who cannot, or will not, legitimize their love for one another. The irony is not lost on the audience, who are fully visible in the light of the *flambeaux*, and arranged in strict order of precedence. In the middle sits the King of

France. On each side of him, the women he is enjoined by duty to love – the one his mother, the other his wife – but somewhere else in the audience is the woman whom, while he might love her in private, he is forced, in public, to treat with disdain. The King and Louise de la Vallière are, as everyone knows, the Princess of Elis and the Prince of Ithaca.

* * *

On the third day the theatre has disappeared, and in its stead, an island rises from the middle of a basin of water; and on top of the island, an enchantress sits in an elegant palace. Below her, imprisoned in the artificial rocks, are Roger and his knightly band.

Alcine descends from her palace, and mounts a whale, which swims towards the two queens and their court, who are gathered on the banks of the basin. She bows to the queens, and asks for their protection; but it is not something lightly afforded, and soon enough, her palace is under attack: first by a band of giants and dwarves, then a troop of Moors, and then by six of the knights who have escaped from the island prison. They are all beaten back by monsters, until another enchantress appears in the dungeon with Roger. She gives him a ring, and using its magical power, the brave knight breaks open his prison and defeats the witch who has imprisoned him.

And then 'thunderclaps followed by several flashes of lightning, portended the destruction of the palace, which was immediately reduced to ashes, which put an end to this adventure, to the pleasures of the enchanted island'.[7]

* * *

It is not recorded how the actors escaped from the burning palace. No-one, apparently, observed Alcine, drenched and covered in smuts, removing her

feathers and silks and becoming, as everyone had known she was all along, Mademoiselle Du Parc – diva, or more properly player, of Molière's company. No-one commented at the time that Aquilant the Black removed his helmet to reveal the Duc de Guise, and Rinaldo his to uncover the head of the Duc de Foix. No-one thought it strange that Roger swam to the shore with the rest of them, vassals and showgirls alike, even though every-one could clearly see that he was none other than the King.

Louis XIV departed for Fontainebleau four days later, and Molière's troupe returned to Paris, several thousand livres richer. The remains of the scenery were burned, and the costumes packed away, or cut to pieces to make others. The leftovers were fed to the dogs or the peasants; and the banquet of the seasons, and Elis, and the Palace of Alcine vanished, as all enchanted islands and palaces must. They left behind them nothing but a clearing in a forest.

The Pleasures of the Enchanted Island was reported in the court gazette, and a set of engravings was made so that those who had not been invited could rue what they had missed. They are not entirely accurate: there is a detail, scarcely noticeable, but repeated on every one of them. At the dead centre of the lower edge of every image, in the place where the middle of the front row of the audience would be, the only seat from which the whole scene composed itself with perfect symmetry, one head can be seen tower-ing above the others, surmounted by a large feathered hat and the sort of embroidered *baldaquin* that could only be held over the head of a king.

It is an impossibility, a trick of the memory. The King could not have been at the same time in the middle of the front row of the audience and imprisoned in a pasteboard dungeon; but the purpose of enchantment is to remove such obstacles. *The Pleasures of the Enchanted Island* was a perform-ance in which the King was both the protagonist and the only audience that counted. He was, at one and the same time, Louis XIV and Roger.

And under this enchantment, pasteboard turned into stone, and the clearing into the park of Versailles as, over a lifetime, André Le Nôtre, the King's gardener, transformed unpromising scrub into what seemed, from the point of view of the King, an enchanted island. Party followed party. After one of them, 'the King abandoned the feast to the pillage of the crowds that followed ... who demolished the castles of marzipan and the mountains of fruit.'[8] At another, the entire court rode gondolas on a Grand Canal, and at the end of the night, a firework was fired from a pasteboard palace of Neptune to the site, where, several years before, had stood the palace of Alcine. With each new divertissement, a new *bosquet* was opened up, a new basin dug, a new avenue cut through the trees.

When, as he often did, the King took a tour of his gardens, the fountains were made to play for him, or rather, they were made to seem to play for him, for there was not enough water to power every one of them. Instead, teams of gardeners were stationed by every waterwork, and as they espied the King's carriage coming, they opened the sluices. The minute he had passed, they closed them again, so that the water could be diverted to the next cascade. No-one ever saw all the waters of Versailles play – or rather no-one did except the King, who, passing from fountain to fountain, could entertain the illusion that the illusion he had conjured was complete.

The waters of Versailles were the mirror that John Dee had offered to Rudolf II a century before, in which its owner could see his heart's desire; and what Louis XIV saw there was himself. The most cutting remark the King could make to anyone was apparently harmless. 'We have not seen you at Versailles for a while,' he used to say. It brought whole careers to an end, for not to be seen by the King was not to exist.

The palace of Versailles was always an enchantment, a performance, and when it came to an end in the Revolution of 1789, its supporting cast

of aristocrats and courtiers stole away from the scene dressed in the peasant costumes they'd had made for the latest *fête champêtre*. Only the protagonists were left behind, half dressed, to face the music. Once they had gone, the place started to return to the nature from which it had been cleared.

* * *

Then one summer's evening in the 1870s, a young man walked into a clearing, in a forest. It must have been a garden once, he could see, crowded with trees cut like statues, and statues thick as trees. It wasn't any longer: here and there he could see the remains of grottoes and fountains run dry. 'Empty of the crowds who once came to see the waters play,' he wrote, 'the place kept its relics and its memories to itself, in silence.'[9]

Ten years later, he found himself directing a team of workmen as they dredged a gilded barge out of the canal. It had once been used, he knew, by the Queen of France for parties with which she bewitched her guests on the glassy water. In 1892, he found himself in charge of the whole place, and years later, when he recalled that first evening in the forest, Pierre de Nolhac was able to claim that he had spent a career restoring the vanished enchantments of Versailles.

Now the fountains are fed by the mains, and on summer weekends they all play together. The trees are cut like statues once more, and the statues stand as thick as trees; and between them, hidden speakers pour out the music that once accompanied the *Plaisirs de L'Île Enchantée*. Versailles is, thanks to its greatest curator, still an island of pleasure, but despite his efforts, it is not enchanted. Visitors can stroll the *bosquets* and the *allées* dressed up as the King and the court who played them into existence three centuries ago. They gaze into the glassy waters, but all they see in the mirror, the players, the people, are themselves.

Appartement

IN 1919, THIRTY YEARS AFTER HE'D STARTED WORKING THERE, Pierre de Nolhac experienced the highlight of his career. He had set out the tables and the chairs in the *Galerie des Glaces* with, he thought, particular sensitivity. The Allies would sit facing the windows, their faces flooded with light, their gaze trained on the endless avenues outside. The representatives of the defeated would look the other way, shrouded in silhouette, the domain they had lost dimly reflected in the mirrors behind the victors' heads.

Nolhac couldn't resist leaning towards President Clemenceau as he fiddled with his pen: 'Monsieur le President,' he whispered, 'you have just achieved the work of the great men of the monarchy ... you have brought the House of Austria low, and destroyed the Empire, just as Richelieu and Louis XIV once dreamed ...'[1] He knew it would irritate the old republican.

Revenge was sweet. Nolhac had spent his career dealing with the stain that had hung over Versailles since 1871, when the Germans had marched into the *Galerie des Glaces* and acclaimed the first Kaiser. Almost every state

visit he arranged had had to be carefully constructed to avoid a diplomatic incident. The Empress of Germany had tried to visit incognito, but he had to ask her to leave. The King of Holland, who had been a signatory to the acclamation of the Kaiser, had to be taken on a tour that avoided the *Grand Appartement* of the palace altogether. It was a near impossibility in a building from which corridors were absent, and room led into room.

But more simply, it was a delight to him to be able to furnish what was usually an unfurnished apartment. It had been empty for years, and only a clock remained from the time of Louis XIV. What little else there was a substitute, installed on the orders of King Louis Philippe, who, in the 1830s, had turned the *Grand Appartement* into a museum to all the Glories of France. His curators were happy to substitute fakes for the genuine article in order to tell the people's story. It infuriated Nolhac, as he rummaged through the attics sixty years later, searching for the original pieces that must once have inhabited those rooms.

He didn't find much. Almost everything had been sold, or vandalized, in the early years of the Revolution. In 1792, the authorities had declared the palace and all its contents state property. Decorators were sent to the palace to chip the royal fleur-de-lys off every wall; and *ebenistes* were commanded to remove the royal insignia on all the furniture. Only Riesener, Marie Antoinette's favourite cabinetmaker, was skilled enough to prise off the veneers, and he found himself forced to desecrate his own masterpieces in the name of liberty, equality, and fraternity.

He also bankrupted himself trying to buy them back. What the Revolution really needed was money, and a series of sales were held in which all the rooms of Versailles were emptied of their treasures for cash. Tax breaks were offered to anyone who would take the stuff abroad, for these exquisite furnishings were now tainted at home by association with the *Ancien Régime*. You'll find more of them in New York or London than

you will in France, where the few surviving pieces have spent decades languishing in obscure government offices, loaded down with unromantic state papers rather than the scented billets-doux for which they were made.

The *Ancien Régime* itself had not been much kinder to its own inheritance. Once upon a time *pietra dura* cabinets lined the walls of the *Grand Appartement*, but most were sent to the museum of natural history in Paris in the 1740s, where the stones were unpicked from the furniture and placed on display for their mineralogical interest. Two, the work of the Cucci Brothers, survived, but were sold in 1751; and now, in a medieval castle at Alnwick in Northumberland, they are far from the splendours of Versailles.

* * *

It was different, once upon a time, for in November 1682, Madeleine de Scudéry, improbably for the authoress of *Artamène*, the longest novel in existence, has discovered a new word:

> I can assure you, without exaggerating, that you have never seen anything comparable to that which is incorporated in the new word Apartment; ... never has any word, in any language, without exception, signified so great a number of beautiful things.[2]

The word does not mean what it means now. Arranged in enfilade, each one leading into the next, the rooms of the *Appartement* are named mostly after the gods of Olympus: Hercules, Abundance, Venus, Diana, Mars, Mercury, Apollo, and War.

If their names tell us nothing about their uses, neither does their decor. Abundance is lined in green brocade, in whose cloudy heaven reclines Plenty with her cornucopia. Venus is lined with marble, in whose purple folds gestures a statue of Louis XIV in the habit of a Roman emperor. The

goddess gazes at him from the cloudy ceiling; and he appears again in Bernini's bust in the salon of Diana. Armies gather on the vault of the Salon of Mars, and the walls of crimson are hung with canvasses of military valour.

In the twenty years since Roger rode into the forest clearing, the hunting lodge of Versailles has been enveloped by an italianate palace. While its facades are the work of the architects Louis Le Vau and Jules Hardouin Mansart, the interiors are the masterpiece of Charles Le Brun, Premier Peintre du Roi, director of the Academies and of the Gobelins manufactory.

He has inherited from Molière the office of King's Upholsterer, and his state rooms have something of the theatre about them. Doors have been turned into proscenia, and the walls are lined with backdrops of silk and velvet. They are known as *tentures* – tentings – and above them, Le Brun's art has turned plaster into the skies, arbours, and marquees of a *fête champêtre*.

And in November 1682, these rooms have been dressed for a performance. In Abundance, a silver cockerel crowns a buffet piled with vessels of juice, wine, tea, coffee, and chocolate. In Venus, tables are laden with oranges and lemons and sweets, piled into pyramids that poke up between forests of cut flowers. In her room, Diana lies dreaming over a billiard table of green lawn amid a *bosquet* of orange trees in silver pots. In the Salon of Mars, a consort of viols plays from a silver tribune; and silver tables have been laid out for games of chance and skill. Mercury rides his chariot over three tables of solid silver: one pentagonal, one square, and one triangular. A balustrade, also of silver, runs down the middle of his salon, and on the other side of it a state bed is flanked by incense burners. It is hung with cloth of gold, and carved white eagles stand at each corner.

A party is about to happen. Mademoiselle de Scudéry is not entirely

accurate when she calls the word 'apartment' a new one – people are already using it to refer to suites of rooms in grand houses – but she is right in noting a new usage. The *Appartement* she attends at Versailles in November 1682 is, for the first time, both a set of rooms and an occasion.

The King has decreed that the same party will take place every Monday, Wednesday, and Thursday, between six and ten. On Fridays, a comedy will be played, and on Saturdays, there will be a ball. The *Appartement* is *The Pleasures of the Enchanted Island* performed again and again; the palace of Alcine constructed in marble rather than canvas.

The *Appartement* is a masque, and everyone must adhere to the strict etiquettes of the script. It is an unusual one: 'Be assured', writes Mademoiselle de Scudéry 'there is nothing you can't say ... as long as you consider well where you are and to whom you speak and who you are yourself ...'[3]

The rooms of the *Appartement* are not assigned to particular functions – the Royal Family gamble at tables set out for them in front of the bed – but they are arranged in strict hierarchy, leading from the antechambers where guests eat and play, to the rooms reserved for the pleasures of the noble. No-one is allowed to cross the balustrade in the Salon of Mercury; and in his absence, the empty bed signifies the King: people bow as they pass it. The mirrors that hang on every wall reflect the guests themselves, reminding them, at every turn, of who, and where, they are. Everyone plays their part in the courtly charade.

Everyone, that is, except one.

On one side of the Salon of Apollo, the last room in the *Appartement*, a dais is covered in a Persian carpet, and on this woven paradise rests the throne. It is nine feet tall, made entirely of silver, and cast in the form of a great sea shell. Here, the King is present not in marble, or paint, but in person, as himself.

He is squatting on the steps in front of his empty chair, laughing and chatting as his daughter-in-law, who has just had a baby, dances for him.

A journalist writing in the social gazette the *Mercure Galant* is touched by the Royal condescension:

> The King, the Queen, and the whole royal family [he notes] descend from their lofty station to amuse themselves with people who would never normally have enjoyed such an honour. This is where the generosity and the good manners of the King are so engaging ...[4]

It is unusual, but, since the King has done it everyone else follows suit. No-one rises when he passes them, and anyone may sit on the *tabourets* – the folding stools that litter the rooms – regardless of their rank. The journalist is astonished to note that 'anyone can talk whenever they choose ... these people are so respectful towards one another that it is not necessary for anyone to raise their voice.'[5]

Mademoiselle de Scudéry has not seen such raffish manners since she arrived in Paris, an ingénue of no distinction, and obtained an invitation to the original *Appartement* upon which the Appartement of the King was modelled. She had been invited to the *Chambre Bleu*, 'Blue Room', she knew, not because of her birth but for her wit:

> The great secret is always to speak worthily of trifling things and simply of grand things, to speak delightfully of *galanterie* and to speak without affectation or undue gravity. And though conversations should always be both natural and reasonable, I wouldn't hesitate to say that there are occasions when even the various

learned sciences may enter the conversation gracefully and when agreeable foolishness can also find a place as long as it is charming and clever.[6]

The Marquise de Rambouillet had designed the Blue Room herself as a retreat from the draughty halls, the crude manners, and the Machiavellian intrigues of the court of Louis XIII. She would recline on a blue silken bed in a blue silken room to receive her guests, who would perch and chat on the balustrade before her as if they were all equals in a republic of letters.

At the time, the court laughed at the Chambre Bleu, referring to its habitués as *precieuses ridicules*. It is ironic that, sixty years later, the new King had chosen to model the royal court on a room that had been designed as its antithesis. What lends the word '*appartement*' such a novel frisson in 1682 is the apparent breach of decorum: the King squats on the steps before his throne, seeming, for a moment, to have forgotten where he was, to whom he was speaking, and indeed who he was.

It is not a mistake. The King has decreed that anyone is entitled to his hospitality so long as he wears a sword and a smart coat; and the openness of the invitation is encoded into the decor. The word '*parquet*', for example, was originally used to signify the 'little park', the marquetry dais under a throne; but in the *Appartement*, the *parquet* extends to edges of every salon, as if everyone has been invited to join the King on his dais. From this eminence, as if they have taken the best seats in the house, which were always placed on this stage itself, they can survey the *parterres* of the real park outside (the word *parterre* is also the name for the pit of the theatres in Paris). Every guest at the *Appartement* is turned by the *Appartement* into the inhabitant of an enchanted palace, in which the weight of worldy hierarchy has, for a moment, been lifted.

It is a subtle moment, and it nearly never happened. It has certainly

had to be rescheduled. On 7 May 1682, the court left Saint Cloud to go to Versailles in order for the King to take up permanent residence, and to hold the first of his *Appartements*. The Dauphine was so heavily pregnant that she had to be carried all the way in a sedan chair; but when they arrived, nothing was ready; and she was forced to sleep in the site foreman's office.

The lying-in went on for three months, and as the Dauphine came to term, the King had his own mattress brought into her room. When the Duc de Bourgogne was born, on 6 August, the common people smashed the windows to get a glimpse of the young prince; and when they had satisfied their curiosity, they tore down the scaffolding that still enveloped the palace, and used it to light their bonfires. Then they tore off their own clothes and threw them on the flames, and when they were naked, they took timber from the building yard and set light to it. 'Let them!' said Louis, 'so long as they don't set us alight!'[7]

As soon as it was safe for the Dauphine to travel, the court left the chaos for Fontainebleau; and the party was delayed until November. No-one mentions it in the fawning reports of the *Mercure Galant*, but by then it is so cold that water has frozen in the vases of flowers that have been set out for the evening.

The last door of the Salon of Apollo has been blocked with a backdrop depicting a gallery lined with mirrors, hundreds of feet long. One day, the *Galerie des Glaces* will eclipse the Salon of Apollo. One day, long after Louis XIV is dead, the French Republic will realize the King's ambition there; but in November 1682, it is not yet ready.

On that winter's night, the *Appartement* is an *impromptu*, running late and unrehearsed. As soon as he has finished the decoration, Charles Le Brun is dismissed from the King's favour, a charge of embezzling the funds of the Gobelins having been trumped up against him.

It is all over by ten o'clock, when the guests are ushered to the door.

By the next morning, the servants have scoffed the leftovers, folded up the stools, piled up the cushions, and placed the tables and the chairs against the wall. Of all the furnishings of the *Appartement*, only the throne and the bed remain in the same place.

Just as he rarely bothers with his throne, the King does not sleep in the bed. Like the *Appartement* itself, like all theatres of power, it is a polite fiction, a comedy of manners, a word.

Lever

THERE WAS ONE ROOM IN VERSAILLES THAT NEVER CHANGED; AND when, some time in the 1890s, Nolhac was showing the Duc d'Aumale around, the old man stopped him there, at the gilded balustrade, with a memory.

It wasn't his own memory. His father had told him about it, he said, when he'd been an old man himself. He'd been a boy, he'd told him, and he'd stood here, right where they were now, before the bed, to watch the King rise in the morning.

Nolhac sighed. He knew exactly how he'd remember it.

* * *

In the early morning, it is silent throughout the palace, and dark. At seven, the Valet who has spent the night sleeping at the foot of the bed wakes and, without making a sound, he dresses himself. At a quarter past seven, he creeps to the door, and opens it, slowly, so that it does not creak, to let the servants in. They fold up his cot, and remove it from the room; and they

take the food that has been left out should Louis rise hungry, in the night.

Then they light the fire and the candles, and open the shutters to admit the sun that is rising in the three windows that face the royal bed. The light kindles the golden embroidery of the hangings, and gleams on the gilding of the balustrades. The scene is set.

At half past seven, the valet approaches the great bed. He does not touch it, but whispers into the heavy folds. '*Sire, voilà l'heure,*' he murmurs: 'Sire, the hour has come.'

And if he has heard anything, the valet informs Louis of new arrivals at the palace. And if Louis wills it, the valet admits the royal surgeon, who examines the royal body, still enfolded, still half asleep, in the soft gloom. His old nurse rubs his back, and changes his nightshirt for him, since he sweats a great deal in the night.

At a quarter past eight the first gentleman of the chamber enters, along with the grand chamberlain and Louis' closest relatives; and when they are assembled in the order proper to their rank, the chamberlain opens the curtains of the bed so that they can see him.

He stares and blinks at them for a moment, bald, short, old. The grand chamberlain passes him a vial of holy water, and then he gestures with his hand, and they retreat into the council chamber next door, where they say their morning prayers. If he thinks they have missed anything, or anyone, Louis shouts prayers of his own through the open door.

At half past eight they come back into the room. The barber and his *perruquier* enter, and Louis chooses his wigs for the day. He gets out of his high bed, and makes his way to one of the armchairs on either side. They are gilded, and upholstered with rich brocade to match the *tentures* of the rest of the room.

When he is sitting on his chair, the doors open into the antechamber for the *seconde entrée*; and suddenly, the room is crowded. The finest in the

kingdom stand in silence outside the balustrade that divides the room from the bed, as they watch Louis dress.

The grand chamberlain passes him his robe and his slippers, and upholstered as richly as the chair upon which he is sitting, he watches as the *perruquier* combs the hair on the first wig. It has been bought at twenty sous an ounce from the peasants around Lille and Arras, who, they say, have particularly fine tresses. When it is ready, he puts it on. He shaves only every other day. He does it himself, and he does not require a table for his toilette: a page kneels before him, holding a mirror, so that he can see what he doing.

At nine o'clock, Louis asks for his breakfast – two cups of tisane, or a bowl of bouillon that he takes in his chair – and after he has taken it, he removes his robe and his nightshirt. His eldest son, the Dauphin, brings him his shirt; and if the Dauphin is not present, then the Duc de Bourgogne, and if he, too, is away, the Ducs de Berry and Orléans. He picks out his cravat, and two handkerchiefs – he is presented with three to choose from – and only when he is fully dressed does the *horlogier du roi* hand him the magnificent fob that Louis will carry with him all day.

And when he is shod, shaved, dressed, wigged, and watched, Louis kneels by his bed to say his prayers. On the other side of the balustrade, as at a communion rail, the cardinals of France kneel on the hard parquet, without cushions. The laity of the court stand in silence.

When they are done, Louis rises, and removes his first wig, replacing it with another, higher, fuller, and more magnificent. He comes out of the alcove behind the balustrade, and walks into the council chamber where his ministers are waiting for him, ready to tell him the business of the day, and to prepare him for the *metier du roi*, the job of being the King.

Just before ten o'clock, he emerges into the *Galerie des Glaces*, and then the *Appartement*. It is crowded with hundreds of courtiers and subjects who

have been waiting for hours for this moment, to catch his eye, his ear, sometimes his hand. They press their suits upon him noisily and insistently, for in the three hours since the valet rose silently in the darkness, Louis, old, bald, bleary and fat, has become the King.

It is a ritual that, by the time the Duc de Saint-Simon describes it in his secret memoir in 1715, has been repeated and refined so many times that every detail is fixed, and the interior that contains it has been dressed perfectly for the occasion. It is a little temple, surmounted by a dome, and encircled by columns woven with vines, which were copied from those that once upon a time had been in the temple of Solomon. The bed stands like an altar behind a gilded rail, and above it, France, gilded and crowned, appears between curtains drawn back by cherubs.

When the curtains are opened and the King sits up in bed, he faces east, and the light of the rising sun streams in through the tall windows that face the road back to Paris. The bed is placed at the dead centre of the chateau of Versailles, and behind the King's head, through the wall, the axis of the whole enchanted forest extends a mile or so, down to the clearing in the forest, where fifty years before, dawn sang an aria to the Princess of Elis. Now, where the palace of Alcine once exploded in fireworks, Apollo emerges from the water on a gilded chariot, facing towards the rising sun, and the King is lying in his bed, in a palace of his own.

Saint-Simon is not impressed: 'Such was the bad taste of the King in all things', he wrote, 'and his proud haughty pleasure in forcing nature; which neither the most mighty war, nor devotion could subdue!'[1]

It is a ritual that contradicts entirely the performance of the *Appartement*; for while that was an exercise in casual éclat, this is a study in a sacred hierarchy that extends all the way from the bed to the borders of the kingdom. It is a ritual and a room that has taken a long time to devise, indeed almost the whole of the King's reign, for the *Chambre du Roi* was only

instituted in its final central position in 1701, when the King was already sixty-two. Previously, the royal bedroom moved around the chateau in tandem with the constant programme of rebuilding.

Thirty-seven years have passed between the moment at which the King rode into the forest clearing in disguise as a medieval knight, to the moment at which he occupies the centre of the world he has created, rising with the sun every day.

He doesn't enjoy the moment for long; and as he ages, his world starts to contract around him. On 9 August 1715, he hunts in the forest for the last time, not riding on horseback, but confined to his carriage. On 11 August, he walks to the bottom of the park. He does not go outside again. On Tuesday 13 August, he sits in his silver throne for the last time, to bid farewell to a Persian embassy. On 14 August, he attends chapel for the last time. On 17 August his doctor, Fagon, sleeps in the King's chamber to keep watch over him, and after 19 August, the King never leaves his bedchamber again. On the evening of 24 August, the court come to watch him sup there for the last time. Saint-Simon reports that: 'he could not finish his supper, and begged the courtiers to pass on, that is to say, go away'.[2] On the next day he takes the last rites, and he does not leave his bed again. On 28 August 'at about seven o'clock in the morning, he saw in the mirror two of his valets at the foot of the bed weeping, and said to them, "Why do you weep? Is it because you thought me immortal? As for me, I have not thought myself so, and you ought, considering my age, to have been prepared to lose me."'[3] Three days later, the King is dead in his bed.

* * *

No-one slept in it again. Louis XV used the room for his own *lever* – he died there too – but he had it redecorated, and the rich *tentures* and the vast bed of his great-grandfather were folded and packed away in the palace stores.

In 1786, Louis XVI had them burned; and he recovered sixty kilos of gold from the brocades. He never really believed in the *lever* anyway, sleeping elsewhere, rising early, and only getting back into bed for the ritual around eleven o'clock in the morning. When, in 1789, the mob appeared at Versailles and demanded to see their King, he appeared to them at the window of the *Chambre du Roi*, convinced that the authority lent him by the room would save him.

It didn't. After the last head to lie on the pillow at the centre of the world was chopped off, the new regime let the room lie. Never again would one person, in one bed, in one room, in one building, exert divine power over all the people. Some discussed destroying it altogether.

But their republican resolve lasted only a few years. In 1794, a decree declared that the palace should be retained by the state 'to serve the pleasures of the people'[4] and Napoleon, then Louis XVIII, and then Charles X considered living there. They held great state occasions in the chateau but they refused to sleep in the *Chambre du Roi*.

Louis Philippe, the successor of Charles X, could remember being there as a child all too well, watching Louis XVI pretend to get out of bed. It had been a performance, he knew, an empty show, but it would have been political suicide for him to repeat it when he, too, became the King. That's what he told his son, anyway.

The Duc d'Aumale finished his story, and he and Pierre de Nolhacs were silent for a while, in the sacred gloom of the room.

No-one will ever sleep in the King's bed; but no-one will take it away either, for without the brilliant shadow of Louis XIV, France, not even the first republic, or the second, or the third, the fourth, or the fifth, would not be France. '*L'état c'est moi*,' he had said, and nearly four centuries since his death in that monumental bed, it still, despite itself, is.

* * *

In the lake of Chiemsee, in the Bavarian Alps, there is an island, and on that island there is a palace and at the dead centre of that palace is a bedroom. The walls are lined with scarlet damask, embroidered with twisted columns interlaced with vines, and the room is divided by a gilded balustrade. Visitors stand on one side of the balustrade, while on the other, little folding stools line the walls. Directly beneath the dome stands the red velvet cube of a bed.

No-one has ever slept in this bed. And no-one has lived in the palace either. It was built by mad King Ludwig II of Bavaria in the 1870s; but it was never finished. He only spent one night in the place – alone apparently. He had the candles lit in his ersatz *Galerie des Glaces*, and wandered from salon to glittering salon, retiring only as the sun rose to another chamber, which he had had made in the form of a cabinet of Psyche.

The palace, a facsimile of Versailles, had been made in honour of the mad King's French namesake Louis XIV, a monument to absolute monarchy; but Ludwig must have realized, in a rare moment of self-awareness, that to sleep and rise even in his copy of the bed of the Sun King would be tantamount to blasphemy.

Cabinet de la Chaise

AFTER HE'D SHOWN THE DUC D'AUMALE THE *CHAMBRE DU ROI*, after the old man had gifted him with his memory, Pierre de Nolhac decided to show him some of the hidden treasures of Versailles.

There were rooms in the palace that were so delicate, so small, and so well concealed that they were never opened to the public, and as a result, the crowds passed through unaware of their existence. They had been forgotten, and Nolhac had discovered them hidden behind the scenes of the *Appartement*, in attics, basements, around light wells, buried deep in the interstices of the building.

He unlocked one door into the *chinoiserie* bathroom of Louis XV and found, behind a panel in the bedroom of one royal mistress, a private library, and the workshops in which the King used to play at being a craftsman. He opened the mirrored cabinet in which Marie Antoinette tried on her shoes every morning; and he climbed into the little entresol from whose hidden window the royal governess, Mme de Tourzel, could spy upon the gilded salon of the Queen. He found the tiny cabinet of Louis XVI,

decorated for his private pleasure with cherubs whose gilded hands experimented with the strange new science of electricity. Pushing on invisible panels, and twitching at dusty curtains, Nolhac tumbled into an enchanted world that had been forgotten for a century.

There was one room that particularly amused him. At one end of this room, there was a recess; and when he showed the old man in, the Duc d'Aumale remembered it well: 'the *Cabinet de Lachaise!*' he cried, 'this is the chapel in which Louis XIV used to make his confession, is it not?'

But his delightful reminiscence turned to dismay when he saw what had been placed in the recess. 'Your grace is mistaken in his recollection,' replied Nolhac, 'this room is the *Cabinet de la Chaise.*' And he pointed to a red velvet seat. There was a hole cut in it, and underneath the hole there had been placed a chamber pot.

The Duc d'Aumale might be forgiven the tricks that memory had played upon him. They had, after all, been played on purpose. His father, King Louis Philippe, had turned Versailles into the museum of all the Glories of France, and in his opinion a lavatory was not among them.

And the room wasn't in the museum proper. Louis Philippe had used the suite of which it formed a part as a private apartment to which he could retreat if he happened to be visiting Versailles. Noting that these rooms communicated directly with the *Chambre du Roi*, and occupied the opposite side of the palace to the *appartement* of the Queen, the curator of Louis Philippe's museum, Vatout, supposed that they must have belonged to the King's mistress. Unwilling to assign them to some powdered pompadour, he earnestly decided that they must have belonged to the one royal mistress whose reputation for piety, good works, and good sense effaced the stain of her fornication. Madame de Maintenon was so respectable that most people believe that late in life she must have married Louis XIV.

And the *Cabinet de la Chaise* must be so called, it was assumed, because

it had been used by her stern confessor, the Père Lachaise. Vatout hung a portrait of Maintenon in the room, placed a *prie-dieu* in the recess, and labelled the room a chapel. No wonder the Duc d'Aumale was confused.

* * *

The *Cabinet de la Chaise* had never been an easy room to remember. On 13 October 1774, a certain Jean Francois Heurtier wrote to the chief architect of Versailles to explain why renovation works in the room were running so late:

> The changes to the inner cabinet of the King involve a considerable amount of work, and it is impossible to estimate exactly how much until we take the hammer to the walls, and the carpenters start to take things to pieces. The drawings we have of the room are completely different, as far as we can tell, to the reality of the room itself.[1]

And the reason that the drawings and the room didn't match was because this little cabinet held more secrets than it might at first have appeared.

A chamber pot had been kept in a cupboard in this part of the palace for as long as anyone could remember; but in 1754, the room was converted to house the *chaise d'affaires* of the King. It was the first purpose-built lavatory in the whole building – a building in which, it should be remembered, some fourteen thousand people (with needs of their own) waited upon the King.

In the time of Louis XIV, the royal stool was as much a part of the spectacle of the *lever* as his prayers. What he left in his chamber pot was a matter of national interest, since the King's turds reflected his own health, and by extension, that of the whole realm. His *chaise d'affaires* was a real

throne, gilded and upholstered en suite with the *tentures* of the *Chambre du Roi*.

Louis XV might have resigned himself to the ritual of the *lever*; but he had no intention of relieving himself in public, and so he ordered a private closet for himself, behind the scenes. The room was fashioned from odds and ends. Two little lobbies were knocked together, and lined with *boiseries*, panelling that had originally been intended for elsewhere. The palace day-books consistently record that the chairs that furnished the room were borrowed from the larger sets made for the *Salon de Pendule* next door.

But the decor of the cabinet was carefully designed to make it appear much brighter and larger than it actually was. The *boiseries* were carved with delicate rocailles, gilded, and painted in *blanc du roi*, the white lead reserved for royal walls. Over the doors, tendrils and shells parted to reveal exquisite painted scenes of ruins, classical and rustic. The window was draped with a luminous white taffeta and over the fireplace there was a mirror, in whose misty surface the cabinet was reflected back into itself. Louis XV intended, perhaps, to spend more time on his exquisite *chaise d'affaires* than anyone suspected.

A desk was ordered, and fashioned by the cabinetmaker Gilles Joubert from rosewood and amaranth, and veneered with marquetry flowers. Each part could be locked with its own key, and one section remained invisible, a secret to all but the owner of the desk. The *boiseries* of the walls themselves were similarly contrived to conceal bookcases and drawers.

And the cabinet was designed so that no-one could find it unless they already knew that it was there. The only window opened onto an internal light well; and the only doors that opened into it were disguised as panels, some of which opened into other rooms and others into cupboards and bookcases. The cabinet was concealed deep in the *poché* – the pockets – of the palace, along with service stairs, the closets, the attics, the garrets, the

garderobes, and all the other spaces that the court were never expected to see.

The truth is that this tiny room was one of the very few places where the King could actually be alone. Only late at night, or early in the morning, or perched on his *chaise d'affaires*, could the King be sure that no-one would disturb him. The rest of the time, everyone knew that it was in their fragile interest to distract the King; and it was not a condition that Louis XV relished. 'She obsesses him continually,' one minister D'Argenson complained of the King's mistress, Madame de Pompadour, 'she follows him, she agitates him, and she leaves him not an instant for himself.'[2]

But, in fact, D'Argenson continued: 'he takes real pleasure in work: he already likes to have his papers for reading and for writing, and he has arranged them himself, in the different cupboards in his cabinet, in orderly fashion.'[3] And so the *affaires* of the *Cabinet de la Chaise* were more significant than the passing of a daily stool. Indeed, the King used the secrecy of the cabinet to pursue enterprises that he was able to keep from both his mistresses and his ministers. He secretly plotted to have his own cousin, the Prince de Conti, elected the King of Poland, while at the same time supporting the candidacy of the Elector of Saxony in public. To this end, he invented a diplomatic service that, rather than reporting to his ministers, or even to his own secret police, would leave letters for him in the hands of the concierge of his 'safe house' in the Parc aux Cerfs. The King would receive them there, and take them back to read and conceal within the *boiseries* of the *Cabinet de la Chaise*. Conti never became the King of Poland; but even when that enterprise had failed, the King maintained his secret service, finding in its occult operations temptations too seductive to lay aside. This secret service, the '*cabinet noir*', was maintained until his death, long after the original reason for its existence had passed away.

When Louis XVI succeeded his grandfather and found out about it, he was horrified. He had the little cabinet ripped apart and refitted as soon as he could.

* * *

No wonder his joiner Heurtier had such problems on site in 1774. No wonder, after the Revolution, Vatout misinterpreted the room as a confessional. No wonder the Duc d'Aumale believed him, despite the evidence of his eyes, sixty years after that. The *Cabinet de la Chaise* had always been designed to pass unobserved, to be misunderstood, and ultimately to be forgotten.

The Last Boudoir of
Marie Antoinette

ONE DAY, PIERRE DE NOLHAC WAS SITTING IN HIS OFFICE AT VERSAILLES when a woman was shown in to see him. She was simply dressed but she was, he could see, very distinguished, and she had come, she said, with a gift for him. She was distressed by the state of the Trianon, Marie Antoinette's little house at the bottom of the park. It had been allowed to fall into appalling decay, she said, and she was prepared to give him the money to restore it.

Nolhac pricked up his ears. He'd started his career at Versailles when he'd found Marie Antoinette's barge in the garden, and an account of the tragic queen and her exquisite palace had been the first thing he'd written about the place.

But there were conditions, she said. She wouldn't give money to the republic that had executed the poor Queen. Her donation would have to be made in secret, to Nolhac personally, to do with as he would. He was, she could tell, she said softly, a sympathizer.

Their eyes met across the desk. They both knew what happened when women and men met in rooms, alone.

<p style="text-align:center">* * *</p>

A hundred years before, on 5 October 1789, in the afternoon, a herald rides into a clearing in an enchanted forest. He goes up to the door of a little house, and knocks; but he may not see who lives there, the servants tell him.

'Then beg her to come at once,' he tells them; and they go inside to find her: up the stone stairs, through the grey antechamber, the dining room with its paintings and gilding, and the salon with its red *tentures*, to the bedchamber, embroidered with flowers.

She is not there, and it is with some trepidation that the servants knock on the last door in the apartment, scarcely noticeable, so beautifully has it been integrated with the panelling.

On the other side of the door is the room that everyone has been talking about. Everyone has read the *libelles* in pamphlets published in Paris. The boudoir is studded with rubies, they say, and even the paint that covers the walls, in subtle shades of grey, suffused with green, violet, or pink, is perfumed with lavender or roses.

And this is the room, they say, in which *L'Autrichienne* (the Austrian bitch) as they call her, pursues her amours – with men, women, children, machines, and anyone or anything else who will do it with her:

> *In a fine alcove artfully gilded,*
> *Not too dark and not too light,*
> *On a soft sofa, covered in velvet,*
> *The August Beauty bestows her charms*
> *[and] the Prince presents the Goddess his cock ...* [1]

They say she watches herself in the mirrors that line every wall, the shameless protagonist and the titillated audience in her own filthy re-enaction of *The Pleasures of the Enchanted Island*.

The origin of the word boudoir is a place to hide and pout (*bouder*). The pouting lip can either protrude with sulky obstinacy, or quiver and moisten with desire; and this boudoir hides and pouts in just the sort of little mirrored house where a gentleman might keep a mistress.

Trianon, at the bottom of the park of Versailles, had been a village once upon a time, but Louis XIV had it demolished and the peasants evicted in order to provide a place where he could see his mistress in the afternoon. He built a villa of porcelain, in whose octagonal chamber a bed was draped with silks and surmounted by a dome of ostrich feathers. When he tired of the spectacular sulks of Athenais de Montespan (and when the porcelain tiles started to fall off the walls) he had it replaced with a *palazzetto* of pink marble, surrounded by a cooling forest and curving rills.

Louis XV built his little house, the Petit Trianon, at the bottom of the garden of this house at the bottom of the garden. It was a gift for his mistress, Madame de Pompadour, and when she died he bestowed it upon her successor, the Comtesse du Barry. He had a staircase built into the northwest corner of the building so that he could arrive and ascend to the bedroom without being seen, even by his own guards.

But by 1789 the Petit Trianon is no longer the retreat of a mistress. It has become, scandalously, the domain of an honest woman; and she has turned it into an island of enchanted pleasures. There is an English garden planted with rare and beautiful trees, a temple of Love on top of a little mountain, a private theatre in which she performs, and even a model village, built on the site of the one Louis XIV had swept away.

She has had ideas of her own about the interiors as well, she has

commanded her favourite architect, Richard Mique, to replace Louis XV's secret stairs with a boudoir. It is invisible from the outside, but from within it affords views of all of her enchanted domain.

The Petit Trianon had been designed to keep a woman; but it has become a little house kept by a woman; and ensconced in the eye of her domain, she has become an enchantress. 'When I am here, I'm not the Queen,' she says of it, 'I'm a woman.'[2] No wonder the servants tremble before the door.

Inside, there are no rubies, and no mirrors, and no painted nymphs abandon themselves to passion on the ceiling. The walls are panelled in virginal grey, the austerity of their geometry relieved by the most restrained and delicate of arabesques. The fireplace is white, square, and simple, and so are the chairs – there are two of them – and a sofa uphol-stered in matching silk of the palest grey. There is an escritoire made by Riesener, exquisitely covered in a marquetry lattice of lotuses; the pink of the petals and the green of the leaves artfully captured in different veneers. The windows of the boudoir look out at yellow leaves, blowing in the autumn rain.

It is a country retreat, nothing more. 'I read, I work … I do a little drawing, that's everything that keeps me busy and amused,'[3] she has written to her mother. Marie Antoinette's large nose and bulbous, watery eyes are matronly. She does not look like an enchantress.

The servants pass on the message, and Marie Antoinette stands up and leaves the boudoir for the last time. She returns to Versailles to be the Queen; and from that moment on, no interior, however exquisite, will protect or pleasure her ever again.

Early the next morning, she is startled from her state bed as the mob rampages from room to room through her apartment. She flies to the King's door, and when, after an age, her husband's staff lets her in, they lock

themselves in the cabinets of the palace that Louis XV had built to escape his own court.

But they cannot hide forever, for the people are demanding to see them. They are led into the *Chambre Du Roi*, and out onto the balcony that faces the great bed. She has not had time to dress properly and, terrified, the Queen holds her children in front of her as a shield; but the crowd demand to see her alone. Only the hasty move of the national hero Lafayette saves her – he kneels and kisses her hand. It saves her life: years later, her daughter can remember seeing a marksman in the crowd, who lowers his trembling weapon at the moment of the kiss.

And then the Royal Family are led out through the rooms of the *Appartement*, and down the stairs to begin their journey to Paris, where, the people say, they belong.

Nothing is ready for them when they arrive there. 'Where should everyone go?' his servants ask the King; but he only sighs in reply: 'Wherever they please.' Lafayette offers to make apartments ready for the Queen; but she cuts him off: 'I was not aware', she comments icily, 'that the King had appointed you his master of the wardrobe.'

Four days after leaving her boudoir, Marie Antoinette entrusts its most precious contents to Daguerre and Lignereux, the decorators in the Rue St Honoré, who had provided most of them in the first place. Lignereux makes an inventory of her rooms before anyone notices him: it is the last inventory of the interiors of Versailles as a home.

Their new residence, the Palace of the Tuileries, is, they all know, not a really a palace, but a gilded prison; and after three years, and several failed attempts to escape – one of them masterminded by Richard Mique, who pays with his life – the Royal Family are removed to a room at the top of the gloomy tower of the Temple.

By then, Louis and Antoinette Capet (they have taken away the holy

'Mary') are no longer King and Queen. They have become ordinary, like everyone else, and so has the room in which they are forced to live. It's the last interior over which Marie Antoinette has any control; and the cheery striped wallpaper and the floral embroidery that covers the bed are the last pathetic, domestic defence she builds around her family.

But homemaking can't save them; and in July 1793 Louis Capet is taken from the room to be tried and executed. In October, his widow follows him. The very last boudoir of Marie Antoinette isn't even really a room. There's a drawing of it, made at the time: a woman lies pouting in a dirty cot in a prison cell; but she isn't alone. A guard leers at her over the folding screen that has been put there, apparently, to safeguard her modesty. It doesn't. In a few hours' time she will be taken outside in her underwear, and executed.

One summer's evening, a year after the Queen has died, a certain Doctor Meyer wanders into a clearing in a forest; and this time, there is no-one to stop any man from entering the little house:

> The halls and rooms are devastated (the exquisite bronze locks to the doors and windows stolen), the mirrors smashed, consoles broken, panels painted over, paintings torn out of frames ... the debris of different types of games litters the floor, along with the broken fragments of carved grotesques ...[4]

But on that rainy afternoon of 5 October 1789 none of this has happened, and Marie Antoinette is still there. She presses a button on the wall and slowly, smoothly, panels rise out of the floor. Within a minute or so, the view of the enchanted gardens has been replaced with a vision more enchanted still. The windows have been replaced with mirrors and, in the sparkling gloom, all Marie Antoinette can see is herself.

The boudoir is just what the *libelles* said it was — a secret machine; and its very mechanics are monstrous. The Queen's button activates a bell, and the bell activates the servants hidden in the basement. They turn the cranks to make the mirrors slide noiselessly up through the floor upstairs.

In order to give the Queen the illusion of solitary retreat in her little house, twenty-one servants, guards, and other functionaries are forced to sleep in attics, or cupboards without air, light, or sanitation. They move up and down in the building on invisible staircases, and bring food from the palace kitchens via underground passages. Their forgotten lives were devoted to one purpose alone — their own invisibility.

Marie Antoinette was an enchantress, every bit as dangerous and strange as Alcine; and her boudoir, while she pouted in it, was, like the pleasures of the enchanted island, an illusionistic performance constructed for the enjoyment of one person. It was a magic mirror that showed its owner her heart's desire; and, most monstrously, all the Queen of France saw there was herself.

* * *

Pierre de Nolhac and the smartly dressed woman stared at one another over his desk, their eyes mirrored for a moment too long. It's often that way when a man and a woman are alone together, in a room.

They both knew the offer was impossible. However it had been before the Revolution, the Trianon was now the property of the republic, and Nolhac would have to declare the gift. The old curator shrugged, and the woman rose to leave. He didn't see or hear from her again.

He found state money instead; and like all the rooms of Versailles, the last boudoir of Marie Antoinette has been restored after a fashion, as a monument to an enchanting vanity. The magic mirrors are raised and

lowered by electricity rather than human sweat; but you can't go in to try them. Instead, a sheet of glass placed under the door allows millions to gaze, without touching, upon what was made for one set of eyes and one set of hands alone.

COMMODITIES

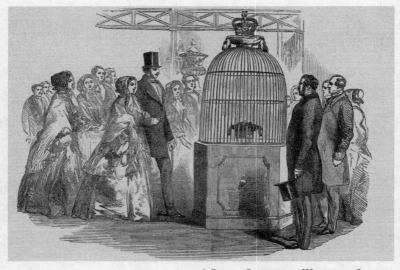

A GILDED CAGE FOR A WORTHLESS CRYSTAL.
The Koh-i-noor in the Crystal Palace in 1851.

All that is Solid
Melts into Air

THERE ARE PLENTY OF OBJECTS IN GRANNY'S SITTING ROOM THAT she never talks about. At least, she never mentions them unless it is to heap abuse on them. The hoover, the fan heater, the light bulbs, and all the rest of them might be technological marvels, but they are, as far as she is concerned, things that just keep going wrong.

The hoover is a particular bugbear. She has to have one: a hoover is an essential part of any interior, after all, since without one, or a lot of elbow grease, it is impossible to keep the floor clean. Since Granny finds it difficult to walk, and since her sitting room is filled with all sorts of little tables, standard lamps and all the rest of it, she also needs her hoover to be as light and as manoeuvrable as possible. The lighter and smaller it is, however, the less suction it is likely to have, and the more likely it is to get blocked. We haven't found one that works properly yet, and the cupboard always contains at least one that she never uses, or is broken.

Every time I visit her I spend some time trying to fix one or other of the products in Granny's sitting room. I am rarely successful, and all too often we end up throwing them away. I am a great deal less mechanically minded even than my grandmother; and the obsolescence of these objects is all part of their maker's plan for them. We end up driving to the dump to throw one away, and then to the hardware store to buy a new one, all too aware that the cycle will begin again.

My grandmother finds it difficult to love products for mass consumption, for while her dining chairs or the miniatures hung around the fireplace are more or less unique, and bear the traces of time, these products exist in their thousands. They are cheap and disposable, and memory wipes clean off their plastic and chrome. While Granny may have inherited many of her most precious treasures, or received them as gifts, she has purchased her consumer products; and all she can remember about them is how much they cost.

Everything in the Doll's House was bought once. It's a stain that interiors like my grandmother's do their best to clean away. She bought her furniture, on the rare occasions she had to, from antique shops rather than new, from the store. Light bulbs were mounted on chinese vases and swathed in shades made for candles. Mechanical wonders like the hoover were like the people they replaced, kept behind the green baize door. Walter Benjamin once described the nineteenth-century collector, ensconced in his room, as one who 'assumes a Sisyphus-like task: to remove from objects, by possessing them, their quality of merchandise'.[1] And my grandmother has tried to do the same.

It's a losing battle in an age in which everything is for sale. The *meubles* of Westminster, the wonders of the *Wunderkammer*, or the *tentures* of Versailles were made for specific rooms and particular people. Only once those people had passed away did any of those objects find their way

onto the market; and their transformation into filthy lucre was an act of *damnatio memoriae*.

'All that is solid melts into air,' wrote Karl Marx in 1848, 'all that is holy is profaned,' for there is something sacrilegious about the dissolution of an object into the universal solvent of money, and the consequent proposition that anything can be exchanged with anything else. At the heart of the profanity lies the idea that everything has its price: that everything is, in the end, a number.

The idea originated in a real sacrilege of sorts. Just as the Protestant reformers of the sixteenth century tore down the stone statues of saints, smashed the stained glass, and whitewashed the frescoed walls of their churches, so they also attacked the very systems of thought that had gener-ated them. Memory palaces and theatres, composed as they were of elaborate halls, filled as they were with reminders, gods, and monsters, were idolatries that required the same iconoclasm. 'Whatever of art may help the memory', wrote the Protestant theologian Ramus, 'is the *order* and *disposition* [author's emphasis] of things, the fixing in the soul of what is first, what second, and what third. As to those places and images which are vulgarly spoken of, they are inept and rightly derided by any master of the art [of memory].'[2]

Ramus's art of memory was intended to reduce the world, and our knowledge of it, to systems of number. It was a point of view that took fertile root in the Protestant parts of Europe, and in the long term, found expression in the all-explaining mathematical formulae of the Newtons of the Scientific Revolution, the Adam Smiths of the Enlightenment, and the capitalist wonders of the Industrial Revolution.

And wonders they were, for the condition of modernity is one of abun-dance unparalleled in history, and spread among a wider proportion of the population than ever before. Built after the French Revolution, the palaces

of the nineteenth century were not the residences of sacred or royal personages, but were gin palaces, department stores, expositions, railway stations, arcades, and theatres, open to everyone. The Crystal Palace of 1851 contained a Great Exhibition that was visited by some six million people in six months. It was equipped with every modern convenience; and contained materials, machines, and manufactures next to whose number, diversity, and sheer strangeness even Rudolf II's *Kunstkammer* pales into insignificance.

These places were open, it should be clarified, to anyone who could pay to get in; and the ritual around which the people's palaces of the nineteenth century revolved was the act of purchase – the cash nexus – in which anything could find its price.

Such palaces, wonderful as they were, were not comfortable places to be in. It is not easy to admit that everything – cotton, gin, domestic bliss, social justice, even a visit to the lavatory – is a commodity that can be purchased; and it was a condition that the creators of the Great Exhibition did everything they could to disguise. No price was affixed to any object until the last day of the show, when, all the proprieties having been fulfilled, the exhibitors started, without prompting, to trade their exhibits with one another. The place was more or less cleared in a day. In a year, even the palace was sold.

Money and number are, as Marx suggested, forgetfulness rather than memory: the medium of exchange rather than the statement of value. The Crystal Palace melted into air years ago, leaving considerably less behind it than the ancient palaces of Rome. The building itself, and all it contained, was like my grandmother's hoover: a mass-produced, disposable, forgettable, commodity.

It's not that she's untidy. She isn't. My grandmother's hoover, designed to clean the traces of inhabitation away rather than to memorialize them,

to melt all that is solid into air, reminds her that everything in her sitting room, even the room itself, was bought once, and one day, will be sold. No wonder she hates it.

A Great Exhibition

SHE COULD NOT BRING HERSELF TO BE THERE TO SAY GOODBYE. Sixty-two years after Marie Antoinette had been dragged from her mirrored boudoir to the guillotine, Queen Victoria had spent a summer among millions of her subjects, the happy chatelaine of a palace made entirely of glass.

Now the autumn had come, the palace was about to disappear, and in Victoria's absence, a vast crowd made the valediction on her behalf. 'Just before 5 o'clock ... the silence of the vast assemblage became deeper and more intense. The moment at last came ...'[1] and the great organ at the end of the palace thundered out the national anthem.

At the same moment the assembled multitudes uncovered; and those who witnessed this act of loyalty from an advantageous position will long remember the effect which it produced upon their minds. Where just before nothing was visible but a mass of black hats stretching away until lost in the distance,

immediately there appeared a great sea of upturned animated faces...[2]

The Queen had spent the whole summer exploring her palace, and every time she'd visited, she'd found something new. There was plate and jewellery, clocks and watches, carriages, locks, furniture, stationery, books, carpets, Aubusson tapestries, and Sèvres porcelain. On 19 May she saw maps on gutta-percha, and a double piano, with two people playing at each end. On 20 May she was shown 'pretty furniture, a toilette set presented to the Duchess of Parma on her marriage ... a beautiful chalice given to the Parisian clergy by the Pope and the sword of General Cavaignac'.[3] On 21 May it was Alençon lace, and parasols. On 22 May she saw straw hats and Swiss watches, chocolate, guns and muskets, doors, chairs, a chimney, cigarettes and combs, boots, cases, carriages, bibles, cutlery, surgical and musical instruments. In June she was presented with a model cottage, pretty Indian boxes, and a 'very curious sort of stone or cake ... from which, when dissolved good beer can be made'.[4]

On 30 May she was shown a new invention by 'Mr Donisthorpe of Bradford for cleansing and combing our cotton ...'[5] She moved on to watch machinery: 'crunching iron, as it were bread!'[6] to 'machines for making screws and rivets, another very curious measuring machine, a knitting one ... a packing machine, printing machine on the vertical principle,'[7] hydraulic machines, pumps, filtering machines, machines for purifying sugar, machines for cutting wood for ships, grinding wheat and linseed, making biscuits, crushing sugar cane, cleansing grain, locomotives, a patent soda water machine, telegraph machines, gold weighing machines, and agricultural implements. It all 'had quite the effect of fairyland',[8] the Queen recalled in her diary. It made her feel as if 'we are capable of doing almost anything ... What used to be done

by hand, and used to take months doing is now accomplished in a few instants.'[9]

Everything had looked magical in the spring: 'Today', she wrote in her diary on 1 May,

> is one of the greatest and most glorious days of our lives ... quite like the coronation, and for me, the same anxiety ... the glimpse, through the iron gates of the transept, the waving palms and flowers, the myriads of people filling the galleries and seats around, together with the flourish of trumpets as we entered the building, gave a sensation I shall never forget ... the Archbishop of Canterbury offered up a short and appropriate prayer, followed by the singing of Handel's Hallelujah chorus, during which time the Chinese mandarin came forward and made his obeisance ...[10]

And she remembered in her journal how, amid the splendour, she'd spotted the man who'd made it all possible. 'He rose from an ordinary gardener's boy!' she remarked, and then she moved on: 'I forgot to mention that I wore a dress of pink and silver, with a diamond ray diadem and little crown at the back with 2 feathers, all the rest of my jewels being diamonds ...'[11]

* * *

The gardener's boy remembered it all a little differently:

> It was at the Midland station, in one of the committee rooms, that the first mark on paper was made ... and the most remarkable part ... is, that the blotting paper sketch indicates the principal features of the building as it now stands, as much as the most finished drawings that have been made since. In nine days, from the time of

making my blotting paper sketch, I found myself again at Derby, with a roll of plans under my arm on my way to London ... at the Midland station I had the good fortune to accidentally meet with Mr Robert Stephenson who had come from Newcastle by the same train in which I was going to London. On our journey I showed the plans to Mr Stephenson and got him to read the specification ...[12]

For, thanks to an hour or two on the trains, Joseph Paxton had found himself, in July 1850, in charge of the construction of the largest interior that had ever been built. It had to be ready in less than eight months. What was more, it was going to be made entirely out of cast iron and plate glass.

Never mind. Joseph Paxton might have been a gardener's boy once upon a time, but he was also director of the Midland Railway, and it was to the railway and the Midlands that he turned for inspiration. The cast-iron structure was manufactured by Fox and Henderson, engineers specializing in components for train and track. The plate glass was supplied by Chance Brothers, who were among the first in Britain to replace the hand-blowing of glass with the mechanical cylinder process. These components were manufactured in foundries and factories in Smethwick before being trans- ported to London by rail, so all that the navvies assembled in Hyde Park had to do was to bolt the pieces together as they arrived. The iron frame of the building acted as its own scaffolding, and the gutters doubled up as rails for glaziers' trolleys during the construction process. The first column was erected on 26 September 1850 and the last pane of glass put into place on 3 January the next year.

Paxton's glasshouse was manufactured by machines; and when it was finished it was filled with an exhibition of thousands of them, for the purpose of the Great Exhibition of the Industry of All Nations was not aesthetic. 'We take it for granted', wrote the *The Economist* magazine, 'that

only things will be exhibited which are supposed to be useful, agreeable, or convenient. The bulk will be made to sell. Things that are of no use, whatever trim and trouble they have cost their makers should find little place in such an exhibition. It is not to be a cabinet of curiosities, or a museum of wonders.'[13] In his essay 'On the Science of the Exhibition' William Whewell wrote:

> We have long boasted of our age as a most remarkable one; the number of useful applications which we have made within a comparatively limited period are no doubt more numerous than were ever before made within the same time. What has been the cause of this? Why have we such vast improvements in steam machinery? Why the electrotype, the electric telegraph, and the other aids of which we are so justly proud? Watt observed a small fact connected with the expansion of steam; Daniel noticed a peculiarity in copper precipitated under certain conditions; Oersted studied the movement of a magnet, in the proximity of a wire, through which an electric current was traversing; and from the observations of simple facts great laws were deduced, and great ends have been attained ... The Exhibition exhibits the beautiful results which have been derived from the study of science ...[14]

And everything about the great glass building was subjected to such factual observation, for it was itself a great machine, whose *primum mobile* was steam, boiled in coal-fired furnaces and sent around the building through a cast-iron plumbing system. The art critic John Ruskin wrote of it:

> The value of every work of art is exactly in the ratio of the quantity of humanity that has been put into it, and eligibly expressed

upon it forever: first, of thought and moral purpose. Secondly of technical skill. Thirdly, of bodily industry.

The quantity of bodily industry … is very great. So far it is good. The quantity of thought it expresses is, I suppose, a single and very admirable thought of Sir Joseph Paxton's – probably not a bit brighter than thousands of thoughts that pass through his active and intelligent brain every hour – that it might be possible to build a greenhouse larger than ever greenhouse was built before. This thought, and some very ordinary algebra, are as much as all the glass can represent of human intellect.[15]

Neverthless, while the building was still going up in the autumn of 1850, Paxton allowed himself a dig at the snobbery of those who called it nothing more than a greenhouse: 'The glass palace', he wrote, 'is going very well, it begins to have the most imposing appearance, everyone who has seen it appears delighted and astonished.'[16] It was a private comment, but in their next issue, *Punch*, the satirical gentleman's magazine, gave Paxton's project a similar nickname: the Crystal Palace, they called it.

* * *

It was only meant as a joke, but the name stuck, for the Crystal Palace was indeed a palace. Joseph Paxton might have started out as a gardener's boy on an aristocratic estate, but by the time he had built his great glass house, he had become a new class of citizen. 'The bourgeoisie', Karl Marx had written three years before:

… has accomplished wonders far surpassing Egyptian pyramids, Roman aqueducts, and Gothic cathedrals …

> The bourgeoisie cannot exist without constantly revolution-
> ising the instruments of production, and thereby the relations
> of production, and with them the whole relations of society ...
> All fixed, fast-frozen relations, with their train of ancient and
> venerable prejudices and opinions, are swept away, all new-formed
> ones become antiquated before they can ossify.[17]

Paxton's greenhouse in Hyde Park was a bourgeois palace, a wonder far
surpassing the pyramids and the cathedrals; and although intellectuals like
John Ruskin, mired in ancient and venerable prejudices, refused to admit
it to their antiquated and ossified canons of art, the Queen herself and
most of her people entertained no such scruples.

Of all the exhibits in the Great Exhibition, none impressed the Queen
more than the spectacle of the masses that came to see it. It had been a
controversial idea to let them in: 'The whole of Hyde Park and, we venture
to predict, the whole of Kensington Gardens, will be turned into a bivouac
of all the vagabonds of London ...', thundered *The Times* on 25 June 1850.[18]
Queen Victoria's autocratic German cousins warned her against fraterniz-
ing with her subjects; they had after all just survived the revolutionary
summer of 1848 themselves. The commissioners didn't let the people in
until 26 May, three weeks after the palace had opened, when the price of
entry was lowered to an affordable shilling, and then they stationed 600
policemen to watch them.

The Queen stood in the gallery to see them come in; and to her and to
everyone else's surprise, they behaved much better than expected. They
made 'a very amusing sight', she recalled in her diary, 'streaming in and
gazing all around ...'[19] Charlotte Brontë observed that:

> the multitude filling the great aisles seems ruled and subdued by

some invisible influence. Amongst the thirty thousand souls that peopled it the day I was there not one loud noise was to be heard, not one irregular movement seen; the living tide rolls on quietly, with a deep hum like the sea heard from the distance.[20]

The invisible influence that subdued the crowd was a mystery to everyone. It was not, they were sure, a magical sympathy. The Queen supposed, of course, that it was loyalty 'greatly increased by the fact of a few words being spoken to them by the highest personages'. John Tallis, writing at the time, imagined the reverse: that 'all social distinctions were for the moment merged in the general feeling of pride and admiration are the wondrous result of the science and labour exhibited ...'[21]

Marx was less sentimental: the invisible influence was the mass of people itself, their relationships with one another revolutionized by the very manufactures and machines they had come to see. What had once been the clan, the village, the caste, bound together by blood and soil, had dissolved into air, and become a new sort of gathering so characteristic of and so fascinating to the nineteenth century: the crowd.

And *The Times*, whether they wanted to or not, agreed with him. On the day it closed, it reported some 'simple facts' about the Crystal Palace. That such facts could be collected was in itself the function of 'some very ordinary algebra'. There were turnstiles to regu- late and count the masses, refreshment rooms and public conveniences to keep them fed and clean, and printed catalogues to guide them round. Everything they did was recorded on registers, printed on presses, and distributed by rail and telegraph.

In the month of May 734782 visits were paid to the building, in June 1133116, in July 1314176, in August 1023435, in September 1155240, and in the first 11 days of October 847107. These figures

give a total of 6201856 as the sum of visits to the exhibition ... the greatest number of people ascertained to have been in the building at any one time was at 2 o'clock on Tuesday last, when 92000 persons were present. Between 11 and 12 o'clock on Monday last 28853 persons entered the building in one hour ...[22]

The palace was the prototype of all the railway stations, arcades, mirrored gin palaces, department stores, and the hotels of the modern age – machines manufactured to manufacture the 'whole relations of society'. The Crystal Palace was an experiment; and on 11 October 1851, the hypothesis had been tested, the experiment had come to an end, and the apparatus was ready to switch off and pack away. At the appointed moment, thousands of individuals doffed their caps in automated synchrony.

Whatever it was that made them do it has since been reproduced, again and again: in malls and airport lounges, art galleries, restaurants, cinemas, public toilets, boutiques, council houses, and pleasureplexes. These public interiors form the very fabric of our lives, and in them, the invisible influence that Charlotte Brontë observed is no less palpable and no less mysterious than it was on 26 May 1851, when, for the first time, the people walked into their own palace, their expressions, like the interior that enclosed them, completely glazed.

A Gilded Cage

NOWHERE IN THE CRYSTAL PALACE WAS THE INVISIBLE INFLUENCE more keenly felt than around a small cage on a plinth in the northern transept. 'A mysterious interest appears to be attached to it,' wrote the correspondent from *The Times*, '... the crowd is enormously enhanced, and the policemen at either end of the covered entrance have much trouble in restraining the struggling and impatient.'[1]

But when he saw the most popular exhibit in the whole of the Great Exhibition of 1851, Mr Simon Sparks of Somersetshire, as he most penitently confessed to the magazine *Household Words*, was, like everyone else, 'strikingly disappointed'.[2]

He didn't expect to be, for mounted at the door of the India Court, which was got up like a maharajah's palace, was the largest diamond in the whole world. The Mountain of Light, they called it: the Koh-i-noor.

It shouldn't really have been there, for its absence from the exhibition, stated one guidebook, 'would not materially detract either from its moral interest or its practical usefulness'.[3] As he walked away from the crowd,

Simon Sparks turned his mind to 'the gigantic Astronomical Telescope ... I bethought me of the various agricultural and other machines at rest, and in motion ... The immense blocks of coal outside, what were they but "black diamonds?"'[4] The Koh-i-noor wasn't half as useful or inventive as the Koh-i-noor graphite pencil that Hardtmuths of Vienna had placed on show.

It wasn't much to look at, either. One commentator described it as nothing more than an egg-shaped lump of glass,[5] and even Lord Dalhousie, who had brought the jewel to the exhibition, admitted:

> The Koh-i-noor is badly cut: it is rose-, not brilliant-cut, and of course won't sparkle like the latter. But it should not have been shown in a huge space ... Dr Login used to show it on a table covered with a black velvet cloth, and relieved by the dark colour all round.[6]

But Sparks couldn't stop returning to the useless crystal that so resolutely failed to glitter in the heart of the Crystal Palace. 'I confess', he later wrote, 'that my chief inducement in these repeated visits, was the strange attraction of the precautions for the preservation of the gem, far greater, I repeat, than the attraction of its equivocal beauty.'[7]

These precautions are remembered in an engraving made at the time. A crowd of ladies and gentlemen are staring at a metal cage, some six feet tall, that rests on a plinth of about waist height, and it is surmounted by a cushion, on which has been placed an imperial crown. The focus of their rapt attention is too small to distinguish properly in the engraving.

All we can see is a little stand, surrounded by a nimbus of flaming gas. Every night, it was rumoured, the Koh-i-noor would descend auto-

matically into a safe buried in the concrete crypts of the Crystal Palace. Secure in its gilded cage, the Koh-i-noor was 'guarded by men and mechanism, by clockwork tricks within, which it is said would cause the diamond instantly to disappear, if the lightest of light fingers were but to touch it'.[8]

The stone itself might have disappointed, but the machine devised to protect it was chief among the marvels presented at the Great Exhibition by Thomas Chubb and Sons, inventors of the patent detector lock and holders of the royal warrant. Chubb's little interior was, quite unlike the object it contained, a worthy companion to the telescope and the steam engine, and the Koh-i-noor patent graphite pencil.

'The precautions and devices seemed to defy the ingenuity of man,'[9] recalled Sparks; but as he returned to wonder at it again and again, Simon Sparks found himself determining to outwit Mr Chubb's clockwork baldaquin, and to liberate its prisoner:

A contest with Chubb above ground, was the very place where he had calculated the grand assault would be made, if at all; whereas, it was extremely unlikely that he should have had the genius to foresee that another genius might construct his plans of attack entirely on the underground principle.[10]

Simon Sparks took an expensive house on Kensington Gore, enlisted a Somersetshire peasant as an unwitting accomplice, paid him handsomely, and set him digging. Weeks later, yards underground, drilling in the dark up into the crypts of the Crystal Palace, the prize literally fell into his hand.

He carried it back down the tunnel to his house, trembling; and back at home, he considered his prize. 'I had got the greatest Treasure of the

earth',[11] he recalled and then, as he turned it in his hands, he was struck by a consideration that had not previously occurred to him.

Selling the gem on the open market was not an option, especially not in London, for it was, in the summer of the Great Exhibition, the most celebrated stone in the world; and Sparks soon became aware that if he was ever going to realize anything of its value, he was going to have to take it abroad. He boarded the boat to France; but when he consulted a jeweller in Paris, he found that even foreigners were suspicious of an ordinary bourgeois, unaccountably in possession of a gigantic diamond.

And he realized, with an awful clarity, that the only way to unlock the value of the jewel was to break it up. Sitting in his hotel bedroom, with a hammer in his hand, he reflected: 'It was a thousand pities to destroy so unique a gem, but ... my bane and antidote were both before me both in one.'[12]

It was, of course impossible, for no domestic hammer can break a diamond; and Simon Sparks returned to London in possession of the most valuable object in the world, a pauper.

Then one day, two mysterious gentlemen came to visit him. They had heard he had a precious gem, they said, and he handed one of them the stone. The man looked at it, then at Simon Sparks, and:

in the most delicate manner, and all in Oriental allegory and parable, he gave me to understand that ... the history and adventures of all the great diamonds were a sort of romance. Take the history, for instance only for instance, he said of the one called the Koh-i-noor.[13]

And rigid with terror, convinced he had been found out, Simon Sparks sat on the edge of his bed, and listened as the man told his story.

The stone had been found in a cave by the Hindu god Krishna, he said, the plaything of some savage child. Once upon a time, it had been the staring eye of a heathen goddess. It had been obtained as a spoil of war by the first Mughal, Babur. In his memoir, the Emperor recalled that the gem was precious enough to feed the whole world for two-and-a-half days; but he, munificent monarch that he was, gave it to his son Humayun, as a gift. Passed down from Mughal to great Mughal, it had ornamented the Peacock Throne of Shah Jahan, and when he was imprisoned by his son Aurangzeb, he had the stone built into the wall of his prison. Locked up in his cell in the fort of Agra, he would peer into its glassy surface and see, reflected in one jewel from his crown, the outline of the other, the Taj Mahal.

It was stolen from the last Mughal by Nadir Shah, who, finding it sparkling in the folds of the imperial turban, cried 'Mountain of Light!' and gave it its name. And it was stolen from Nadir Shah by Shah Shujah, the King of Afghanistan, then it was given by the King of Afghanistan to Ranjeet Singh, the Maharajah of the Punjab, who was 'very anxious to ascertain its real value'.

> He sent to merchants at Umritsir, but they said its value could not be estimated in money. He sent it to the Begum Shah, Shoojah's wife. Her answer was thus, 'If a strong man should take five stones, and should cast them, one east, one west, one north, and one south, and the last straight up in the air, and if all the space between those points were filled with gold and gems, that would not equal the value of the Koh-i-noor.' Runjeet (thinking this a rather vague estimate, I suppose) thus applied to Shah Shoojah. The old man's answer was: 'The value of the Koh-i-noor is that whoever holds it is victorious over all his enemies.'[14]

The Koh-i-noor had fallen into British hands the year before the Great Exhibition, and even though it belonged by rights to the East India Company, Lord Dalhousie was anxious that it should be presented to Queen Victoria by the prince who had lost it in battle:

> The Court [of the East India Company] you say, are ruffled by my having caused the Maharajah to cede to the Queen the Koh-i-noor; ... [My] motive was simply this: that it was more for the honour of the Queen that the Koh-i-noor should be surrendered directly from the hand of the conquered prince into the hands of the sovereign who was his conqueror, than it should be presented to her as a gift – which is always a favour – by any joint-stock company among her subjects.[15]

Three centuries before, the oriental gentleman averred, Humayun had written much the same thing: 'Such precious gems', he wrote, 'cannot be bought; they fall to one by arbitrament of the flashing sword, which is an expression of divine will, or else they come through the grace of mighty monarchs.'[16]

And the man turned to Simon Sparks with a rueful smile. They both knew he was undone.

* * *

It was only a dream. Simon Sparks' *Penitent Confession* was but a titillating tale of an exotic curse; an occasional piece in *Household Words*, a monthly journal of literary miscellany. But all the same, people couldn't resist repeating it and there were several attempts to copy his imagined crime, all foiled. As one commentator observed in 1851, 'the most learned of savants, the coldest of utilitarians, the political economist, the bishop and

the Quaker, all found themselves seduced by the Koh-i-noor.'[17] No wonder, for it confronted them with a singularity in the Great Exhibition of the Industry of All Nations: an indestructible object both useless and desirable, priceless and worthless, which of its very nature could not be bought or sold.

At the end of the exhibition, the Koh-i-noor was taken to Amsterdam to be recut according to European standards. The weight of the stone was reduced by some forty-two per cent from 186.0625 carats to its current 105.602: it cost them £8000 to do it. It hardly sounds like a sensible financial decision, but no matter: the Koh-i-noor has never passed through the market. Instead, it was mounted into a brooch, then a tiara, and then the crowns of the Queen consorts Alexandra, Mary, and Elizabeth, the last Empress of India. Its last public outing was on top of her coffin in 2002.

The stand upon which the stone once stood was sent to the Natural History Museum, which was founded in Kensington out of the proceeds of the Great Exhibition; but since the Koh-i-noor had been recut and mounted elsewhere, it was forgotten.

Then in 2007, a certain Scott Sucher came to visit. The curators were ready for him, for they knew that Sucher had a keen interest in researching and recreating historic diamonds; and they took him into the attic and pointed to a blue velvet display stand, and asked him what he thought it was.

Sucher knew exactly what it was, and he also knew how to prove it, for he had brought with him a replica he had made of the Koh-i-noor before it was cut in 1851.

... I looked across the room at my wife. Karen caught my eye, and just smiled and nodded. Without a word, she took the backpack

off her back, pulled out the Tupperware container ... and then unwrapped the KIN replica and put it in my hands.[18]

It was a perfect fit.

The cage was less fortunate. It was sent back to the foundry from which it had come, where it survived until the 1950s. It was probably melted to realize its scrap value.

Chubb's clockwork *baldaquin* was the microcosm of the Crystal Palace itself: a gridded cage upon which the worth of art and industry could be plotted and in which it could be captured. The invisible influence that subdued the crowds also subdued the exhibits they came to see, subjecting their wonders to remorseless disenchantment. The diamond was, as one visitor observed, 'carbon, mere carbon'.

The cage had been devised to imprison the bounty of the orient within a mechanical interior, but Chubb's artistry stimulated the very desire it purported to frustrate. The jets of flaming gas arrayed around the base, the blue velvet against which the facets of the mountain of light would shine more brilliantly, the very transparency of the cage, coupled with its stern refusal of entry, its metallic sheen, its legendary ingenuity, were designed to tempt the thousands who, like Simon Sparks, clustered around it.

The gilded cage has since become a must in smart boutiques, from Schiaparelli in the Place Vendôme in the 1930s to the Prada store in downtown Manhattan in the 1990s. Tempting you to buy, reminding you that you'll never afford it, Chubb's cage is the prototype of the modern shop, an interior designed to arouse, as it did in the doomed soul of Simon Sparks, an invisible influence, an unaccountable, insatiable possession.

Spending a Penny

THERE WAS ANOTHER INVISIBLE INFLUENCE THAT SUBDUED EVERY
visitor to the Crystal Palace at some time or another; and the commis-
sioners of the Great Exhibition were forthright about it: 'No apology
is needed', they wrote, 'for publishing these facts, which ... strongly
impressed all concerned ... with the suffering which must be endured by
all, but more especially by females, on account of the want of them.'[1]

'They' had been the most visited – and the most profitable – exhibit
in the whole of the Great Exhibition. In twenty-three weeks, 827,280
people visited them, and they made a profit of £1790, since everyone who
went in had to pay a penny for the privilege.

No apology was needed. They were among the most popular interiors
in the whole of the Crystal Palace, as 'they' must be in all public interiors;
but they did not appear in the Queen's diary. *Punch* published no cartoons
of them, and no engravings appeared in any catalogue. We are left with no
record of their character, other than a euphemism.

It first appeared in print in 1945, in Harriet Lewis's novel *The Strange*

Story; but the phrase is, so they say, much older. 'Spending a penny', the practice and the phrase, has a special history, for it originated, so they say, and as its name suggests, in the greatest public interior of the capitalist era.

It's not that the facts weren't there for all to see. There in 'Class 22 objects "GENERAL HARDWARE, INCLUDING LOCKS AND GRATES"', on stand 810, George Jennings of Great Charlotte Street proudly showed his 'India rubber tube water closets'. He'd received a medal for them four years before from the Royal Society of Arts (RSA).

Jennings didn't invent the water closet; but his was the one machine in the Great Exhibition that, for a fee, people could actually sample. And as its name implied, it was also an interior, the lock to which, so they say, yielded to the open sesame of an inserted penny.

But it was an intimate and somewhat alarming machine, for the ghost at its heart was not a breath of steam, or a roaring furnace, but the human body. Locked into its vitreous cylinders, the lady of quality undid her stays, and the gentleman removed his fitted frock coat to strain and heave and fart like beasts. The water closet was the meeting place between cold china, polished brass, encaustic tile, and quivering, shivering buttock. No wonder no-one wanted to recall the experience.

All the same, one week after Jennings' invention opened to the public, the RSA established a committee to provide more of them:

The committee recommend that the Council should undertake to lease several ground floors in the Strand, Holborn and Cheap-side.

... That in each shop there be a waiting-room, having two classes of water-closets and urinals, for the use of which a penny and two pence should be charged.

> ... That each set of waiting-rooms be provided with a lavatory
> for washing hands, clothes' brushes, &c., at a charge of twopence
> and threepence.
>
> ... That each set of waiting-rooms have a superintendent and
> two attendants.
>
> The committee recommend that it be suggested to manufac-
> turers of lavatories, water-closets, and urinals, who desire to bring
> their inventions before the public, immediately to present samples
> for the object in question.[2]

And George Jennings was, of course, first among them. He had started out
a cabinetmaker, but the cabinets he made had turned him into something
of a crusader for public hygiene.

The cause needed one, for as Mr Jennings' retiring rooms opened to the
public in the Crystal Palace, *The Times* reported the appearance of another
machine, elsewhere in the city:

> For some days past a vehicle, constructed on the principle of the
> prison van, but painted in conspicuous colours, has been stationed
> at the western end of Cheapside. It is intended for the convenience
> of gentlemen only, who are admitted by an attendant inside on
> payment of 1d. each person. In consequence of the great novelty of
> the speculation crowds have gathered round the vehicle every
> morning, as soon as it has taken its station ...

One might imagine that such a marvellous invention would attract praise,
but in fact *The Times* reported it as a criminal incident: 'if the parties would
only select some retired spot for these machines,' they wrote, 'no com-
plaint would be made about them ...'[3]

George Jennings encountered considerable opposition to the campaign; and seven years after the Great Exhibition he complained of the lack of progress:

> My offer (I blush to record it) was declined by Gentlemen (influenced by English delicacy of feeling) who preferred that the Daughters and Wives of Englishmen should encounter at every corner, sights so disgusting to every sense, and the general public suffers pain and often permanent injury rather than permit the construction of that shelter and privacy now common in every city in the world ... I could give you particulars as to the opposition I have had to encounter from individuals, who if measured by their obstructive policy, one would suppose that they themselves had never required any convenience of any kind.[4]

The RSA did their best to placate their delicacy. They proposed that their new facilities should be euphemistically named 'Public Waiting Rooms'. They should be concealed inside other interiors, or underground, and, furthermore, they should be rigidly separated by sex:

> ... public waiting-rooms for men and women be established in distinct shops, on opposite sides of the street.
>
> ... the police should be requested to cause these establishments to be visited from time to time.
>
> The shops which appear to be most suitable for waiting-rooms for ladies are staymakers', bonnet-makers', milliners', &c. Those most suitable for gentlemen's waiting-rooms are hairdressers', tailors', hatters', taverns', &c.[5]

They should also, they proposed, be segregated by class. In the facilities erected in Bedford Square in 1852, ladies of quality paid tuppence to use seats concealed in mahogany closets, while working women would spend a penny to squat over a hole in the ground, veiled by a curtain quaintly called a 'urinette'.

Even so, they closed soon afterwards, for the retiring room wasn't just the fraught junction between goose-pimpled thigh and chilly porcelain. It was the meeting place between classes and sexes of people who were never meant to meet. No wonder no-one would admit to using them, disguising their intentions with an airy foray into a Fleet Street staymaker or a Holborn hatter to 'spend a penny'.

The water closet had been invented to alleviate a 'suffering which must be endured by all' but its machinery engendered new comedies of manners, new anxieties, and none greater than the fear of the very thing the machine was designed to process.

Once upon a time, shit was everywhere. In 1539, Francois I issued a decree to the citizens of Paris:

> We forbid all emptying or tossing out into the streets and squares
> of the aforementioned city and its surroundings of refuse, offals,
> or putrefactions, as well as waters whatever their nature, and we
> command you to delay and retain all stagnant and sullied waters
> and urines inside the confines of your own homes.[6]

In order to cleanse its public spaces, the excrement of Paris was to be confined to the private interior of the home; and there, it was confined to an interior more private still: 'we enjoin all proprietors of houses, inns, and residences not equipped with cesspools', the ordinance continued, 'to install those immediately ...'[7]

By the late eighteenth century, every house in London was built over a cesspool. It would be emptied once a week, at a cost of one shilling. The 'nightsoil men' made a handsome profit, selling the manure on to farmers around the capital for two shillings and sixpence per load.

But by 1851 the system was breaking down under the weight of its own scale. There were by then 200,000 cesspools under London, and Thomas Cubitt, whose elegant houses in Belgravia were built right next to the Great Exhibition, estimated that the number of water closets in London had increased tenfold. The poor quite simply could not afford the shilling per week to clear their cesspits, or indeed, to repair them. In addition, nightsoil men found it less and less profitable to transport ever-increasing loads of ordure to farms that, as London grew, were further and further away. The cesspools began to fill up and leak into the city above.

In 1832, the first of a series of cholera epidemics had swept across the city, originating, so people believed, in the dark interiors lurking under their drawing rooms and cabinets. The commission appointed by the government to investigate sent their men down into the blackness and they were quite literally struck dumb by what they found: 'we were very nearly losing a whole party by choke damp,' wrote Edwin Chadwick, one of the commissioners, 'the last man being dragged out on his back (through two wet feet of black foetid deposits) in a state of insensibility.'[8]

The solution was obvious. The 1844 Metropolitan Buildings Act outlawed the construction of cesspools, specifying that no new buildings should be built without being connected to a public sewer that could carry the sewage away, rather than storing it up. By 1847, the Metropolitan Commission for Sewers was empowered to insist on the provision of a water closet with a sewer connection for every building. The cesspools of London are gone now, a city of lost interiors that, hopefully, will never need to be entered again. It was a triumph of vision and will.

It was a disaster. Thomas Cubitt observed:

Fifty years ago nearly all London had every house cleansed into a
large cesspool ... now sewers having been very much improved,
scarcely any person thinks of making a cesspool, but it is carried
off at once into the river. The Thames is now made a great cesspool
instead of each person having his own. [9]

And all too often the sewage never made it as far as the river. In 1848 the
Metropolitan Commission for Sewers heard that:

The sewers of the Holborn and Finsbury division having been
greatly improved and enlarged, the city sewers became inadequate
to carry off their contents, and a number of houses in the vicinity
of the river were inundated after each fall of rain, the contents of
their own drains ... being actually forced back up into their own
houses from the volume of water which occupied the main sewer. [10]

The cholera epidemics of the 1850s, and the Great Stink of London of 1858,
were not some medieval throwback, but a modern problem. It was not
solved until 1870, when Joseph Bazalgette's Thames Embankments were
completed, diverting millions of gallons of sewage to pumping stations
built a safe distance out of town.

But in 1851 that had not yet happened, and all that stood between the
sewer and the home was George Jennings' little machine. It wasn't new.
Sir John Harington had described one to Queen Elizabeth I, in which a trap-
door separated the closet from the cesspool, and in 1785 Alexander Cummings,
a watchmaker from Bond Street, invented the 'stink trap': the 'S' bend,
perpetually filled with water, that both cleansed the bowl and separated the

fresh airs above from the foul miasmas below. Jennings' innovation was to use the new rubber technology to ensure that the seal was airtight.

Not only was the retiring room a faintly sickening marriage of man and machine; not only was it a mechanical violation of social niceties. It confronted the delicate lady with the possibility that the hole over which she daintily perched, in her crinoline, in her closet, was a mechanical arse, ready to belch up not just her own shitty filth, but that of millions.

Once upon a time an Englishman's home had been his castle, and his closet had been a place of retreat. The replacement of cesspool by sewer transformed home and closet into nodes on a network, cogs in a machine so vast and complex that no-one could work out what it was going to do, or how. Shit had become the horrible mirror image of capitalism itself: 'A society', wrote Marx, 'that has conjured up such gigantic means of production and of exchange, is like the sorcerer who is no longer able to control the powers of the nether world whom he has called up by his spells.'[11]

The invisible influence that subdued the crowds at the Great Exhibition wasn't just admiration for wonderful objects like the Koh-i-noor, nor even an urgent desire for momentary relief. It was awe – awe that a room could contain so many, awe that the many were so connected, awe at the incomprehensible complexity of their connection. If one thing glazed the masses in 1851, it was their own mass, their number.

Long after the Crystal Palace had melted into air, the retiring rooms remained on Rotten Row, buried in the bushes. They must have provided discreet relief and mysterious anxiety to hundreds of thousands, if not millions, before they were removed in the 1890s. We have no idea what they were like inside, and never will. No-one wanted to remember. Instead, they were cloaked in a euphemistic phrase that referred to the smallest unit of currency in circulation. All we know is that to enter this interior, you had to spend a penny.

A Model Cottage

IN THE 1960S A ROW OF COTTAGES WAS DEMOLISHED IN WARRINGTON. They were 'unfit for human habitation',[1] the council said; but the truth was that no-one was prepared to spend any money on them. They were a century old, by then; and they'd only cost £370 to build in the first place.

There are plenty of other cottages just like them. There's one in Kennington Park that's the original, apparently. It was meant to be a house for the park-keepers and a 'museum for articles relating to cottage economy'. No-one lives there any more — it was never really a home anyway.

I KNEW they would turn out a failure, sir; I knew they would. It's infamous. What has a Prince to do with building cottages? What has the royally high to do with the villainously low, sir? When the Prince becomes a bricklayer, what are the bricklayers to be?[2]

Bendigo Butler, occasional columnist in *Household Words*, wasn't the only one who thought so. The commissioners for the Great Exhibition didn't

want a cottage cluttering up their Crystal Palace, and the Duke of Wellington replied to Prince Albert's request for a site in the barracks next door with courtly *froideur*; but his Royal Highness got his Trianon in the end, and in June 1851 Bendigo Butler went to take a look:

> First we squeezed among some old gents in a little lobby four or five feet square, into a room that is the model living room, a little bit larger than fourteen feet by ten. There were a lot of people in it, and a table, and a few chairs of stained deal, and a dresser under the window; that is, a dresser by day, and folds up over the window as a shutter at night; so that it's indifferent whether you say that a model cottager is forced to make pies on the window shutter, or to barricade his window with a dresser … there's some kind of model grate, of course, and a slate mantel-piece, and simple cornicing of glazed brick, and a rod for picture-hanging over the mantel-pieces, and a cupboard, and a run of shelf, considerably above the reach of children; model children not being exempt from a propensity to taste the 'rat poison', or break the mugs.[3]

'Move on!' said the policeman, when Bendigo tried to peer into the other apartments, 'the four sets of rooms are all precisely on the same plan.' 'What?' says Bendigo, 'all exhibited with the doors locked, for to be peeped at through a keyhole?' For Albert's cottage wasn't a real cottage, but an exhibit, listed in the catalogue of the Great Exhibition along with encaustic tiles, metallic lava flooring, a table of Moorish stalactites, and a lump of coal, carved into a garden seat.

But it was an exhibit that had to be there. The Great Exhibition was after all an exhibition about industry, and *Punch* commented:

An exhibition of the manufactures and commodities is not an exhibition of industry, but one of the results of it. A real exposition of industry would require that the INDUSTRIOUS themselves should be exhibited as well as their productions. In a glass hive we ought to show the bees at work. However, as needlewomen cannot be starved, nor tailors 'sweated', nor miners blown up, amongst a multitude of people, with any degree of safety, it is suggested that paintings of our various artisans labouring in their usual vocations should accompany the display of substances and fabrics which we owe to the labourers of ingenuity of various classes.[4]

The living room in Prince Albert's cottage went one better: for it showed the visitors to the Great Exhibition not just what the labouring classes did; but how they lived.

Or, at least, how they should live, for Mr Henry Roberts, honorary architect to the Society for the Improvement of the Condition of the Labouring Classes (SICLC), had thought of everything: warm air heating from the range, running water, sinks and lavatories and drainage boards and plate racks and rubbish chutes and cast-iron fireplaces:

The sleeping apartments, being three in number, provide for that separation which, with a family, is so essential to morality and decency ... The children's bedrooms contain 50 feet superficial each, and opening out of the living room, an opportunity is provided for the exercise of parental watchfulness, without the unwholesome crowding of the living room ...[5]

For unlike most of the houses of the poor, this cottage was an apartment of several rooms, divided by stout brick walls and floors that prevented the

transmission of sound, disease, and indecent thoughts. The house was a moral project, as well as a functional one:

> It is the humbler classes themselves who chiefly require to be educated in the more correct notions of what cleanliness and domestic comfort render necessary, and if they once thoroughly appreciate the sanitary defects of their present habitations their feelings and opinion would largely control the plans of those who usually build for them.[6]

He had thought of everything, Henry Roberts; but Bendigo Butler wasn't impressed. It wasn't that that the model living room was mean – precisely the reverse:

> Humbugs may ... get up agitation about wholesome dwellings. What I say is, Britons won't be humbugged. You say, that thousands of Her Majesty's subjects are filthy and ignorant. They are of age, aren't they? Let them look after themselves; wait, if you please, you mighty forward gentlemen, until they ask you to be cleansed and taught. Mind your own business, and don't be prying into the affairs of other people.[7]

Bendigo Butler wasn't just a laissez-faire bourgeois. He had, he admitted to his readers, a little money himself, and quite a few properties that he rented out to labourers, and a filthy and ignorant lot they were.

But he'd thought of everything, Henry Roberts, and when Mr and Mrs B. went upstairs, the representatives of the SICLC were ready for him. As Mrs B. took a seat by the range in the corner, they furnished the old bulldog with exactly what they knew he would be looking for:

Rent per week.

Room 13 ft. by 14 ft., 6 ft. high . . . 3s

Room 11 ft. 4in. by 11 ft. 3 in., 6 ft. 5 in. high . . . 8s

Room 17 ft. 6 in. by 13 ft., 8 ft. high . . . 5s

Room 11 ft. 2 in. by 9 ft. 4 in., 6 ft. 5 in. high . . . 2s

Room 14 ft. 6 in. by 13 ft., 6 ft. 5 in. high . . . 4s

Room 9 ft. by 7 ft., 6 ft. 5 in. high . . . 4s

I put my tongue in my cheek, and look at Molly. Sir, I remark, as far as I can see, you are a little hard upon existing landlords. Lanes and allies yield a profit. Certainly, he answers, smiling – nine, twelve, twenty per cent. Seven, say I, with a chuckle; but look at the losses. It's necessary that rents of poor folks' dwellings should be high, because so many don't pay, that we must hope to get a living out of those who do.[8]

But Mr Roberts had thought of everything; and the smooth assistant proceeded to explain how the design of the cottage would help to maximize investment, for Mr Roberts was well aware that unless his cottages turned a profit, their philanthropic purpose would be useless.

The cottage would yield a developer a return of seven per cent, the assistant told Bendigo Butler. It had been designed so that it could be reproduced in any number of combinations – as a detached cottage in a garden, or piled up into tenements on a tight city site. The materials, fixtures, and fittings were mass produced, cheap, readily available, and easy to use, he explained; and he provided a list of them all: bricks, tiles, windowsills, drains, ranges, water closets, sinks, and even iron bedsteads.

And importantly, he continued, they were durable. Three-quarters of the SICLC's expenditure that year had gone on repairs, he stated, but this

cottage, whose floors and ceilings were finished in Portland cement or Staffordshire tiles, whose walls were covered in glazed bricks or washable plaster, whose deal skirtings were stained and varnished so that they would not need repainting, was designed to require the minimum of maintenance.

Not just that, but every detail was designed to prevent tenants from damaging the property: iron rails were fixed to the walls so that tenants would not drive nails into the plaster to hang pictures. Shelves were built in so that they would not try to install more. When tenants vacated the premises, every trace of them could be wiped from glaze and varnish, cement and plaster with a few sweeps of the mop. Mr Roberts had thought of everything.

The cottage was like those snorting beasts of iron and steam in the Crystal Palace. Its cogs and wheels were bricks and sinks and picture rails, a dresser that folded up into a window shutter, and bedsteads that could be stripped down in a trice. It was a machine, designed to process raw human lives and turn them into rent.

Bendigo Butler got up to go, irritated by the smooth answers to all of his questions. He wasn't convinced, but plenty of other people were, and after the exhibition copies of Prince Albert's model cottage started turning up all over: in Cowley Gardens and Bethnal Green, in Ramsgate, Warrington, and Windsor. They built so many of them that there are plenty of them left.

They were never built purely as charitable enterprises. The cottages in Windsor, for example, were paid for by a joint stock company, whose working capital was £6,000, raised in £10 shares by investors who were promised a five-and-a-half per cent return. They were sold in 1872 to a developer, and while he demolished some, the few that survive are now in private ownership. The prototype was, like all the rest of them, sold on and re-erected in Kennington because it had long been a centre for left-

wing activism. It was thought that the sight of the houses there would teach the local proletariat how to behave themselves.

* * *

Mr Roberts had thought of everything; but the labouring classes didn't respond to his model cottage quite as gratefully as he had intended. In April 1851, another columnist for *Household Words*, Charles Dickens, had been to see another worker's dwelling only a mile or so away in Spitalfields. His guide, a Mr Broadelle, showed him into a home that was everything the model cottage was not:

> In that corner are the bedstead and the fireplace, a table, a chair or two, a kettle, a tub of water, a little crockery. The looms claim all the superior space and have it. Like grim enchanters who provide the family with their scant food, they must be propitiated with the best accommodation. They bestride the room, and pitilessly squeeze the children ... the children sleep at night between the legs of the monsters, who deafen their first cries with their whirr and rattle, and who roar to the same tune when they die ...[9]

But it wasn't the chaotic jumble that shocked him. It was the reluctance of the poor to leave it, in spite of all the well-meaning gestures of Mr Roberts and his society for their improvement. Mr Broadelle took the writer aside, and explained: 'they are', he whispered, 'so interlaced, and bound together by marriage, debt, and prejudice, that despite many inducements ... they prefer dragging on a miserable existence in their present abode.'[10]

Reflecting on his visit later, that bourgeois bulldog Bendigo Butler had, despite himself, nailed the problem when he'd written: 'You say, that thousands of Her Majesty's subjects are filthy and ignorant ... wait, if you

please, you mighty forward gentlemen, until they ask you to be cleansed and taught.'[11]

But he would have to have been right, wouldn't he? Bendigo Butler was, as all his readers knew, none other than Charles Dickens himself, who knew enough about the labouring classes to know that they were as complex, contradictory, and ultimately irreducible as everyone else.

They weren't going to let anyone turn their homes into money-making machines. Home was, they knew, something that industry could not mass produce, nor philanthropy bestow; and one labourer dismissed the Great Exhibition as an insult to his kind:

> The events of this year must have demonstrated to the working classes that neither the upper nor the middle orders are inclined to elevate their inferiors in social position, the thousands and tens of thousands of hard working, industrious mechanics and labourers, who perform their duties faithfully and honestly towards society, are in return recognised as human machines in the hands of hereditary tyrants, for the production of necessaries and luxuries: or by capitalists to add to their accumulated wealth.[12]

The invisible influence that subdued everything it touched, both in the great glass palace and its proletarian Trianon, wasn't ancestral piety, nor social station, not magic or manners, or the result of Marx's new 'social relations'. It wasn't, they knew, wonder at the uncountable, nor awe at the vast and the complex. It was what Marx and the workers had said it was. It was Money.

Mr Roberts had thought of everything, but he hadn't thought of that. Soon after his model cottage was moved to Kennington, he left suddenly for Italy; and while he continued to be involved from a distance, his post of

Honorary Architect to the SICLC was quietly removed. At the time, everyone was too polite to say why.

It only came out much later when his nephew indiscreetly repeated an old family story. While Henry Roberts was building the model cottage, he whispered, he had 'enjoyed an indiscreet liaison with a member of the lower orders'.[13]

Roberts had encountered a member of the labouring classes he could not improve: a person, rather than a passive object of charity, a cog in a machine, a commodity on the market. It ruined him.

A Crystal Palace

MR SALTEENA HAD DARK SHORT HAIR AND MUSTACHE AND wiskers which were very black and twisty. He was middle sized and he had very pale blue eyes. He had a pale brown suit but on Sundays he had a black one and he had a topper every day as he thorght it more becoming.[1]

Mr Salteena was, like Henry Roberts, or Bendigo Butler, George Jennings, Simon Sparks, or Joseph Paxton before him, 'not quite a gentleman but you would hardly notice it but it can't be helped anyhow'[2] and one day in the 1890s he went to see his friend Bernard, who was. He had a favour to ask:

You can help me perhaps to be more like a gentleman said Mr Salteena getting rarther hot I am quite alright as they say but I would like to be the real thing can it be done he added slapping his knees.

I dont quite know said Bernard it might take a good time.

Might it said Mr S. but I would slave for years if need be. Bernard scratched his head. Why dont you try the Crystal Pallace he asked several peaple Earls and even dukes have privite compartments there.[3]

It was a delightful, childish conceit; and in his introduction to the literary sensation of 1919, *The Young Visiters*, J.M. Barrie was indulgent to its author, Daisy Ashford, for she had been a child of nine when she had written it, twenty years before. It wasn't just the spelling that Barrie was prepared to forgive, or the Victorian snobbery. The young Miss Ashford had never been to the Crystal Palace, he was sure, and she had certainly mixed it up with Hampton Court or some other proper palace. No matter: the author of Peter Pan wasn't averse to a little childish fantasy himself.

But Daisy Ashford was not mistaken, for the palace had not dissolved after the toll of the bell on 11 October 1851; and when Mr Salteena arrived there forty years later, he was greeted by footmen in gold braid, a pretty crystal fountain, and a door marked 'to the private compartments'.

Ah ha said Mr Salteena to himself this is evidently my next move, and he gently pushed open the door straitening his top hat as he did so. Inside he found himself in a dimly lit passage with a thick and handsom carpet. Mr Salteena gazed round and beheld in the gloom a very superier gentleman in full evening dress who was reading a newspaper and warming his hands on the hot water pipes. Mr Salteena advanced on tiptoe and coughed gently as so far the gentleman had paid no attention. However at the second cough he raised his eyes in a weary fashion. do you want anything he asked in a most noble voice ... my name happens to be

> Edward Procurio. I am half italian and I am the Groom of the
> Chambers.
>
> What chambers asked Mr Salteena blinking his eyes.
>
> These said Edward Procurio waving a thin arm.[4]

'These' had been built to replace the exhibits of 1851. Where industrialists had once exhibited their materials, manufactures, and machines, there was now a series of chambers, each built in honour of some other vanished palace. There were Assyrian and Egyptian courts, complete with seated pharaohs, a Pompeiian atrium and a marble room from Byzantium, an Alhambra, a medieval hall, a Renaissance cabinet, and French salons. No wonder Mr Salteena crept, on tiptoe, up to the last door, which was labelled with the words 'Clincham, Earl of' in big letters.

> You see these compartments are the haunts of the Aristockracy
> said the earl and they are kept going by peaple who have got some-
> thing funny in their family and who want to be less mere if you can
> comprehend.
>
> Indeed I can said Mr Salteena.
>
> Personally I am a bit parshial to mere people said his Lordship
> but the point is that we charge a goodly sum for our training here
> but however if you cant pay you need not join.
>
> I can and will proclaimed Mr Salteena and he placed a £10 note
> on the desk. His Lordship slipped it in his trouser pocket. It will
> be £42 before I have done with you he said but you can pay me here
> and there as convenient.[5]

The 'aristockracy' didn't live there; but Daisy Ashford was right about the Crystal Palace in one respect, for the reason that it was open to Mr Salteena

and the other members of his class, was that all its courts were for sale, or, at least, for hire: 'You may enjoy an unrivalled prospect from the grand saloon dining room,' read the 1870 brochure:

Fountains spurt silvery streams, and indigo tints from summer nights are lit up by the firework festivals galleries. The price of dinner is from five shillings to four guineas. A second class dinner for humbler customers is twenty pence, a third class one, beer included, being half that amount.[6]

The Great Exhibition of 1851 had been just that, an exhibition. No prices were affixed to anything. It would not be proper, it was thought, to sully so edifying a spectacle with trade.

But two days after the bells tolled on 11 October, its doors had opened one last time – this time exclusively to the exhibitors themselves. By lunchtime 'the building resembled a bazaar, so brisk and general was the trade going on'[7], wrote the correspondent from *The Express*; and within a month, almost everything had been sold. Queen Victoria, making one last visit, noted in her diary: 'the English side is almost entirely empty ... the beauty of the building with the sun shining through it was never seen to greater advantage. One cannot bear to think of its all coming down.'[8]

For once its contents had been sold, the cabinet itself became the greatest of all its curiosities; and like all the rest of them, it was put up for sale.

When we saw the auctioneer's placards desecrating or rather staining the glass of the great exhibition building, we felt a sort of curdling of the blood – a kind of figurative conversion of it into cold cream – at the idea of our pet palace being besieged by the

broadsides of the billsticker. When we observed the word materials in gigantic letters, announced to be knocked down by the hammer of the auctioneer, we thought the public were ninny-hammers themselves for not protesting against the sad sacrifice.[9]

'People of England,' *Punch* continued, 'swear yourselves into your selves – as special constables to preserve this Crystal Palace;'[10] and Joseph Paxton, as astute as ever, was already raising the funds to purchase the building. A month later, on 18 May 1852, 5,000 shares of £5 each were floated in the newly formed Crystal Palace Company; and in May it bought the building for £75,000.

But the palace couldn't stay in Hyde Park, and just as they had in the beginning, the railways rode to the rescue. The chairman of the London to Brighton Railway had an estate on the southern fringes of London, and a deal was done by which his land would be made over to the Crystal Palace Company at a reduced price, provided that he could monopolize transport to it from the capital. The railway company would transport the components of the palace out to Penge, where Fox and Henderson would rebuild it for £120,000.

That was the plan presented to the investors, but by the time Queen Victoria reopened the resurrected palace in 1854, the cost of the enterprise had spiralled to £1.3 million, and the Crystal Palace Company was in massive debt.

It haunted them. In 1866 the north transept of the palace burned down, and since the company had not been able to afford insurance, it was never reconstructed. By 1877 the financial situation was so serious that a meeting was held at Mansion House to discuss its future. Two years later, a public enquiry found the palace in poor repair: quite simply there had not been enough money to carry out the necessary works. The

company went bust in 1911, and was only saved by public subscription.

The Crystal Palace, you see, had only one source of income – the visitors who flocked to it to savour, like Mr Salteena, for a few hours, the pleasures of a palace. The only possible way of attracting them, and thereby turning a profit, was to provide them with atria ever more palatial, halls more royal, cabinets more curious, and apartments more enchanted. As the *Weekly Record of the Temperance Movement* explained:

> We are not talking of Buckingham or St James'. They are not holiday places; not of Windsor, nor Hampton Court, though they are. It is with our palace just now we have to do – yours and mine ... a dream comes the nearest to it ... we defy you to do anything for the first half hour, but give yourself up to the willing enchantment, the most delicious bewilderment, the fullness of gratification ... the light, the space, the sound, the knowledge of vastness, the consciousness of height and breadth and room and variety, are in themselves a joy ...[11]

The financial demise of the Crystal Palace may be inversely measured in the splendour of its interiors. There was, from the beginning, an amphitheatre for music; but it was soon joined by a gaiety theatre, a jungle filled with dinosaurs, a fairy archipelago, Maxim's flying machine and a panorama of Paris. In 1911, the very year the company went bust, a Festival of Empire was held, to which each colony contributed a miniature model of its own imperial palace. During the Great War it was turned over to the navy as HMS *Crystal Palace*. Afterwards, the great glass ship docked as the Imperial War Museum, in which captured enemy aircraft were hung up among the traceries of the Gothic court.

Three years before the opening of the Great Exhibition, Karl Marx's

Manifesto of the Communist Party had launched a critique that the Crystal Palace, for all its wonders, was never to answer. The bourgeoisie, he wrote:

> ... has put an end to all feudal, patriarchal, idyllic relations. It has pitilessly torn asunder the motley feudal ties that bound man to his 'natural superiors', and has left remaining no other nexus between man and man than naked self-interest, than callous 'cash payment' ...[12]

And for that, he found a metaphor in the great glass palace. 'Money is a crystal', he wrote in *Das Kapital*, 'formed of necessity in the course of the exchanges, whereby different products of labour are practically equated to one another and thus by practice converted into commodities.'[13]

And the palace had witnessed that crystallization time and again. Mr Salteena went to the Crystal Palace to purchase 'aristockracy' for a tenner. Simon Sparks had stolen the Koh-i-noor only to find that, on the market, the most precious crystal in the world was valueless. Henry Roberts had turned home itself into a vitreous commodity, and even excrement had been smeared by the Crystal Palace with a monetary metaphor.

The interiors of the Crystal Palace were subdued, as they had always been, by the invisible influence that Charlotte Brontë had observed in 1851. Like a night in a hotel bedroom, or a product in a department store, they were commodities; and they could not escape the inexorable law of depreciation. The last event that took place there, in November 1936, was a dog show. By then the palace had become, as Ruskin had always said it was, a gigantic glass house, nothing more. Marx had already prophesied its necessary end; and on 30 November 1936, it's exactly what happened. The place dissolved into air. No-one knows how the fire started. It burned for several days, and once it was over, the ruins were melted down or sold for scrap.

Crystal Palace is still a place. Take the new overground, and you'll arrive at a Victorian railway station, incongruously grand for so remote a suburb. Walk up into the park and you'll find granite sphinxes, enormous flights of steps that lead nowhere and a couple of headless statues. In the bushes there's a little museum, run by volunteers. They don't have much money, and everything they have to exhibit is worthless, in monetary terms anyway. There are a few china souvenirs, a broken plate, a piece of handrail, an iron socket, a tile from the Alhambra court and a piece of plaster.

And there is, of course, a lump of glass molten in the flames, a fragment of shattered crystal, and, fused together by the heat of the fire, recovered from a burning vending machine, a couple of spent pennies.

IMAGES

A Palace in Your Front Room
Watching the Coronation in 1953.

A Screen

AROUND ONCE A WEEK, I GIVE GRANNY A CALL. IT'S NEVER EASY TO
slip into conversation: she picks up the phone breathless, surprised by the
intrusion, fumbling and confused. I'm usually walking home from work
past thundering lorries and buses; and I end up shouting down the line. So
does she. Neither of us can really hear one another.

As we talk, I imagine her sitting in her sitting room, enthroned at the
heart of all that the modern media have to offer. Her chair faces the tele-
vision. To her left, an occasional table supports the phone. To her right a
radio, permanently tuned to Radio 4, perches on top of a bureau. When
opened, the bureau spills forth a lifetime of the photographs and telegrams
with which we mechanically mark births, marriages, and deaths.

Among those telegrams is a message dated February 1941. It reads,
simply, 'Anything but Scarlett' and it always makes Granny smile. That
year, the year of the Blitz, she gave birth to her first child. Like many first-
time mothers, my grandmother was ill prepared. She had just moved into
a new house, she couldn't cook – apart from blancmange, she recalls – and

the only sewing she knew how to do was elaborate dressmaking. When Granny got home from the hospital, she received a telegram telling her that her husband was missing in action.

But as my grandmother always reminds us, It Was The War and she was going to have to Get On With It. Just before the baby was born, she went, undeterred by pregnancy or the Blitz, to the Palace Cinema in Harrow-on-the-Hill to watch *Gone with the Wind*; and there was one scene that she still savours, in which Scarlett O' Hara tears down the curtains in her parlour to make a dress. Walking out of the cinema, impressed by the resourcefulness, pluck, and, yes, vanity, of her new heroine, Granny decided to call her child, if it was a girl, Scarlett.

When the baby arrived, its name was telegraphed into the abyss of the War. My grandfather, who was less missing than in action in the siege of Tobruk, had been too busy to watch *Gone with the Wind* and was in quite a different mood: 'Anything But Scarlett', he replied, 'V for Victoria.' And so Auntie Vicky received her name by telegraphic command.

The draperies of Tara were just one among many phantoms that were projected onto the wall of the Palace Cinema in that year of blackout. They issued from what was then, as now, called the Dream Factory. Inside great sheds in distant Los Angeles, settings from the antebellum South to the Emerald City were conjured from pasteboard, paint, canvas, and light for the duration of a shoot. Despite its industrial appearance, Studio City was a palace to rival the grandest of them. Like the Palatine it was generated by, and was the generator of myths, from *Gone with the Wind* to *The Wizard of Oz*. Like Westminster, it was a scene of repeated rearrangement, as interiors were fabricated and then struck down the moment they had been committed to film. Like the showplaces of the *Ancien Régime*, it was the residence of semi-divine personages: to this day, you will still be shown the studio school in which the child stars of Metro Goldwyn Mayer were

groomed for adult radiance. Like a great exposition, or a department store, Studio City was a factory of mass-produced desire.

Thousands of miles might have separated my grandmother from the sound stages of Hollywood; but as the film rolled in the darkness they were, for a moment, separated and connected by nothing more than a flickering, filmy curtain, a veil at times transparent, at times opaque: a screen.

Screens are everywhere now. In *The Ecstasy of Communication*, the philosopher Jean Baudrillard described contemporary space as composed of 'Great screens on which are reflected atoms, particles, molecules in motion. Not a public space but gigantic spaces of circulation, ventilation and ephemeral connections.'[1]

The silver screen that hung in the proscenium arch of the Palace Cinema in 1941 might have had its own roots in the *tentures* of the theatre, but it has since wormed its way into every room we inhabit: taking its place in the 1950s parlour encased in The Box, and in the twenty-first-century teenage bedroom as a games console. The contemporary interior does not exist until it is turned on and tuned in.

Screens are everywhere now, and nowhere. Granny goes to bed early when I'm staying with her, and after she has gone upstairs, I turn the TV down and take my iPhone out of my pocket to check for Wi-Fi. My grandmother is, of course, innocent to the pleasures of the Web, but the Doll's House is close enough to its neighbours for me to be able to piggyback into their clouds. They are rooms of which, although she lives in them, Granny is more or less unaware.

And then I'm in: racing through a great exhibition, down hundreds of glassy galleries, rummaging through thousands of cabinets, and millions of curiosities. In the world outside, all that is solid has melted into air, commodity, and number. Inside the computer, the process is alchemically reversed, and number becomes matter. Just as Ramus once hoped, ones and

zeros fire out their machine code and silicon, solder, copper, cathode ray, and liquid crystal congeal into imagined, imaginary spaces, and, moments later, dissolve again.

I'm in a memory palace to dwarf all memory palaces, crowded with caverns and halls that appear and vanish in seconds. I have no idea where it is, or where it is coming from, other than that it resides in the screens that surround me. I have no idea whether this memory palace is real or not, for the screen elides fact and fantasy. Memory has become something we delegate to machines, and keep in cabinets of plastic and silicon, somewhere else.

I'm sitting in Granny's chair, surfing the Web, watching the telly, and checking my phone. Granny hasn't gone to sleep, I can tell, since the sound of the television she has next to her bed thunders through the floor. She's watching the same programme as I am, and the sitting room of the Doll's House is filled with a strange stereo as the two sets resonate, nanoseconds apart. The curiosities in the cabinet and the icons by the hearth rattle slightly, as millions of artificial memories vibrate invisibly through them.

A Curtain

UNDER THE ARC LIGHTS, SHE BREATHES INTO A MICROPHONE, AND the drawl of a southern belle is spiked with the clipped consonants of a real lady. 'I've spent a good deal of my time on Peachtree Street this year', she whispers, 'and now that I'm here it feels just as if I were coming home.'[1]

On the evening of 13 December 1939, Vivien Leigh has been joined by 2,000 others at the Loew's Grand Theater in Atlanta. The facade has been framed with white columns for the occasion; and once she has spoken, the film star walks through them into a vanished world. Marble piers frame maple marquetry, depicting the virtues, the arts, the sciences, and the seasons; and as she ascends the shallow stair, her hand trails over balusters wrought in the form of magnolias. Fluted pilasters rise into a room frantic with the spikes and triangles of deco decor; and in the gloom overhead hangs the crystalline moon of a chandelier.

The Loew's Grand hadn't been built as a cinema. In 1893, Laurent de Give, a Belgian émigré, had opened the Grand Opera House to bring a little

European glamour to Atlanta; and the gilded proscenium arch was hung with heavy velvet portières. Thirty years later, the opera house was converted by the architect Thomas W. Lamb into a picture palace, and the auditorium was lined with a decor more suited to the silvery fantasies of the screen.

Vivien Leigh takes her seat of scarlet velvet, and settles down to face the tasselled curtain where once the stage had been. As the lights go down, it is drawn aside to reveal another one, quite at odds with the richness of the rest of the room. It is completely blank.

An unseen orchestra begins to play, and as it does, the white screen dissolves into Technicolor, and the frame is filled with a vision 'no more', say the credits, 'than a dream remembered, a civilization, gone with the wind'.[2]

* * *

An hour later, she hasn't moved from her seat, she's still watching, and at the same time she's somewhere else entirely.

She's lost everything, you see: Ma, Pa, a husband, and now the Yankees have turned up demanding money – 300 dollars – and if she can't find it, she's going to lose Tara, the beautiful house her parents built, her birth-right and her home.

The walls of Ma's parlour are washed with wintry grey, and their calm panelling frames the gilded frame around Ma's picture. She absently fingers the golden tassels fringing the green velvet portières, as she gazes at the view that is framed by the window they frame.

The fields are dry, and the windows have been smashed. The velvet of the portières is faded, and the walls against which they hang are stained with damp and dirty blurs where, once upon a time, other pictures hung. Ma's portrait has been defaced, and the console tables are cluttered with

broken pottery and guttering candles. The fire is dead in the grate.

Mammy the house slave lays her great black hand on the fragile white shoulder: 'You been brave so long, Miss Scarlett. You jes' gotter go on bein' brave. Think 'bout yo' Pa like he useter be.'

'I can't think about Pa,' she snaps, 'I can't think about anything but that 300 dollars!' and Scarlett moves away from the window and walks, wretchedly, across the room.

'Ain's no good thinkin' 'bout dat, Miss Scarlett. Ain' nobody got dat much money ... Nobody but Yankees and Scalawags got dat much money now!'[3]

That may be, but Scarlett is still Scarlett. She needs that money if she's going to save Tara, and as God is her witness, she'll lie and cheat and steal to get it, if she needs to. Her eyes widen, and her lips part; but when she speaks, her voice is low and quite matter-of-fact:

'Rhett.'

And cut.

To the pierglass opposite the windows, in whose surface, hideously cracked, Scarlett surveys her own broken form. 'I'm so thin and so pale, Mammy,' she sighs, 'and I haven't got any clothes!' And then her eyes, and ours, refocus on the gloomy green blur behind her. 'Scoot up to the attic', she orders, 'and get Ma's old box of dress patterns.'

'Whut you up ter wid Miss Ellen's po'teers?'

'You're going to make me a new dress.'

'Not outta Miss Ellen's po'teers! Not while Ah got bref in mah body!'

'Great balls of fire! They're my portières now!', cries Scarlett; and she jerks down the curtains, pole and all; drapes the material over her shoulder; turns back to Mammy. 'I'm going to Atlanta for that 300 dollars', she laughs, 'and I've got to go looking like a queen!'[4]

And there she is, back on Peachtree Street, swathed in green velvet

and golden tassels in order to seduce Rhett Butler into giving her the 300 dollars. Scarlett O'Hara has gone to Atlanta to save Ma's parlour, and in order to do so, she's wearing it.

* * *

Since the 1980s that dress has been kept under carefully controlled conditions at the Harry Ransom Center at the University of Texas. It is undergoing restoration, and it's a painstaking process, for its conservators must not only unravel the damage that time has done to the garment, but also unpick the circumstances of its making. 'Complete restoration', say the restorers, 'would effectively erase the historical context of the creation.'[5]

Of course it would, for a complete restoration would require the transformation of the dress into a pair of curtains, and that would entail the loss of a wonderful story. There's something theatrical about it: the long gothic sleeves, the jaunty cap, and the Lincoln green of the velvet recall Robin Hood stealing from the rich to give to the poor – which is of course, exactly what Scarlett made it to do. There's something slightly absurd about it too: the use of golden tassels as fringes and tiebacks as a belt remind one perhaps a little too insistently that once upon a time the garment had been pelmet and portière.

The parlour from which it has been taken was just as theatrical; and was telling its story long before Scarlett ripped it to pieces. Before the War, Ma used it for family prayers, and the velvet curtains were rich green, their tassels shining with gold. The walls were smooth and pale, and hung with smart landscapes. The pierglass stood between the windows, reflecting the light of a sparkling candelabrum back into the elegant room.

But when Scarlett returned from Atlanta they'd used the room to lay out Ma's body. The light was dim and the decor dirty grey, stained where

the Yankees had torn the paintings from their gilded frames. The portières were faded and dusty, their elegance exhausted.

By the time Scarlett takes the curtains down the pictures have been rehung and the furniture rearranged in a shabby effort at gentility. The light is dull and flat, but the portières are slightly brighter, a little more tempting than before. The next time we see it, the parlour has turned into a dress, and disappeared.

* * *

It was never there in the first place.

'It's a puzzle …',[6] say the conservators in Texas, and well it might be: it's one thing to restore something that existed once upon a time, quite another to restore something that never was. The dress was donated to the Center as part of the archive of the Hollywood producer David O. Selznick, whose dream factory at Studio City produced the movie of *Gone with the Wind* in 1939.

Selznick was simultaneously inexperienced, capricious, and indecisive; he was also, disastrously for his crew, a perfectionist. The shooting of *Gone with the Wind* is a well-documented catastrophe that devoured three directors, countless scriptwriters, and scripts, and, in preparation, hundreds of Scarlett O'Haras.

Only the storyboard, compiled by the production designer William Cameron Menzies, remained constant. Menzies drew quickly and fluidly from shot to shot, assembling an epic in snatched glimpses of parlour and portière; and from his 3,000 vignettes, the production team were expected to construct an entire civilization gone with the wind, in ninety rooms.

Adherence to Menzies' vision was an article of faith, and in January 1939, a couple of weeks after filming began, Selznick had already sent a furious memo to his crew: 'our sets always look exactly what they are,' he

fulminated, 'sets that have been put up a few hours before, rather instead of seeming in their ageing and dressing, rooms that have been lived in.'[7]

The crew took note, and three months later, by the time they shot Scarlett tearing down the portières, Ma's Parlour had been repainted, refurnished, relit, and redrawn enough to feel like a room that had been lived in for years.

It was the result of an extraordinary attention to detail. The bleaching of the green velvet of the dress is not the result of hanging in a window in the antebellum southern sun, nor of decades of decay. It is a chemical effect, deliberately applied in 1939, when the garment was made by the Hollywood costume designer Walter Plunkett.

* * *

Ma's parlour was only there for an hour or two, in the end. The shooting schedule for *Gone with the Wind* was so dense that sets were taken down the moment any scene had been committed to film. In fact, the whole project began with the destruction of a host of them. In order to clear his backlot for the construction of Tara, Selznick burned down the Jerusalem of Cecil B. de Mille's *King of Kings* and the Manhattan of *King Kong*. Their destruction appears in the film as the Yankee sack of Atlanta.

All of the interiors of Tara had disappeared by the time they appeared on screen at the Loew's Grand in Atlanta; but even if you had made it to Studio City in time to watch them filming it, you wouldn't have found what you were looking for.

The interiors of Tara didn't occupy some antebellum mansion, but had been manufactured room by room in a shed, on stage 12 in the Culver City Studios in Los Angeles. The sheds of the dream factory offered what real life could not: complete control over light, space, people, and sound. The oldest of them dated back only to the 1920s, and they were built of glass

to admit the reliable Californian sunshine, and lined with muslin to diffuse it. But by 1939 the glass had been smashed and the muslin torn, and most of them had been replaced by artificially-lit spaces: blank canvasses upon which any dream could be remembered. Since that spring in 1939, stage 12 has been washed clean by countless fictional interiors, from Manderley in Hitchcock's *Rebecca* to the spaceship in *Galaxy Quest*.

The parlour itself, such as it was, possessed no ceiling, since the construction of one would have interfered with the rigs needed to light the scene properly. The walls were canvas, stretched over timber boards twelve feet tall, which was the maximum height the lights could wash. They were placed at crazy angles to one another so that the room would look larger through the lens, and also so that the pier glass in which Scarlett espies her future would reflect only herself and the portières, rather than the assembled crowds of the film crew. The window didn't look out through curtains at some southern plantation, but at a painting of one, hung on a curtain rail. Tara, the house the room was destroyed to save, was an empty plywood carcase thrown up outside, overlooking the ashen remains of Jerusalem and Manhattan.

After the wrap, no-one knew what to do with it. It mouldered away until it was sold in 1959 to Southern Attractions Incorporated, whose intention was, curiously, to return it to its fictional home in Jonesboro County, Georgia.

The house, or what was left of it, was packed away into crates and rail-roaded east, but Tara was never re-erected. Most of it is stacked away in a barn in the estate of the late Betty Talmadge, who bought it from Southern Attractions in 1979. In 1990, she had the old front door taken out and set up for a party for Jane Fonda and Ted Turner. It's now in the Atlanta History Center, although there's nothing about it, other than a fiction, that relates it to the history of that city.

Betty Talmadge died in 2005, but just before her death, she gave some fragments of the house to a neighbour of hers, a Mrs K.C. Bassham, who ran an inn in Concord. Mrs Bassham set a door and shutter up in her bed-and-breakfast; but she was mercenary about the rest of it. The set was so deteriorated, she claimed, that the best thing to do with it was to cut it up into pieces and sell them on for cash, along with certificates of authenticity. Scarlett O'Hara herself would have approved.

David O. Selznick certainly wouldn't have minded. When he got the set off his hands (and off his backlot) in 1959, he commented: 'Nothing in Hollywood is permanent. Once photographed, life here is ended. It is almost symbolic of Hollywood. Tara had no rooms inside. It was just a facade. So much of Hollywood is a facade.'[8]

Or a picture. William Cameron Menzies' storyboard didn't just dictate the design of the sets for *Gone with the Wind*, but also the ways in which the camera was going to see them: following Scarlett's meander from door to window in one lazy pan, the dramatic cut on the word 'Rhett' and the frenzied to and fro as she races to the curtains to tear them down, and back to the mirror to survey herself, draped in green velvet. The place where Ma's parlour still survives is the only place it ever existed: on screen.

Scarlett, and her portières, and her parlour and her home had been hastily contrived, erected and painted in days, dressed and lit in hours, filmed in minutes, printed on plastic, and spliced together in seconds. They are all gone. They never were. But set spinning in front of a bright light in a darkened room, projected onto a white sheet, they turned into rooms that had been lived in, that had lives of their own.

* * *

By the end of the night the film has finished, the lights have come up, and the velvet curtain has fallen over the white one. Within three days Vivien

Leigh has flown back to Hollywood. Within a week, they're taking down the plantation portico they'd erected over the front door of the Loew's Grand.

Within forty years the cinema is gone. No-one was going to the pictures by the time it stopped showing movies in 1977; and it was declared an historic monument in the same year – not least because the premiere of *Gone with the Wind* had taken place there. The next year the Loew's Grand burned down. Many suspected arson: no-one wants to be stuck with a monument to a story that never happened.

In the photos taken after the fire, daylight obtrudes into the dark heart of the cinema. It might have been beautiful in the correct lighting, but it was shabby in the sun. Here and there, Thomas W. Lamb's film of decor has fallen away, exposing the baroque architecture of the opera house that it had been built to conceal.

As soon as it had been committed to film, it was demolished. It was only ever a picture palace, after all, a monument to dreams remembered, and civilizations gone with the wind.

A Box

'THERE IS A SECRET HERE,' SHE WROTE, BUT 'WHAT THAT SECRET was, I could not say. No doubt it was the primitive and magical feeling which ancient and beautiful ceremonials still evoke, in no matter how rational a breast. That tiny golden figurine was the point of light under a vast burning glass: the vision of an uncounted multitude was narrowed down to this.'[1]

Margaret Lane, writing in the pages of *Esquire*, wasn't the only one to feel it: everyone felt it. First, the hundreds of peers gathered around the tiny golden figure on the throne, then the thousands of worthies sitting on the other side of the choir screen in Westminster Abbey. Then, at a signal given, the great guns at the Tower of London were fired; and the three million people standing in the streets of the city added their acclamations.

But on 2 June 1953, most people stayed at home, inside, with the curtains drawn.

'I was playing outside on a sunny day', recalls one, 'until my mother called me in and said: "This is history, come and see the Queen being

crowned." There must have been about twenty people crowded into this small room waiting for the moment.'[2] 'I was eight years old,' says another, 'the room was darkened to improve the picture. The adults sipped sherry. I didn't like the smell. I wanted to go to the beach.'[3]

For staying indoors that day, drawing the curtains and watching television wasn't an act of apathy or protest. 'Put an H-aerial up over your house', wrote one commentator, 'and you will be astonished to find how many friends you have in the street.'[4] 20.4 million people watched the coronation on 2.7 million sets – that's an average of ten people per set. Some 7.8 million people watched in their own homes, but 10.4 million watched in other people's front rooms. A further 1.5 million watched in public, in cinemas, halls, and pubs.

By five o'clock 'The Greatest Day in the History of Television'[5] was over. The children were shooed outside to play, or sent upstairs to bed. Curtains were opened, armchairs and sofas were returned to their traditional positions around the fire, and ornaments were rearranged on mantelpieces. The television ceased to be a great burning glass, and became a box, a piece of furniture like any other.

The most popular model, the Bush TV22, released in 1949, was deliberately designed to appear that way. The silvery trumpet of the cathode ray tube was concealed in a box of Bakelite, stippled to resemble deal or oak, and styled in nostalgic thirties deco rather than the spiky lightness of the atomic age. Dumpy dials reassured rather than dazzled the tremulous hand.

Most sets were similarly conceived to mitigate, rather than to celebrate, the technological wonder of television. The Invicta T102BL was available in walnut or mahogany veneer. The Ecko TSC48 had been designed to resemble a pre-war gramophone. The screen was concealed inside a tall maple cabinet, and, like the head of a gorgon, it could only be

viewed obliquely, through a mirror set into the open lid. On the day of the coronation, one child remembers a television with 'a large magnifying glass fitted over the screen'[6] so that everyone could see it.

And like any precious piece of furniture, the television was kept in the front room. One child of 1953 recalls: 'we all sat in grandma's "Front Room", which was normally only used on Sundays – I've no idea why.'[7] Television was still, on Coronation day, kept for the chilly, awkward 'best' of the parlour rather than for the banter of the kitchen, or the sweet nothings of the bedroom. The presenter Sylvia Walters wore evening dress all day, and some of her colleagues thanked viewers for inviting them into their homes.

'It was the longest, most boring day of my life,'[8] wrote another child of the time. Afternoons spent in Sunday best in the front room usually were; but now conversation was killed stone dead by the box in the corner. One early viewer complained: 'Everywhere you go you have to out-talk TV. TV people have entered your home and life more than people who should be friends and companions.'[9]

Television was like any other guest invited into the front room: polite, awkward and never quite at home among the more established pieces of furniture. Photographs record the same comedy of manners time and time again: father's chair and the sofa are arranged around the fireplace, the ancient focus of the parlour, but the attention of the family is fixed elsewhere. The adults twist their bodies uncomfortably in their upholstered vantage points, and inevitably, the children sit on the floor. The object of their gaze lurks to one side of the mantelpiece, not quite sure whether, or where, to stand or sit.

The television had, apparently, impeccable manners, but like all guests, it soon began to make itself at home. In *Television: The Medium and its Manners*, Peter Conrad later observed:

Granting it entry into our houses as furniture, we've allowed it to take over those houses. In the 1950s a fan of the CBS *Today* show demolished a wall between his breakfast area and his living room so he could watch the programme before leaving for work. Other devotees, in those days before a household could afford a set for each room, rigged up arrangements of mirrors so that they could see round corners.[10]

Once upon a time, the front room had always been set aside for best; but once the television moved in, it was used more and more regularly for informal as well as formal family time, and the distinction between the front and the back of the house began to blur. It was not long before the wall that divided them, the last redoubt of ancient distinctions between public propriety and private intimacy, would be ripped down. The irruption of the television into the home was its cause.

* * *

As the greatest day in the history of television came to a close, feelings were equally ambivalent at the other end of the cathode ray tube, behind the choir screen in Westminster Abbey. As the royal cavalcade pulled away and the cameras stopped rolling, the Duke of Norfolk, who had been in charge of the whole affair, turned to Richard Dimbleby, the BBC commentator, and commented wryly: 'From all I hear, it was a marvellous occasion.'[11] He was acutely aware that the millions of ordinary people sitting at home had had a much better view of it than he had.

Norfolk had been against the idea of televising the coronation. He wasn't against cameras following the Queen in procession through London: George VI had been filmed on the way to both his coronation and his state funeral, as had the Princess Elizabeth on the way to her wedding; but on

none of these occasions had the eye of the camera ever penetrated behind the screen, into the inner sanctum of Westminster Abbey. Winston Churchill was wary of letting daylight shine upon the mystery of monarchy; and the Queen Mother was convinced that the cameras and the harsh lights of television would place an undue strain on her daughter, still a vulnerable young woman. They all feared, however dimly, that the television would steal the soul – in this case not just of an individual, but of the body politic itself.

The BBC believed, in the words of Peter Dimmock, the producer assigned to the event, that 'we could be trusted and we also knew it would be an enormous disappointment to the nation NOT to see the Queen crowned live at that moment',[12] and they said so again and again.

The BBC might not have had had the palace on their side, but they did have all the resources of the modern media; and when ordered to announce that the coronation would not be televised, they worded the statement carefully: 'The Queen', it was announced, 'has, *on the advice of her counsellors* [author's emphasis], decided to prohibit filming within the abbey.' The innocuous subclause had exactly the desired effect. Press and people assumed that the monarch had been traduced, and a wider campaign was mounted to televise the coronation. It succeeded.

But once their cameras had been admitted to the hallowed precincts the BBC found that there was still much etiquette to be agreed upon, for like the box in the front room, they were there as guests, on sufferance only.

On the Saturday before the coronation, a full dress rehearsal was held in the abbey; and the Duchess of Norfolk acted as the Queen. The television cameras were permitted to rehearse their own filming as well; but their recording was, on the orders of the palace, instantly destroyed, lest an ersatz vision of the sacred event ever usurp the real thing.

Only four cameras were allowed inside the church itself on the great

day, and they were required to be invisible. The camera closest to the throne was hidden behind the balustrade in the choir loft, draped in black velvet, and allowed only to peep through a hole made in the tracery. The cameraman Budd Flanagan was especially chosen for his small size, and in addition, was required to wear white tie and tails so that even if he were spotted, his diminutive person would blend into the aristocratic crowd.

The palace would, the BBC knew, be placated by the mellifluous, reverent and Churchillian tones of Richard Dimbleby, whose commentary made television seem as integral to royal ritual as Westminster Abbey itself:

> So, to that stirring music, majesty, music and splendour fade from our sight ... as the Queen goes in her lovely robe out of the nave of the Abbey. History has been written and sung here today, in this worn and beautiful old building where it has been written and sung for many hundreds of years; but never before have so many seen the crowning of the sovereign, or so many shared in her dedication in this abbey church which, in its many forms, has sheltered the crowning of our kings and queens for nigh on a thousand years.[13]

Just as the television set insinuated its way into the front room disguised as a piece of furniture, a hesitant guest, so the television camera wormed its way into the inner sanctum of Westminster Abbey with head bowed and forelock tugged, uttering reassuring platitudes, veiled in black velvet, and wearing white tie and tails.

But just like the box, it could not resist outstaying its welcome. It was forbidden to film the Queen's face too closely, but as she left her coronation in procession, she came closer and closer to the camera mounted over the west door – closer by far than the letters of protocol allowed. The cameramen and producers stood and debated whether to stop rolling – and

allowed their discussion to continue just long enough to get the shot they desired.

It was a momentary and microscopic breach of etiquette, but it was a prophetic one. Thirty years later, Peter Conrad described a diplomatic incident in the White House:

> The cameras are forbidden to show the monarch eating, and the American networks had to interrupt their coverage of the Washington banquet for the Queen in 1976 while food was being consumed ... but the media devised an adroit reprisal. If eating couldn't be shown, then the preparation of the food could be, and one of the networks retained Jean Marsh, the parlour maid from *Upstairs Downstairs* to describe it ... upstairs the toffs were gourmandising; television's place, which it confirmed with a vengeance when it engaged Jean Marsh, was downstairs, among the disrespectful scullions.[14]

On 2 June 1953, the monarch in her sanctuary and her people in their front rooms shared, for an hour or two, a magical intangible interior, and touched one another through a screen flickering with wonderful, shimmering, invisible cathode rays. Once the picture faded from sight, the box became a box, the room a room, and the abbey an old, grey, abbey, nothing more.

Television might have seemed, on that day, a well-mannered guest, a mere eye observing, a mere picture showing, a blank or transparent screen; but the box was never just a box, and neither, once the cathode rays had punctured them, could the front room and the sanctuaries of the state remain so either. In June 1953 an innocuous little square of glass became 'a vast burning-glass'[15] ready to consume the very thing it illuminated.

A House

THEY'RE JUST LIKE YOU AND ME. THERE'S A DJ FROM SOUTH LONDON, Alex the male model, a travel rep, Jade the dental nurse from Bermondsey, Johnny the fireman, Kate the personal trainer from Leicester, an art student from Aberdeen, Sandy the personal shopper from Fife, Spencer and Sunita. They're tall, short, black, white, fat, thin, posh, and rough.

They don't seem like the inhabitants of a palace; but they're living in one. They all gasp when they walk in down the steps, and see it for the first time. Designed by Markus Blee, up to the minute, it's open-plan, with island units and patio doors, and a hot tub. It's decorated in white and orange, and it's furnished with all the latest stuff. We've read about it in the magazines: 'there are plenty of innovations in the house layout and the products to intrigue design professionals and the viewing public alike', they say. The pictures illustrate part of the Italian kitchen 'where socializing is actively encouraged'. Next to it stands the Lem bar stool by Shin and Tomoko Azumi.[1] The rugs that adorn the floor are by Milliken.

It's a great pad; but no-one comes to visit. There's no post, no phone,

no radio, not even a telly. There's nothing to do, either. They bicker and cook and sunbathe, and one day blurs into another until they have no idea when they are, let alone where. Food arrives and waste is removed. The grass in the garden seems to cut itself; the bills are automatically paid, and the temperature and the light are regulated by an unseen hand.

In fact, it's so boring that on day seven Sunita walks out. They chat about her for a while, but she is soon forgotten. A few days later, a new girl, Sophie, appears to replace her. She comes from the world outside, she says, but she has nothing to tell them about it, despite their questions. At least, there's nothing she's allowed to tell them. Perhaps there is no outside.

But something's up. On day sixteen, Alex stumbles into the kitchen-cum-lounge to make a cup of tea, and stops dead. 'Fuck me!' he splutters, and the rest of them, hearing him, troop in to see what he's on about.

It's not a wall exactly, more a cage, a row of bars, dividing the house into two. Five of them are on one side, and five on the other. They stare at one another, blinking, not yet awake. They're fucked if they know what's going on.

For five of them, life goes on as normal. They sleep in the bedroom, and cook in the kitchen, and lounge by the pool. The other five find themselves in the same house, but in a different world. Sleeping on metal bunks, living on basic rations, they are only allowed to wash by showering in the garden, come rain or shine.

And then half the housemates are ordered to act as servants to the other half. No-one thinks it's fair — it's not; and four days later Kate and Spencer, who are confined on separate sides, find a way to swap places. The house doesn't like it, and they are sent back to where they started.

Later the same day, Sandy has had enough. He walks out into the garden and starts to climb the wall. Like Sunita, he disappears without trace; and four days later, the house replaces him. Tim walks in through a

door one sunny afternoon, and behaves as if he knows them and their house already, intimately. Perhaps he has been watching them.

There are no windows in the house. Instead, it is lined with mirrors. The housemates are a vain lot, and they spend a lot of time looking at themselves in them. They know that mirrors see everything; but they also guess that these mirrors do not just reflect back what they see.

'It's amazing to think the whole nation is watching us,'[2] says Kate. She knows that behind the mirrors there are eyes. They belong to television cameras, and the pictures they are taking are broadcast to every house in the country. They are running all the time. There's a television channel that broadcasts them twenty-four hours a day, capturing every tear, every kiss, every sleeping fart.

They struggle with the knowledge. 'No-one can act twenty-four hours a day,'[3] they agree, but they all suspect one another of playing to the cameras. They begin to lose a sense not just of who their housemates really are, but who they are themselves. They not only share their house with eleven other people they've only just met; they share it with millions they will never meet, and despite themselves, they find themselves trying to please them.

They have all been watching each other, after all: there's nowhere private in this house. Nowhere, that is, apart from one little room whose door is locked by a luminescent eye. It's a tiny space, but a grand throne has been crammed into it, facing the only camera in the house the housemates can actually see. Sitting on the throne, they listen as the house speaks to them. They bargain, and plead, and accuse, and confess. No-one else in the house can hear them. The diary room, it's called, because it's where the housemates go to record their intimate thoughts – and to share them with the nation.

All of them leave in the end. Once a week, the house calls one of them,

and that person walks up the stairs to a door which slides opens, and closes behind them, unleashing for a second a mysterious roar. It's a sound about whose import they speculate endlessly, as they wonder who, or what, is waiting for them outside.

The remaining housemates only find out when they find themselves there, walking the gangplank into a storm of flashbulbs and microphones and boos and cheers. By then, the house has done its work. A hundred days of seclusion from the world, exposed at the same time to an unremitting electronic gaze, has changed them. As they wait to leave, Alex and Johnny turn to one another. 'We no longer have faces that will just blend into the crowd,' says Alex, but Johnny reassures, or warns, him: 'we are all just the same people as when we came in – it's out there that's changed.'[4]

It's not true. It's they who have changed. No-one quite believes it, not even the presenter, who tells the crowd to cheer 'the most famous non-famous people'.[5] When she meets them she whispers a secret in their ear – they have been told she will, for it is part of the ritual – 'Don't worry,' she says, 'it's all just a pantomime.' Not even the housemates are convinced, and Jade tells her interviewer: 'I don't call us celebrities – you have to work to be a celebrity, all we've done is be in a house.'[6]

But being in a house is enough; and a few weeks later *Heat* magazine hits the stands sporting a picture of Jade. 'Look at her now,' it yells, 'sporting waist-length hair extensions and with her figure poured into a sexy black dress, the twenty-one-year-old is unrecognizable from the bikini-clad "kebab-bellied" housemate'[7] who was, the magazine seems to be saying, the chrysalis from which the true celebrity has emerged. They are right, and seven years later, Jade dies on television.

Kate is the last to leave, and as she sits there alone, on the sofa in the lounge, she looks at herself in the mirrors for the last time, and they look back, with millions of eyes.

* * *

Big Brother is over for another year. The designer furniture is sold off to relic hunters. The sales of Azumi chairs and Milliken rugs and Meson kitchens will already have shot through the roof thanks to three months of televisual product placement. The house itself is broken down, and discussions begin about how it will be reconfigured for the next series.

In the meantime, all that is left is an armature. There is the backlot itself, in Elstree, somewhere off to the east of London. There is the production suite, which, being behind the scenes, remains unaltered. There is a metal boundary wall, inscrutable, and impenetrable except for the door by which housemates enter and celebrities leave; and inside it there is, of course, the circulation system of power and data that infests everything. The house was never really a house: it was a television studio all along.

It's just like our house. It is fifty years since the screen edged its way, cautiously, into the corner between the sofa and the mantelpiece. Now it is everywhere, and everyone is on screen: in the bedroom, the kitchen, the living room, on CCTV, on home video, on the home computer.

Once upon a time, rooms were secluded from the world; but that time has long gone. The rooms of the nineteenth century were connected to others by networks of plumbing, gas, and, ultimately, electricity. The interiors of the twentieth century – the cinema, or the living room – their enclosures ruptured by the screen, were the passive receptacle for broadcast information. Now the phone, the home computer, the Webcam, and even the television itself allows rooms to transmit, as well to receive.

And that's just what we've done. On the phone, pushing the red button, online, we elect who stays in the Big Brother House and who leaves it. From one room, our own, we have decided what happens to someone else, in another. 'You live in a democracy! Use your vote!' screams the

presenter, and she laughs at the camera, because she knows, just as well as we do, that all we're voting for is the result of a game show.

And then we tune in to watch the results of our decision. The very popularity of the practice alarms our moral guardians, who still quaintly see television as a medium of instruction and improvement rather than of mass participation. Jerome Clement, the head of Arte, a highbrow French TV channel, fulminates:

This programme brings together all sorts of perversity ... it is television which finally created Silvio Berlusconi's power. This type of absolute stupidity means an abandonment of free thought. Political power is replaced by that of the media. It is dangerous for democracy.[8]

And his argument is inadvertently reinforced by the title of the show. Despite the denials of Endemol, the production company, everyone knows where it comes from, for George Orwell's *Nineteen Eighty-Four* begins in a room which, like the Big Brother House, can both broadcast and receive:

The telescreen received and transmitted simultaneously. Any sound that Winston made, above the level of a very low whisper, would be picked up by it, moreover, so long as he remained within the field of vision which the metal plaque commanded, he could be seen as well as heard. There was of course no way of knowing whether you were being watched at any given moment. How often, or on what system, the Thought Police plugged in on any individual wire was guesswork. It was even conceivable that they watched everybody all the time. But at any rate they could plug in your

wire whenever they wanted to. You had to live – did live, from habit that became instinct – in the assumption that every sound you made was overheard, and, except in darkness, every movement scrutinized ...[9]

Nineteen Eighty-Four was written in 1948, in a world haunted by the shadow of totalitarianism; but it was prophetic all the same, for it came to pass, if not quite as soon as 1984. We are now so observed that any power could, if it chose, know far more about us than the dictators of the twentieth century ever knew about their subjects.

The difference is, we've all consented to it. We are so used to being on screen that it has lost its transgressive frisson. Once the high-minded outrage that accompanied the appearance of *Big Brother* on television had died away, so did the ratings. The game, and all the houses in which it was played, have passed away, or at least have been put out to pasture on cable.

The screen is no longer the burning-glass of 1953, through which the attention of millions is focused upon one person. It's not even the stentorian eye of Orwell's Big Brother. Now, we can all watch one another, and we can all be on screen, if we choose, all of the time. The screen has become like a house – there is no longer an exclusive distinction between an active broadcasting side and a passive audience, no rich and poor, no master and servant, no Big and little brothers. We're all living at the palace now.

A Labyrinth

THERE ARE THOUSANDS OF THEM OUT THERE, IN THERE, BEHIND THE screen. Millions. Shamblers prowl the rhizomes; fiends and scrags spawn in muddy dungeons; and shoggoths, 'large, oily black and polymorphic',[1] guard the endless forks in the countless paths. Chattering in filthy pidgins, they tell one another stories of horrible deaths and wonderful places, of worlds of warcraft and dooms to make them quake. Out there, in there, behind the screen, they tell one another myths and legends. Goblin tells this one, and although he's one of the filthiest, it starts innocently, normally enough, with a little boy:

> Dennis doesn't remember much about his life … Except for
> cheerful games with his chum, an Italian guy Winnie-the-Bull by
> nickname. At the age of 5 years he first kissed with a girl and since
> that time it's OK with girls for him.[2]

Not any more. One day 'passing his brother's room, Dennis heard a wild

screaming behind the door, stunning explosions and random shooting. Got interested he entered the room and asked about what was going on.'[3]

And then he was in; and no-one knows Dennis as Dennis any more. He's no longer a little boy. His nickname started out as 'Threshold of Pain', but when he found out that it was too long, he decided 'to shorten his colorful title and become just Threshol':

> Do you understand that it sounded a bit dopey? Just like asshole, and it's not the way that a expert like him could be addressed. So he shortened his nick up to simple Thresh.
>
> Though he had a profound knowledge of English, Thresh took the time and trouble and consulted the dictionary. And then he found out that his new nick means 'to strike repeatedly'. Thus 'Threshold' invisibly, smoothly and steadily became 'Thresh'. Dennis was very much content about his new nick.[4]

It's a world famous 'nick' now. So famous, in fact, he can't use it anymore because when he starts to play, 'excited folks start offering fighting to death cause they want to be more tough than Thresh …'[5]

But Thresh was no-one until Red Annihilation in 1997. Anything could have happened: the prize was, after all, spectacular: a scarlet Ferrari that belonged to the Master of Doom himself.

> Having heard the news and having got excited very much, thousand of players were slaughtering … Until there were 16 best of the best. There were Entropy, Gollum, Froggy, Unholy, Kiljoy, Whitewolf, Hijinks, B2, Kenn, Ultra P, Cross, Sho, Pookie, Reptile, Rom and, of course, Thresh … After desperate combats Entropy and Thresh were in the final.[6]

They run panting, grunting, through a subterranean dungeon. Lava erupts through the floor, and bubbles in pits. Tunnels, ramps, and stairs, shafts run round and round, up and down, back upon themselves, inwards, downwards, to the little room they are looking for, the one with the door. Then they're through, into another room, laced with pipes and ducts and wires and grilles – the sort of post-industrial hell that hides behind the neutral linings of congress centers and shopping malls – and puddles of acid smear the filthy floor.

And then they burst through again, into somewhere bright, open, and empty. It could be a spaceship, deserted and sinister as the one in *Solaris*. It's certainly a vision of the future, rather than the post-industrial present or the gothic past. They could be on Mars, or in the Vaults of Zin, or the Ebon fortress of H.P. Lovecraft. They're just kids, and they've ended up in the Castle of the Damned. Only one of them can live, and for that to happen, the other has to die.

* * *

Not that it looks like that from the outside. Entropy and Thresh scarcely move. They hunch forward in their chairs, right hands jerking and clicking the mouse, left hands punching and stroking the keyboard. Their jaws tighten and flex, their faces, pressed against the screen, are washed blue.

At the end of the tournament, everyone is dead. Everyone, that is, apart from Thresh, who is led, embarrassed and shy, up to the dais on the arm of a leggy blonde. John Carmack gives him the Ferrari, although it'll be a few years before he'll be allowed to drive it. His parents take him home instead.

And the infinite labyrinth implodes back into a plastic box. Volunteers log off, switch off, unplug, and pack. Screens are rolled up, cables are coiled, tables are folded away, and chairs stacked. What's left is junkspace. It's

hardly an interior. The walls are non-existent, or at least Microsoft beige, the colour that goes with everything; and they slide and fold in any direction. Data and aircon and power can be made to appear anywhere in the tiled floor or the gridded ceiling. It's one of those voids where anything can happen: the World Congress Center, just a stone's throw away from Peachtree Street in Atlanta.

* * *

But the game they're playing at Red Annihilation, *Quake*, carries on – in thousands of teenage bedrooms, and at countless office desks. The millions who play it inhabit another world, created by the man for whose scarlet Ferrari they were prepared to kill, and die. John Carmack is the master of their Doom, and everyone regards him with sacred awe:

> ... after so many years immersed in the science of graphics, he had achieved an almost Zen-like understanding of his craft. In the shower, he would see a few bars of light on the wall and think, Hey, that's a diffuse specular reflection from the overhead lights reflected off the faucet. Rather than detaching him from the natural world, this viewpoint only made him appreciate it more deeply. 'These are things I find enchanting and miraculous,' he said, 'I don't have to be at the Grand Canyon to appreciate the way the world works. I can see that in reflections of light in my bathroom.'[7]

Games have always been played in imaginary interiors. In the early 1970s, *Dungeons and Dragons* were conjured in text. The courts of Atari's *Pong*, released in 1978, were depicted in the most rudimentary of plan formats, drawn onto the flat plane of the screen as if it were a sheet of paper. *Pac Man* wandered labyrinths drawn in two-dimensional elevation. The *Crystal*

Castle of 1983 or the *SimCity* of 1989 were rudimentarily rendered in the three dimensions of axonometric. Four years later, *Myst* and *Doom* conjured seemingly realistic rooms in two-dimensional images, painted with all the illusionism of a nineteenth-century diorama.

But *Quake* was one of the first games built with the same software that architects used to design spaces in the analogue world. Its dungeons and tunnels were designed, lit, decorated, and furnished just like real rooms in 'maps', three-dimensional virtual models, which could be viewed, run around, and shot in, from any angle.

* * *

It's the three-dimensional software that gives *Quake* its realistic thrill; but there's something else too. Even when little Thresh had grabbed the keyboard from his brother, he'd guessed what it was:

> Dennis drove his brother away of the keyboard and driven by the sport interest tried to play himself. As a result he was smashed up. Dennis surprize was beyond the boundaries! He started questioning his brother about the way his opponent was programmed as he had unusual skills and was completely unpredictable. And it turned out at once that he had been playing not with a computer but with his brother pal at San Jose.
>
> An opportunity to play on computer with another man stroke Dennis completely. To play with a man was just the thing he got used to. But to play with a man on a computer, it was something new![8]

There's something more exciting about killing people when you know that they're, like, real. The formless spawn of Tsathogua, the armoured death

squad, may be sitting in the next seat, or several rows away, or further. *Quake* is hooked up to the Internet; and that means that your enemy could be anywhere: a porch on Peachtree Street, an apartment in France, or a palace in Rome. Multitudes of them will be sitting at work, pretending to work, as they stare and click and jab. All you know is that, like you, they're ready to murder someone they've never met.

<div align="center">* * *</div>

He's a generous man, John Carmack, one of the evangelists of the Web, and open source computing. When the codes for *Quake* were leaked in 1996, Carmack didn't take legal action, but took the thieves on, and used their know-how to improve the game.

Anyone can access the coding for *Quake*, and this has had the most curious consequence for the interiors in which the game is played. When, in 1996, Id Software created the original 'maps' for the game, there were four of them. Carmack wanted the interiors to be in the Aztec manner, but there were others on the team who preferred something a little more traditional, and gothic they became.

But Id's commitment to open source computing has meant that players can add modified maps – 'Mods' – of their own. *Quake* started out as four circumscribed rooms; but it has turned into a labyrinth that goes on forever. As some parts of it grow, others wither and die. There are corners of *Quake* that no-one has visited for years, and arenas that no-one has ever used. Even as players play, and data streams from Web to individual computer, halls and corridors are conjured into existence a few paces ahead of them, and vanish the instant they are lost from sight.

There are cityscapes at dusk, dungeons, spaceships, temples, homes, and offices, indeed every type of interior one can imagine, and they are all posted online for praise or critique by those who choose to die in them:

The looks are totally gorgeous, a huge gothic church or cathedral with parts exposed to the open world, some areas have been completely ripped apart by earthquakes or blasts and the broken architecture that is left behind is simply outstanding ...[9]

'Modders' share design techniques and tricks, for they are all engaged in an infinite collective exercise: 'whatever you do,' writes one, 'there's just one way of learning solid mapping, and that is to PRACTISE A LOT ... Study other people's maps. Not for textures and architecture (remember, these should be original!) but for technique ...'[10] It's what design teachers have been telling their students for centuries.

And it's not just the environments they're designing, but the creatures that will haunt them too. 'It's an archaic map,' writes one modder:

so you'll need archaic monsters ... In particular, Scrags would be great in the open arched windows, Fiends would be cool hiding round corners and in alcoves to surprise the player, and Death-knights are good on ledges where they can harass the player with their flame attack.[11]

It's a story after all, and every interior is built to clothe a story in space. 'Shambler' writes of his latest map:

He spawns near the Quad, where the small stairwell used to be, and heads down the corridor to the RL area. Heads up the stairs, and may well head along the corridor to the main room, but will find his way blocked by a key door. So he will have to continue up the stairs and into the rooftop garden. From there, he will head down the opposite stairs, and retrieve the key from the ledge above the

Quad. Then he will return to the corridor beneath the RA where he spotted a door, and enter the main room from that direction. He will make his way around the room and into a corridor by the YA that leads into Daydream.[12]

It's a daydream that has been conjured, just like memory palaces of old, from the jumbled fragments of real life. 'Always take a look around yourself when walking around the mall etc.', posts one modding blogger, 'wouldn't those stair arrangements make for good RL camping :),'[13] and in the early years, many modders added to the game by recreating, online, the offices and convention centres and teenage bedrooms where they were playing the game, turning them into scenes of mass carnage and fights to the death.

* * *

Once upon a time, a screen on Peachtree Street was a window framed with velvet portières, that peered into dreams remembered and civilizations gone with the wind. Now it's the portal into a labyrinth where anything is possible, and everything, even spawning and dying, is just a game. Goblin ends his pidgin fairy tale with a terrifying observation:

> what is interesting here is that having played such terrible games and having watched such awful films Thresh has never gone out of the street with a Shotgun to shoot out lazy citizens. Though with his bloody game experience it is high time … What can I say? Good chap. Get so high and still so nice – in his 22 it's not easy![14]

It's what Goblin would like to do. Perhaps it's what he did as a cop in Kirovgrad in the Ukraine, back in the 1990s, after the collapse of the old,

analogue, evil empire. Dmitry Puchkov and his colleagues were so corrupt that when the papers started calling them 'Goblins in Militsiya Overcoats' they just laughed, and he decided to find somewhere where he could become one for real. At least, that's his online name; and lurking in some corner of the endless labyrinth, he tells his fellow monsters the legends of *Quake*.

A Cloud

YOU'LL ONLY REALIZE YOU WERE IN THIS ROOM WHEN YOU'VE LEFT it. Everything will look exactly the same; but the vibrations and the pushes cease, the twittering dies away; and the writing fades from the wall. You are where you are, alone, outside.

We don't need interiors any more. Not physical ones, anyway. Once upon a time, they were caves in the ground. Once upon a time they were constituted in heavy furniture, and their treasures cluttered in secret cabinets. Once upon a time, interiors dissolved in myriad mirrors, then transparent glass; and then they were conjured up in silver nitrate, cathode rays, and liquid crystal. Now they are defined by nothing more than a vibration in the ether.

Once upon a time, the screen was a gigantic curtain, studded with stars. Then it entered our homes, waiting politely, at first, in the parlour, before devouring the very rooms into which it had been invited. Now the screen hides in our pockets, our laps and our palms. It is everywhere and nowhere, a mere chink, a shard of mirror, through which we squint, fragments at a time, into a lost, palatial interior.

The Cloud, it's called. Radiating out from a transmitter, it takes the form of a sphere with a radius of around ninety-five metres. That's if this inside is outside. In physical rooms, its form distorted by walls and furniture, metal objects, mirrors, and windows, it rarely extends further than thirty-two metres.

It's been there all along – ever since Alexander Graham Bell spoke to Charles Tainter on a wireless phone in 1880 – but its use in computing dates to the early 1990s when the US telecoms company AT&T developed a system to connect cash registers to the mainframes of department stores. By 1993, Carnegie Mellon University in Philadelphia was using wireless technology to connect up its campus. By 1999, the Wi-Fi alliance had established an international network with which anyone could register.

In the next decade, Wi-Fi went outside: Grand Haven in Michigan claims to be the first city to go Wi-Fi, in August 2004; but Mysore in India had also set up a transmitter in that same summer; in November, Jerusalem followed suit; in 2006 Europe's largest Wi-Fi area was installed at Canary Wharf, and Philadelphia entered the cloud; in 2009 Chennai went Wi-Fi. In 2012, London launched the world's largest cloud as part of the Olympics. There were already 827 hotspots[1] in the city before they started; and at the time of writing, the UK boasts 9,453. The cloud has even wormed its way into the countless tunnels of the London Underground.

But it's not easy to get in. As anyone who has tried to 'piggyback' onto someone else's cloud will know, access is closely guarded. Daryl Brown of Texl predicted '"shrink wrap", turnkey, private clouds' for 2012.[2] 'Who will win the cloud in 2012?' wrote Dana Blankenhorn, a Web-based business analyst,[3] while Jelle Frank van der Zwet of Interxion talks of 'cloud deployment'.[4] The cloud may be invisible, but its apartments are as politicized as those of any palace of old.

And that's because the cloud lends its occupants palatial power.

Interiors have always been the seat of authority; but they have also been ephemeral affairs, patiently contrived of marble and generations of ash, furniture, trinkets, *tentures* and mirror, glass and vitreous china, serving to remind us of the partiality of our own knowledge and power.

It's different in the cloud. Launching iCloud in 2011, Apple put it poetically:

> *Start a project in one place, and pick up right where you left off, in another.*
> *Catch a moment here, and it's waiting for you there.*
> *Make a change on this, and it updates on that.*
> *And with iCloud it all works automatically, and wirelessly*
> *So you always have the things you want,*
> *Exactly where you want them.*[5]

Once upon a time, the Internet was an unknown collection, assembled at random, without a catalogue; but in 1996, two PhD students at Stanford University, Larry Page and Sergey Brin, tried to write one. Rather like the alchemists in a *Wunderkammer*, Page and Brin realized that knowledge would only ever be power if it could be organized and accessed.

In the two decades since, Google has turned from a search device into a project to know everything that can be known. Google satellites take pictures of the earth from space; Google vans prowl the streets; Google scanners are digitizing everything that has ever been printed on paper, and Google servers are translating every language that has ever been spoken.

Google is a catalogue of an unknown collection; and the most important thing they want to know everything about are the multitudes who use them to find out everything else – that's you, dear reader, and me. Our searches are recorded and logged, our preferences noted, and Google subtly tuned to greet us personally the next time we visit them.

Google is not unique. Amazon started out as an online bookshop, but has turned into an infinite library that will suggest new books for you to read. iTunes has done the same for music, Flickr for images, and Facebook for people. The cloud isn't just a collection of information, for infinite knowledge is infinite power. It is the room in which everything happens, and in which everything that happens is remembered.

* * *

It's magic, for the cloud is an enchanted memory palace. Industry insiders call Google 'the Chocolate Factory', partly because like Willy Wonka's wonderland, it is so improbable, so fecund in wonders; but partly, also, because it is so secret. It's not necessarily malice – 'don't be evil' is the watchword of the company – who wouldn't want to be careful if they were in possession of the memory of the whole world? You'd want to put it somewhere safe, wouldn't you?

So Google Google, try to find where they keep their cloud, and you'll discover surprisingly little. In the absence of hard data, rumours abound. There's one doing the rounds of the Web at the moment that Google is planning a 'data navy' of ships containing gigantic computers and Wi-Fi transmitters that can float around the world independently of governments and legislations, sailing to information hotspots at will.

Google admit to possessing ten buildings which contain (they do not confirm) around 900,000 servers in total, upon which all the digital wonders of the world are stored. Informed rumour abounds that there are more like a billion such servers, spread in more than forty data centres in places from Milan to Tokyo, Sao Paolo to Berlin. They are connected by a network of cables and transmitters to all the clouds in the world.

The clouds of Iowa, Oregon, and Nebraska used to scud over miles of waving corn and the occasional wagon trail, but now the prairie is

welcoming new settlers. Yahoo, Paypal, and Ebay have located their data centres in Omaha, and up in Des Moines, Microsoft has moved in. Time Warner and IBM keep their data at the other end of route 80, in Colorado; and at the time of writing, Facebook had just spent 210 million dollars in Prineville, Oregon. Since 2007, Google have opened data centres in: Berkeley County, South Carolina; Douglas County, Georgia; Mayes County, Oklahoma; Lenoir, North Carolina; The Dalles, Oregon; and Council Bluffs, Iowa. Data farms, they call them, so as not to frighten the natives.

But the Midwest has not turned into Silicon Valley or Bangalore. Far from it. Far from the world, far from national borders, far from monarchs and presidents and inventors, and great cities, far from anything much other than wind, water, space, and power, they're over the rainbow, in Kansas.

Only the wind can disturb them, but they've thought of that. At Hastings, Oregon, and Grand Island and Aurora, Nebraska, one company has buried thousands of servers in Prairie Bunkers, half-submerged in the soil and roofed with grass. Just outside Columbus, Indiana, a company called Datacave have built exactly that: caves for clouds, protected from tornadoes by concrete roofs twelve inches thick.

Council Bluffs, Iowa, is, like the rest of these places, in the middle of nowhere: it's an outer suburb of Omaha, Nebraska, another city, in another state. It's a place where things begin and end: the start of the Mormon Trail, the end of the transcontinental railway, and, once upon a time, a savage village, described in the 1830s by one explorer as:

> a great number of cabins and tents, made of the bark of trees, buffalo skins, coarse cloth, rushes and sods, all of a mournful and funeral aspect ...[6]

It doesn't sound much like a place for an enchanted memory palace, but in 2007 Google built one there. It's just off the Veterans Memorial Highway, in the business park, tucked in among the car dealerships and the Wooded Lake Trailer Park. There's a chain-link fence, studded with CCTV cameras, and a moat. There's a security booth, where they check your ID: you won't get in unless they're expecting you. If you try, your car will get caught in the steel nets that stretch across the slipway.

The palace itself is a tin shed. It's surrounded by cooling towers and generators, neatly lined up on the gravel, and tanks of fuel and ranks of batteries – this is a place that's designed to work isolated from the world, independent of its intricate networks of power.

They're waiting for you at the door, and even though they already know who you are, you must still swipe your security pass and stare into the iris scan. There's a mantrap, and an airlock, and that's even before you've checked in with the guards at the desk. Once you've got that far, they'll show you the canteen, and the preternaturally tidy offices, and the games room, with its pool table and darts board. They don't feel much like rooms in a palace.

They are, in fact, just antechambers: there's another door at the back of this apartment, one you're not allowed to open. It's a door into a room you'll never enter.

But they've put a glimpse of it on YouTube. It doesn't look like an enchanted room. The light inside is every bit as flat as the prairie without. The ceiling is laced with ducts and conduits, and the hard surfaces of the room amplify the hum and the 'shhhhh' of hundreds of chillers. Lined up, in aisle after aisle, in cages locked with keypads, are other interiors: shipping containers painted white and beige; and inside them are still others: thousands of cabinets of grey steel, and inside them, others still, tiny trays of black plastic studded with winking lights.

The room is almost completely devoid of habitation. Here and there, from time to time, some youth rides up and down the empty aisles on a scooter, and stops to attend to one of the cabinets. Here and there, little lights wink on and off. Otherwise, nothing happens.

But we are all in that room. Locked in those countless cabinets, racing through those cables, behind the doors and the mantraps, kept to a temperature of twenty-seven degrees centigrade in a tin shed, surrounded by a moat, a fence, watched by CCTV, in a suburban business park, in a town in the middle of nowhere. Google knows everything, and what they know, they keep in places like Council Bluffs.

One visitor recently asked an employee: 'So in the year 2020 when Google becomes self-aware, will humans be spared?' The man didn't even smile.

In the cloud we remember not just who, where, and what we are, but how to remember at all. It has released us from the fetters of our own memories and the rooms in which we used to contain them, in stone and wood, gold and paper, marble and mirror, glass and light. We can be anyone, anywhere. We can know anything. We are over the rainbow, stuffing ourselves like a starving Charlie in a chocolate factory.

It's an illusion. Somewhere out there in the fields, protected from the cloudburst, we are still lurking in caves. There are rooms, just as there have always been, and just as we always have, we use them to remember who we are.

EPILOGUE

DECONSTRUCTION.
By Osbert Lancaster.

A Book

SOMETIMES, WHEN I GO TO STAY WITH MY GRANDMOTHER, WE HAVE an awkward conversation. 'What would you like', she asks, 'when I'm gone?' It's a difficult question to answer without opening oneself up either to accusations of callous avarice, or hypocrisy.

But it's a sensible question to ask. Like anyone her age, my grandmother has seen enough times now the unseemly scrum that can develop when the contents of interiors, liberated from the shackles of belonging to one person, are suddenly up for grabs. She doesn't want that to happen when she goes.

And I doubt it will. Brought up on beanbags and plastic, IKEA and Apple, we expect the interiors we inhabit to be simpler, tougher, cheaper, and quite simply emptier than Granny's sitting room. We don't collect like she has, and we aren't used to polishing our furniture and our silver, for our children's children. I'm convinced I'd break her most precious pieces (I've already broken some), and, to be honest, the burden of their memory scares me.

But Granny has made a list all the same, an inventory of everything her sitting room contains. She has told me what she can remember, sitting in her chair, pointing at this corner or that as we gulp our last gin and tonic before dinner. In the process, she has told me the story of her life, and of all the interiors in which it has been lived. The memory palace that has prompted this story is the interior in which it has been told: a sitting room in a doll's house.

* * *

That room echoes with traces of all the others in this book, for they are all my grandmother's sitting room. That room encodes the story of the interior, from earliest times until the present. This is a story of demateri-alization: as technology advances, we emerge from the stone cave into the porphyry chamber, the flexible hall, the portable cabinet, the mirrored *tenture*, and the transparent glasshouse until we lose ourselves in a cloud. As the interior dissolves into air, so its very interiority seems to vanish with it: the cave was a place set apart; while the ubiquity of the Web makes everywhere everywhere, and therefore nowhere.

And that is the story of palaces, too, and the authority they embody. The cloud allows us to go anywhere and be anyone: we can all be, at one and the same time, Roger and Louis XIV. At the other extreme, the temple of Vesta was accessible only to virgins, sworn to silence. The arrangement of furniture in the medieval hall; the cataloguing of the wonders in the cabinet; the etiquette of the apartment or the pricing of goods in the Great Exhibition were all negotiations between priceless mountains of light and their valueless inverse. The story of the palatial interior is the story of authority per se and also of the social and spatial framings that lend it lustre.

And that is also true of the knowledge from which all authority must

derive. Ancient mysteries were handed down in whispers, from initiate to initiate. The Web, on the other hand, makes all knowledge instantly available, and memory artificial. The hall, the *Wunderkammer*, the apartment, and the exhibition are all experiments with knowledge, and the power it engenders. In each of them, memory plays a different part, as rooms remind us who we are, what we desire, how to behave, or what we are worth.

That would make a neat story, anyway. It would even work if every present was a present and no more, and history could be told in chapters divided neatly into periods; but interiors remind us that this is never so. My sitting room (and my grandmother's and every room in this story) is specific to one moment in time; but it is also a meeting place between the present and the past. Even when the revolutionaries of 1649 or 1789 turned the world upside down and started again at zero, they found themselves picking over the rooms their predecessors had left them, for nothing can begin *ab initio*.

This memory palace reminds us about memory itself, for the story it tells is about our changing relationship with the past. Once upon a time, it was ritually relived in caves like the Lupercal; now, sublimated into ones and zeroes, it is filed on digital databases. So far so simple; but the Web extends its tendrils through the halls of Westminster, and the Great Exhibition was filled with wonders as ancient as the Koh-i-noor. The present is the ruin of the past, a room rearranged rather than invented.

* * *

And the future will be the same, for the same process will happen again, as the present passes into memory. It is happening all the time, and always will, and the writing of this book is part of the process. I have shown this manuscript to my grandmother. She has read it, and, just as I expected, she

is indignant: 'I don't just sit around watching television, you know!' she retorts, 'and you've missed out all the interesting things I used to do!'

But she's read it all the same, I can tell, because when I next go to see her, Granny has changed the sitting room – only a little, but just enough to tell. She has cleared the mantelpiece of photos and invitations, and now, furnished only with two candles, a tea caddy like a ciborium, and icons of her daughters, it is more of a solemn altar, rather more like my description of it at the beginning of this book, than it ever was before.

A month or so later, I receive a call. Her voice is confused, querulous: 'Don't come this weekend, darling,' she says, 'I'm not feeling myself, and we'll just have to sit at home ... there won't be any parties ... any parties ...'

Two days later, I'm sitting in the sitting room again with a gin and tonic. Granny is in bed, upstairs. Downstairs, we are matter-of-fact: 'She can't go on. She can't cope. She knows.'

It's Remembrance Day. We spend the next morning hoovering, tidying, cleaning, rearranging, sorting, talking. After she's listened to the service, she is feeling a little better. Granny comes down to the sitting room to eat some lunch. We've rearranged the card table in front of her chair, so she can watch the TV at the same time.

It's a bright November day. She can see what we've done, she knows what it means, and as she toys with the morsel of plaice on her plate, her face sets into a mask. 'I think I'll go back upstairs,' she says. That's all.

* * *

That's not all; there's always an end after endings. There's a problem with endings, for how would they be endings, if we knew what came after them?

But you can guess. It is now contained in another. Along with all the other memory palaces it remembers, from the Palatine to Studio City,

Granny's sitting room is stored in the processors of my laptop. It is floating somewhere in the cloud, too, since in order to back it up, and so that I can enter it from anywhere, I've uploaded it to Google. That means its caves, halls, cabinets, boudoirs, and closets must be lurking in data centres from Oregon to Singapore.

And my laptop is the latest survivor in a long line of computers with which I have done battle to write this book. Its battered predecessors sit in a box reserved for obsolete products. There's one I broke in half last summer, and another that is so large and heavy it feels like a tank. There are flexes for products that no longer exist, and products with no flexes, reduced to inert plastic. I'm stuck with them.

The room I'm sitting in is painted with exactly the same French grey my grandmother would have chosen. It is back in fashion; and Farrow & Ball make a fortune selling it among a range of colours whose names – rectory red, pavilion blue, print room yellow – are designed to recall a vanished world of leisured elegance. The only accent of colour is provided by a couple of little cushions covered in a pink *toile de Jouy* recycled from a pair of old curtains.

Wedged between the books on the shelves that fill one wall is a red-lacquered bowl. My grandmother used to keep a chess set in it. I inherited the bowl and the set from her as a child and though I've lost most of the pieces, I keep its remnants in there anyway, unable to throw them away. There are other curiosities on the shelves, too: a brass bell sits oddly among the paperbacks, but like them, it is a fragment of other lives, other knowledges, other curiosities, placed in a cabinet.

When I'm writing, I sit at Granny's card table. It's too low to work at, but it's useful since when guests come to stay, I can fold it up and put it away. The chair I sit in to write is one of her old director's chairs and it, too, can be folded up and put into the cupboard when people come. In fact

all the furniture in here is flexible. It has to be this way: the flat is too small to have a permanent spare room, and it's not as if I can move the walls around every time someone comes to visit.

But wherever I put the furniture, I always have to negotiate the fireplace. It was bricked up when we moved in, but we excavated it, and use it on winter evenings – more to be able to stare into its embers than for the heat, which can't match the central heating. We've painted the wall around it a sooty black, and just above it, I've hung a painting in a gilded frame. It depicts a young man, wrapped in a black greatcoat, fixing the painter with a gloomy stare. 'From CH', says the inscription at the bottom, '1901' – or 1907 – it's not clear.

It's been in the family since then, for sure, but none of my living relatives know how it was acquired, although my aunt thinks it was gift from my grandfather, whose initials were C.H. It's possible, but unlikely: he was born in 1901, and would only have been six in 1907. None of us has any idea who the man in the painting actually is: he is the unknown ancestor, reminding me of all the ones I've never met, as well as those I have. I couldn't resist hanging it by the hearth.

My sitting room, like all interiors, is only a temporary arrangement, assembled from bricks and mortar, buckets of paint, rolls of fabric, a heap of consumer goods, and the objects I have inherited from the ghosts whose images, painted or photographed, I have hung on every wall. One day, the Doll's House will exist only in other images, in whose blurred background it will appear in fragmentary glimpses. One day, some child will pick up a brass bell in the shape of a maidservant, and wonder what it was for.

'There's nae pockets in shrouds,' they say, and none of our things belongs to us. We have borrowed, inherited, purchased them all, and one day we shall lose them. In the meantime, the rooms we live in are doll's houses and memory palaces. We arrange their worthless elements as shrines

to departed shades, temporary meeting places, cabinets for curiosity, settings for tiny plays and reveries, items of exchange, electronic images, texts like the one you are reading now, and, ultimately, ringings, that fade on the ear, even as they are heard.

Notes

INTRODUCTION

A Doll's House

1 Mario Praz, *An Illustrated History of Interior Decoration: From Pompeii to Art Nouveau* (Thames and Hudson 1964), p. 20.

2 Aaron Copland, *How we Listen*, 1939. http://www.montgomeryschoolsmd.org/uploadedFiles/schools/wheatonhs/departments/aphonors/Copland_HowWeListen.pdf (accessed April 2012)

3 Praz, *An Illustrated History*, p. 13.

4 Praz, *An Illustrated History*, p. 30.

5 Praz, *An Illustrated History*, p. 42.

6 Cicero, *Rhetorica ad Herennium*, Book III, 13, tr. Harry Caplan (Loeb Classical Library 1954).

7 Praz, *An Illustrated History*, p. 20.

8 Mario Praz, *The House of Life*, tr. Angus Davidson (Methuen 1964, originally Arnoldo Mondadori Editore 1958), p. 350.

9 Frances Yates, *The Art of Memory* (Routledge and Kegan Paul 1966), p. 374.

ARCHITECTURE

Focus

1 *Dialexeis*, quoted in Frances Yates, *The Art of Memory* (Routledge and Kegan Paul 1966), p. 44.

Porphyrogenitos

1 Anna Comnena, *The Alexiad*, tr. Elizabeth A.S. Dawes (Kegan, Paul 1928), p. 1.

2 Comnena, *The Alexiad*, p. 151.

3 Comnena, *The Alexiad*, p. 1.

4 Comnena, *The Alexiad*, p. 170.

5 Constantine Porphyrogenitos, *Le Livre des Ceremonies Tome 1*, tr. Albert Vogt (Société d'Édition les Belles Lettres 1935).

6 Liutprand, *Antapodosis*, quoted in Linda Safran, *Heaven on Earth: Art and the Church in Byzantium* (Pennsylvania State University Press 1998), p. 30.

7 Liutprand, *Relatio*, tr. Ernest Henderson, in *Select Historical Documents of the Middle Ages* (George Bell 1910) p. 449. http://www.fordham.edu/halsall/source/liudprand1.asp (accessed April 2012)

8 Liutprand, *Relatio*.

9 Constantine Porphyrogenitos, *Le Livre des Ceremonies Tome 1*.

10 Comnena, *The Alexiad*, p. 1.

11 Comnena, *The Alexiad*, p. 170.

12 Comnena, *The Alexiad*, p. 170.

Domus Aurea

1. Vasari, *Life of Giovanni da Udine*. http://members.efn.org/~acd/vite/Vasari Udine.html (accessed 12 April 2012)

2. Suetonius, *The Twelve Caesars: Nero*, tr. J.C. Rolfe (Loeb Classical Library edition 1914), p. 31. http://penelope.uchicago.edu/Thayer/E/Roman/Texts/Suetonius/12Caesars/Nero*.html (accessed 12 April 2012)

3. Tacitus, *Annals*, 16:18, Alfred John Church, William Jackson Brodribb and Sara Bryant, eds., *Complete Works of Tacitus* (Perseus, reprinted 1942). http://www.perseus.tufts.edu/hopper/text?doc=Perseus%3Atext%3A1999.02.0078%3Abook%3D16%3Achapter%3D18 (accessed 12 April 2012)

4. Suetonius, tr. Robert Graves, quoted in Michael Grant, *Nero, Emperor in Revolt* (American Heritage Press 1970), p. 169.

5. Tacitus, *Annals*, quoted in Grant, *Nero, Emperor in Revolt*, p. 170.

6. Suetonius, *The Twelve Caesars: Nero*, p. 31.

7. Tacitus, *Annals*, 15:44.

8. Tacitus, *Annals*, 16.18.

9. Suetonius, *The Twelve Caesars: Nero*.

10. Martial, *Liber de Spectaculis*, quoted in Miriam Griffin, *Nero, the End of a Dynasty* (Batsford 1984), p. 138.

Domus Augusti

1. Suetonius, *The Twelve Caesars: Augustus*, tr. J.C. Rolfe (Loeb Classical Library edition 1914), p. 237. http://penelope.uchicago.edu/Thayer/E/Roman/Texts/Suetonius/12Caesars/Nero*.html (accessed 12 April 2012)

2. Suetonius, *The Twelve Caesars*, p. 209.

3. Suetonius, *The Twelve Caesars*, p. 239.

4. Suetonius, *The Twelve Caesars*, p. 208.

5. Vitruvius, *Ten Books on Architecture, Illustrated Edition*, tr. Morris Hicky Morgan (Echo Library 2008 6.5.1), p. 165.

6. Ovid, *Fasti IV* 949, tr. Sir James George Frazer. http://www.theoi.com/Text/OvidFasti4.html (accessed 1 April 2012)

7 Dio Cassius 55.12.5, quoted in Ian Barton, ed., *Roman Domestic Buildings* (University of Exeter Press 1996), p. 94.

Regia

1 Plutarch, *Parallel Lives: Numa*, tr. Bernadotte Perrin (Loeb 1914), p. 319. http://penelope.uchicago.edu/Thayer/E/Roman/Texts/Plutarch/Lives/Numa*.html (accessed 12 April 2012)

2 Plutarch, *Parallel Lives: Numa*, p. 317.

3 Plutarch, *Parallel Lives: Numa*, p. 357.

4 Plutarch, *Parallel Lives: Numa*, p. 341.

5 Plutarch, *Parallel Lives: Numa*, p. 11.

6 Plutarch, *Parallel Lives: Numa*, p. 342

7 Vitruvius, *Ten Books on Architecture, Illustrated Edition*, tr. Morris Hicky Morgan (Echo Library 2008 6.5.1), p. 38.

Lupercal

1 William Green, 'The Lupercalia in the Fifth Century', *Classical Philology*, vol. 26, no. 1 (January 1931), pp. 60–69. http://penelope.uchicago.edu/Thayer/E/Journals/CP/26/1/Lupercalia*.html (accessed 12 April 2012)

2 Plutarch, *Parallel Lives: Caesar*, tr. Bernadotte Perrin (Loeb 1914), p. 585. http://penelope.uchicago.edu/Thayer/E/Roman/Texts/Plutarch/Lives/Numa*.html (accessed 12 April 2012)

3 Plutarch, *Parallel Lives: Caesar*, p. 585.

4 Ovid, *Fasti II* 425, tr. Sir James George Frazer. http://www.theoi.com/Text/OvidFasti4.html (accessed 1 April 2012)

5 M. Terentius Varro, *De Lingua Latina* 5.85–6.13, quoted in T.P. Wiseman, *Unwritten Rome* (University of Exeter Press 2008), p. 52.

6 Ovid, *Fasti II* 359–381.

7 Ovid, *Fasti II* 267–303.

FURNITURE

A Table for Games

1 Frances A. Yates, *The Art of Memory* (Routledge 1966), p. 78.

2 Yates, *The Art of Memory*, p. 70.

A Chair

1 Ian Hamilton, *The Taking of the Stone of Destiny* (Lochar Publishing 1991), p. 189.

2 Nick Aitchison, *Scotland's Stone of Destiny: Myth, History and Nationhood* (Tempus 2000), p. 125.

3 Christine and Jacqeline Riding, eds, *The Houses of Parliament: History, Art, Architecture* (Merrell 2000), p. 181.

4 Nick Aitchison, *Scotland's Stone of Destiny: Myth, History and Nationhood* (Tempus 2000), p. 120.

5 Aitchison, *Scotland's Stone of Destiny*, p. 25.

6 Aitchison, *Scotland's Stone of Destiny*, p. 15.

7 Aitchison, *Scotland's Stone of Destiny*, p. 17.

A Table

1 Martin Biddle, *King Arthur's Round Table: An Archaeological Investigation* (Boydell Press 2000), p. 265.

2 Biddle, *King Arthur's Round Table*, p. 405.

3 Biddle, *King Arthur's Round Table*, p. 424.

4 Biddle, *King Arthur's Round Table*, p. 399.

5 Biddle, *King Arthur's Round Table*, p. 402.

6 Biddle, *King Arthur's Round Table*, p. 381.

7 'For his noble barons, each of which held himself better than the others, and none of whom knew fear, Arthur made a round table, which they still tell

stories about in Brittany, at which each of his vassals and knight could sit, with full equality. None could put himself higher than another, and everyone was sat together, without estrangement.' (Author's own translation.) Biddle, *King Arthur's Round Table*, p. 9.

8 Biddle, *King Arthur's Round Table*, p. 411.

A Cloth

1 Emilie Amt and Stephen Church, eds, *Dialogus de Scaccario*, and *Constitutio Domus Regis/The Dialogue of the Exchequer*, and *The Establishment of the Royal Household* (Oxford University Press 2006), p. 9.

2 Amt and Church, eds, *Dialogus de Scaccario*, p. 9.

3 Amt and Church, eds, *Dialogus de Scaccario*, p. 37.

4 Amt and Church, eds, *Dialogus de Scaccario*, p. 27.

5 Amt and Church, eds, *Dialogus de Scaccario*, p. 27.

6 Amt and Church, eds, *Dialogus de Scaccario*, pp. 97–9.

7 Amt and Church, eds, *Dialogus de Scaccario*, pp. 97–9.

8 Amt and Church, eds, *Dialogus de Scaccario*, p. 63.

9 Amt and Church, eds, *Dialogus de Scaccario*, p. 11.

10 Amt and Church, eds, *Dialogus de Scaccario*, p. 191.

11 Amt and Church, eds, *Dialogus de Scaccario*, pp. 191–3.

A Hall

1 Bradshawe's journal, quoted in Joseph George Muddiman and John Cook, *The Trial of King Charles I* (W. Hodge and Co. Ltd 1928), pp. 75–6.

2 Muddiman and Cook, *The Trial of King Charles I*, p. 81.

3 Muddiman and Cook, *The Trial of King Charles I*, p. 77.

4 Muddiman and Cook, *The Trial of King Charles I*, pp. 82–3.

5 Snorri Sturluson, *The Prose Edda*, tr. Arthur Gilchrist Brodeur (American Scandinavian Foundation 1916), p. 51.

6 Muddiman and Cook, *The Trial of King Charles I*, p. 129.

A Palace

1 Gavin Stamp, *Giles Gilbert Scott and the Rebuilding of the House of Commons*, in Christine and Jacqueline Riding, eds, *The Houses of Parliament: History, Art, Architecture* (Merrell 2000), p. 157.

2 Hansard 1943, in Riding and Riding, eds, *The Houses of Parliament*, p. 150.

3 Hansard 1943, in Riding and Riding, eds, *The Houses of Parliament*, p. 150.

4 Stamp, *Giles Gilbert Scott*, in Riding and Riding, eds, *The Houses of Parliament*, p. 152.

5 Hansard 1943, in Riding and Riding, eds, *The Houses of Parliament*, p. 150.

6 Stamp, *Giles Gilbert Scott*, in Riding and Riding, eds, *The Houses of Parliament*, p. 153.

7 Hansard 23 July 1836. http://hansard.millbanksystems.com/commons/1836/jul/21/new-houses-of-parliament (accessed 12 April 2012)

8 Hansard 23 April 1850. http://hansard.millbanksystems.com/commons/1836/jul/21/new-houses-of-parliament (accessed 12 April 2012)

9 Hansard 5 February 1851. http://hansard.millbanksystems.com/commons/1836/jul/21/new-houses-of-parliament (accessed 12 April 2012)

OBJECTS

A Cabinet of Curiosities

A Catalogue

1 Rotraud Bauer and Herbert Haupt, 'Das Kunstkammerinventar Kaiser Rudolfs II. 1607–11,' *Jahrbuch der Kunsthistorischen Sammlungen in Wien* LXXII (1976), p. 1.

2 Bauer and Haupt, 'Das Kunstkammerinventar,' *JKSW* LXXII (1976), p. 1.

A Cabinet

1 http://www.independent.co.uk/news/obituaries/sir-arthur-gilbert-729379.html

2 http://www.independent.co.uk/news/obituaries/sir-arthur-gilbert-729379.html

3 http://www.independent.co.uk/news/obituaries/sir-arthur-gilbert-729379.html

4 Peter Marshall, *The Theatre of the World: Alchemy, Astrology and Magic in Renaissance Prague* (Harvill Secker 2006), p. 74.

5 Marshall, *The Theatre of the World*, p. 73.

6 http://www.liechtensteinmuseum.at/en/pages/artbase_main.asp?module=browse&action=m_artist&lang=en&sid=7417362&oid=K-2672004103915343&config=1,1,1 (accessed 12 April 2012)

A Clock

1 F. Staudacher, *Jost Bürgi*, Swiss Physical Society. http://www.groups.dcs.stand.ac.uk/~history/Biographies/Burgi.html (accessed April 12.4.12)

2 http://collections.vam.ac.uk/item/O120887/mechanical-globe-clock/?print=1 (accessed 12 April 2012)

3 Tycho Brahe to Holger Rosencrantz, Prague, August 1599, quoted in Paula Findlen, *Cabinets, Collecting, and Natural Philosophy*, in Eliska Fucikova, ed., *Rudolf II and Prague: the Court and the City* (Prague Castle Administration/Thames and Hudson 1997), p. 217.

4 Oswald Croll, *Basilica Chymica*, quoted in Peter Marshall, *The Theatre of the World: Alchemy, Astrology and Magic in Renaissance Prague* (Harvill Secker 2006), p. 90.

5 Marshall, *The Theatre of the World*, p. 76.

6 Arthur Koestler, *The Sleepwalkers: A History of Man's Changing Vision of the Universe* (Penguin Books 1990), p. 325.

7 Nicolas Copernicus, *De Revolutionibus*, tr. Edward Rosen (John Hopkins University Press 1985). http://www.webexhibits.org/calendars/year-text-Copernicus.html (accessed 12 April 2012)

8 Johannes Kepler, *Astronomica Nova*, Chapter 49. http://wlym.com/~animations/part2/16/index.html accessed april 2012

9 Jean Strouse, *John Pierpont Morgan, Financier and Collector* (Metropolitan Museum of Art 2000), p. 22.

A Bowl and a Horn

1 'Einhorn, gantz lange,' Rotraud Bauer and Herbert Haupt, 'Das Kunstkammerinventar Kaiser Rudolfs II. 1607–11,' *JKSW* LXXII (1976), Entry no. 1 (author's own translation).

2 'Erstliche das schoenste, kostliche, grosseste, agatin beckhen oder vaso, darinne der nam b. Kristo stehet, mit handtheben abd allem von ganzem stuck schatzkammer,' Bauer and Haupt, 'Das Kunstkammerinventar Kaiser Rudolfs II. 1607–11,' *JKSW* LXXII (1976), Entry no. 1350 (author's own translation).

3 Philip Sidney to Francis Walsingham, May 1577, quoted in Peter Marshall, *The Theatre of the World: Alchemy, Astrology and Magic in Renaissance Prague* (Harvill Secker 2006), p. 38.

4 Marshall, *The Theatre of the World*, p. 56.

5 *Propositions to the Archdukes in Vienna 1606*, quoted in Marshall, *The Theatre of the World*, p. 120.

6 Marshall, *The Theatre of the World*, p. 98.

7 Frances A. Yates, *The Art of Memory* (Routledge and Kegan Paul 1966), p. 225.

A Museum

1 Eliska Fucikova, ed., *Rudolf II and Prague: The Court and the City* (Prague Castle Administration/Thames and Hudson 1997), p. 163.

DECOR

French Grey

1 Elsie de Wolfe, *New York Times*, 1 February 1914.

An Enchanted Island

1 Robert Ballard, *Complete Works of Molière: Les Plaisirs de L'Île Enchantée*, tr. Henri Van Laun (George Barrie 1820–96), p. 8.

2 Ballard, *Complete Works of Molière: Les Plaisirs de L'Île Enchantée*, p. 8.

3 Ballard, *Complete Works of Molière: Les Plaisirs de L'Île Enchantée*, p. 8.

4 Molière, *Complete Works of Molière: The Princess of Elis*, tr. Henri Van Laun (George Barrie 1820–96), p. 37.

5 Molière, *Complete Works of Molière: The Princess of Elis*, p. 24.

6 Molière, *Complete Works of Molière: The Princess of Elis*, p. 24.

7 Molière, *Complete Works of Molière: The Princess of Elis*, p. 28.

8 'Apres leur mejestés eurent êtes quelques temps dans cet endroit si charmant, et les dames eurent fait collation, le Roi abandonna les tables au pillage des gens qui suivent ... qui demolissaient ces châteaux de massepains, et ces montagnes de confitures,' Felibien, quoted in Philippe Beaussant, *Plaisirs de Versailles: Théâtre et Musique* (Fayard 1996), p. 41 (author's own translation).

9 Pierre de Nolhac, *Le Résurrection de Versailles, Souvenirs d'un Conservateur 1887–1920* (Plon 1937), p. 5.

Appartement

1 Pierre de Nolhac, *Le Résurrection de Versailles, Souvenirs d'un Conservateur 1887–1920* (Plon 1937), p. 187. 'Monsieur le Président, dis-je, vous venez d'achever l'oeuvre des grandes hommes de la monarchie ... vous avez abaissé la maison d'Aûtriches, detruit l'Empire, comme l'ont rêve Richelieu et Louis XIV' (author's own translation).

2 Mlle de Scudéry to Philemon, quoted in Guy Walton, *Louis XIV's Versailles* (Viking Penguin 1986), p. 115.

3 Mlle de Scudéry, *Conversations Sur Divers Sujets 1680*, quoted in *The Other Voice in Early Modern Europe*, tr. Jane Donawerth and Julie Strongson, eds (University of Chicago Press 2004), pp. 57–8.

4 *Mercure Galant*, December 1682, p. 48. http://gallica.bnf.fr/ark:/12148/bpt6k115298j/f4.image (accessed 12 April 2012) 'Le Roy, La Reyne, et toute la maison royale, descendent de leur grandeur pour jouer avec plusieurs de L'Assemblée qui n'ont jamais eu un pareil honneur. C'est icy ou les bontez et

les manieres du roi doivent paroistre toute engaegeantes' (author's own translation).

5 *Mercure Galant*, December 1682, p. 47. http://gallica.bnf.fr/ark:/12148/bpt6k115298j/f4.image (accessed 12 April 2012) 'La Liberté de parler y est entire et l'en s'entretient les uns les autres selon quand se plait a la conversations. Cependant le respect dans lequel chacun se tient, fait que personne ne haussant trop la voix ...' (author's own translation).

6 Mlle de Scudéry, *Conversations Sur Divers Sujets 1680*, quoted in *The Other Voice*, pp. 57–8.

7 Le Duc de Saint-Simon, quoted in Jaques Levron, *Daily Life at Versailles in the Seventeenh and Eighteenth Centuries* (Macmillan 1968), p. 67. 'Laissez les faire ... pourvu qu'ils ne nous brûlent pas!' (authors own translation).

Lever

1 Le Duc de Saint-Simon, David Widger, ed., *Memoirs of Louis*, Chapter LXXIV. http://www.gutenberg.org/files/3875/3875-h/3875-h.htm

2 Le Duc de Saint-Simon, Widger, ed., *Memoirs of Louis XIV*, chapter LXXII.

3 Le Duc de Saint-Simon, Widger, ed., *Memoirs of Louis XIV*, chapter LXXII.

4 Jean-Marie Perouse de Montclos, *Versailles*, tr. John Goodman (Abbeville Press, London 1991), p. 74.

Cabinet de la Chaise

1 Jean François Heurtier, quoted in Gilles Perrault, *Le cabinet des dépêches: histoire de la piece la plus secrète de Versailles* (Mille et Une Nuits 1998), p. 111. 'Les changements de l'arrière cabinet du roy donnent un ouvrage considérable et dont il etait impossible de prévoir la consequence avant d'y mettre le marteau parce que l'apparence et les rapports du charpentier joints à l'inspection des anciens plans annoncent une construction toute différente de celle qui existe en effet' (author's own translation).

2 D'Argenson, quoted in Perrault, *Le cabinet des dépêches*, p. 21. 'elle obsède le Roi continuellement, elle le secoue, elle agite, elle ne laisse pas un instant à lui même ...' (author's own translation).

3 D'Argenson, quoted in Perrault, *Le cabinet des dépêches*, p. 111. 'prendra goût au

travail: il aime déjà des papiers, l'étude et même beaucoup à écrire…il a fait faire des armoires dans un cabinet séparé et là ses papiers sont rangés dans un ordre soigneux, le tout étiqueté de sa propre main' (author's own translation).

The Last Boudoir of Marie Antoinette

1 *The Love Life of Charlie and Toinette 1779*, quoted in Chantal Thomas, *The Wicked Queen: The Origins of the Myth of Marie-Antoinette*, tr. Julie Ross (Zone Books), p. 186.

2 Marie Antoinette, quoted in Philippe Beaussant, *Plaisirs de Versailles: Théâtre et musique* (Fayard 1996), p. 212. Ici, je ne suis pas reine, je suis femme (author's translation)

3 Marie Antoinette to Maria Teresia 1774, quoted in Beaussant, *Plaisirs de Versailles*, p. 212. 'Je lis, je travaille … j'ai repris un peu le dessin, tout cela m'occupe et m'amuse' (author's own translation).

4 *The Visit of Doctor Meyer*, quoted in Gustave Desjardins, *Le Petit-Trianon: Histoire et Description* (L. Bernard 1885), pp. 358–9. 'Les salles et chambres étaient devastées (on avait enlèvé jusqu'au serrures des portes et fenêtres, superbe travail en bronze), les glaces cassées, les consoles brisées, les dessus deportés, peints arrâchés … des debris de differentes espèces de jeux, des chars brisées, des fragments de figures fantastiques d'animaux ayant servie à des traineaux …' (author's own translation).

COMMODITIES

All that is Solid Melts into Air

1 Walter Benjamin, quoted in Mario Praz, *An Illustrated History of Interior Decoration: From Pompeii to Art Nouveau*, tr. William Weaver (Thames and Hudson 1964), p. 24.

2 Ramus, *Scholae Dialecticae*, quoted in Frances A. Yates, *The Art of Memory* (Routledge and Kegan Paul 1966), p. 266.

A Great Exhibition

1 *The Times*, Monday 13 October 1851, quoted in C.R. Fay, *Palace of Industry, 1851:*

A Study of the Great Exhibition and Its Fruits (Cambridge University Press 1951), pp.126–35.

2 *The Times*, Monday 13 October 1851, quoted in Fay, *Palace of Industry*, pp. 126–35.

3 Queen Victoria, quoted in Fay, *Palace of Industry*, p. 54.

4 Queen Victoria, quoted in Fay, *Palace of Industry*, p. 65.

5 Queen Victoria, quoted in Fay, *Palace of Industry*, p. 59.

6 Queen Victoria, quoted in Fay, *Palace of Industry*, p. 59.

7 Queen Victoria, quoted in Fay, *Palace of Industry*, p. 59.

8 Queen Victoria, quoted in Fay, *Palace of Industry*, p. 46.

9 Queen Victoria, quoted in Fay, *Palace of Industry*, p. 57.

10 Queen Victoria, quoted in Fay, *Palace of Industry*, pp. 46–7.

11 Queen Victoria, quoted in Fay, *Palace of Industry*, p. 48.

12 Joseph Paxton in *Daily News*, 7 August 1851, quoted in Fay, *Palace of Industry*, p. 11.

13 *The Economist*, 13 April 1851, 396, quoted in Jeffrey A. Auerbach, *The Great Exhibition of 1851: A Nation on Display* (Yale University Press 1999), p. 119.

14 William Whewell, *Inaugural lecture, November 26, 1851: The General Bearing of the Great Exhibition on the Progress of Art and Science* (Royal Society of Arts 1851), p. 25.

15 John Ruskin, *The Stones of Venice*, quoted in Anthony Bird, *Paxton's Palace* (Cassell 1976), p. 120.

16 Auerbach, *The Great Exhibition of 1851*, p. 52.

17 Karl Marx and Friedrich Engels, *Manifesto of the Communist Party* in *Marx/Engels Selected Works, Vol. 1*, tr. Samuel Moore (Progress Publishers 1969), pp. 98–137. http://www.marxists.org/archive/marx/works/1848/communist-manifesto/cho1.htm#007 (accessed April 12.4.12)

18 *The Times*, 25 June 1850, quoted in Bird, *Paxton's Palace*, p. 25.

19 Fay, *Palace of Industry*, pp. 126–35.

20 Clement Shorter, ed., *The Brontes: Life and Letters* (Hodder and Stoughton 1908).

21 John Tallis, quoted in Auerbach, *The Great Exhibition of 1851*, p. 119.

22 *The Times*, Monday 13 October 1551, quoted in Fay, *Palace of Industry*, pp. 126–35.

A Gilded Cage

1 *The Times*, quoted in http://www.duke.edu/web/isis/crystalpalace/mzl/page4.html (accessed 12 April 2012)

2 Richard Hengist Horne, 'A Penitent Confession,' in *Household Words*, vol. III (1851), pp. 436–7. http://www.djo.org.uk/household-words/volume-iii/page-437.html?layout=restore (accessed 12 April 2012)

3 *The Guide-book to the Industrial Exhibition; with Facts, Figures and Observations on the Manufactures and Produce Exhibited* (Partridge and Oakey 1851), quoted in Patrick Beaver, *The Crystal Palace: A Portrait of Victorian Enterprise* (Hugh Evelyn 1970), pp. 74–5.

4 Horne, 'A Penitent Confession,' in *Household Words*, vol. III (1851), p. 437.

5 Tallis's *History*, in Paul Young, '"Carbon, mere carbon": The Kohinoor, the Crystal Palace, and the Mission to Make Sense of British India,' *Nineteenth-Century Contexts*, vol. 29, no. 4 (December 2007), p. 345.

6 http://famousdiamonds.tripod.com/koh-i-noordiamond.html (accessed 12 April 2012)

7 Horne, 'A Penitent Confession,' in *Household Words*, vol. III (1851), p. 437.

8 Horne, 'A Penitent Confession,' in *Household Words*, vol. III (1851), p. 437.

9 Horne, 'A Penitent Confession,' in *Household Words*, vol. III (1851), p. 437.

10 Horne, 'A Penitent Confession,' in *Household Words*, vol. III (1851), p. 437.

11 Horne, 'A Penitent Confession,' in *Household Words*, vol. III (1851), p. 439.

12 Horne, 'A Penitent Confession,' in *Household Words*, vol. III (1851), p. 442.

13 Horne, 'A Penitent Confession,' in *Household Words*, vol. III (1851), p. 445.

14 http://famousdiamonds.tripod.com/koh-i-noordiamond.html (accessed 12 April 2012)

15 Ian Balfour, *Famous Diamonds* (Antique Collectors' Club 1987), p. 24.

16 http://famousdiamonds.tripod.com/koh-i-noordiamond.html (accessed 24.10.11)

17 Young, '"Carbon, mere carbon".'

18 http://www.museumdiamonds.com/~scottsuc/index.php/koh-i-noor.html
 (accessed April 2012)

Spending a Penny

1 Lawrence Wright, *Clean & Decent: The Fascinating History of the Bathroom and the
 Water-Closet Principally in Great Britain, France and America* (Routledge and Kegan
 Paul 1960), p. 200.

2 Wright, *Clean & Decent*, p.201.

3 *The Times*, 6 June 1851.

4 Wright, *Clean & Decent*, p. 201.

5 *The Times*, 26 May 1851.

6 Dominique Laporte, *A History of Shit*, tr. Nadia Benabid and Rodolphe El-
 Khoury (MIT Press 2000), p. 4.

7 Laporte, *A History of Shit*, p. 5.

8 Mayhew, quoted in Wright, *Clean & Decent*, p. 154.

9 Halliday, Stephen, *The Great Stink of London: Sir Joseph Bazalgette and the
 Cleansing of the Victorian Capital* (Sutton Publishing Ltd 1999), p. 35.

10 Halliday, *The Great Stink of London*, p. 41.

11 Karl Marx and Friedrich Engels, *Manifesto of the Communist Party*, in *Marx/Engels
 Selected Works Vol. 1*, tr. Samuel Moore (Progress Publishers 1969), pp. 98–137.
 http://www.marxists.org/archive/marx/works/1848/communist-
 manifesto/ch01.htm#007 (accessed April 12.4.12)

A Model Cottage

1 James Stevens Curl, *The Life and Work of Henry Roberts 1803–1876 Architect: The
 Evangelical Conscience and the Campaign for Model Housing and Healthy Nations*
 (Phillimore 1983), p. 106.

2 Henry Morley, *Household Words*, 5 July 1851, vol. III. http://www.djo.org.uk/
 household-words/volume-iii/page-337.html (accessed 12 April 2012)

3 Henry Morley, *Household Words*.

4 *Punch*, 1 February 1851, quoted in C.R. Fay, *Palace of Industry, 1851: A Study of the Great Exhibition and Its Fruits* (Cambridge University Press 1951), p. 42.

5 Henry Roberts, in *The Builder*, vol. IX (1851), 311–2, quoted in Curl, *The Life and Work of Henry Roberts*, p. 69.

6 *The Times*, 13 June 1851, quoted in Jeffrey A. Auerbach, *The Great Exhibition of 1851: a Nation on Display* (Yale University Press 1999), p. 111.

7 Henry Morley, *Household Words*.

8 Henry Morley, *Household Words*. http://www.djo.org.uk/household-words/volume-iii/page-335.html (accessed 12 April 2012)

9 Charles Dickens, 'Spitalfields,' from *Household Words*, 15 April 1851, in Harry Stone, ed., *Charles Dickens' Uncollected Writings from Household Words, 1850–1859* (Indiana University Press 1968), pp. 233–4.

10 Dickens 'Spitalfields' from *Household Words*, 15 April 1851 (Stone, Harry ed.) *Charles Dickens' Uncollected Writings from 'Household Words' 1850–1859* (Indiana University Press 1968), p. 231.

11 Henry Morley, *Household Words*.

12 Edward Reynolds, 'The Impostor Representatives of England's Labour', *Reynolds' Newspaper*, 24 August 1851, p. 7, quoted in Peter Gurney, *The Exhibition of 1851, an Appropriated Space*, in Louise Purbrick, ed., *The Great Exhibition of 1851: New interdisciplinary essays* (Manchester University Press 2001), pp. 121–51.

13 Curl, *The Life and Work of Henry Roberts*, p. 53.

A Crystal Palace

1 Daisy Ashford, *The Young Visiters* (Chatto and Windus 1919), p. 1. http://www.gutenberg.org/files/21415/21415-h/21415-h.htm (accessed 12 April 2012)

2 Ashford, *The Young Visiters*, p. 1.

3 Ashford, *The Young Visiters*, p. 43.

4 Ashford, *The Young Visiters*, pp. 49–51.

5 Ashford, *The Young Visiters*, pp. 56–7.

6 *The Graphic Bird*, guidebook published by the Crystal Palace (1871), p. 131.

7 *Express*, 15 October 1851, quoted in Jeffrey A. Auerbach, *The Great Exhibition of 1851: A Nation on Display* (Yale University Press 1999), p. 121.

8 C.R. Fay, *Palace of Industry, 1851: A Study of the Great Exhibition and Its Fruits* (Cambridge University Press 1951), p. 71.

9 *Punch*, vol. XXII, quoted in Fay, *Palace of Industry, 1851*, p.113.

10 *Punch*, vol. XXII, quoted in Fay, *Palace of Industry, 1851*, p. 155.

11 *Weekly Record of the Temperance Movement*, 11 August 1860, pp. 357–8, quoted in Peter Gurney, *The Exhibition of 1851, an Appropriated Space*, in Louise Purbrick, ed., *The Great Exhibition of 1851: New interdisciplinary essays* (Manchester University Press 2001), p. 129.

12 Karl Marx and Friedrich Engels, *Manifesto of the Communist Party*, in *Marx/Engels Selected Works Vol. 1*, tr. Samuel Moore (Progress Publishers 1969), pp. 98–137. http://www.marxists.org/archive/marx/works/1848/communist-manifesto/ch01.htm#007 (accessed April 12.4.12)

13 Karl Marx, *Das Kapital*, in *Marx/Engels Selected Works Vol. 1*. http://www.marxists.org/archive/marx/works/1867-c1/ch02.htm (accessed 12 April 2012)

IMAGES

A Screen

1 Grace Lees-Maffei and Rebecca Houze, eds, *The Design History Reader* (Berg 2010), p. 183.

A Curtain

1 'Making *Gone With The Wind*,' Pt. 1/5, *Our World*, ABC, 1987. http://www.youtube.com/watch?v=DroCn55mgnU (accessed 12 April 2012)

2 David O. Selznick, *Gone with the Wind*, 1939.

3 http://www.hrc.utexas.edu/exhibitions/web/gwtw/wardrobe/curtain/curtchoose.html (accessed 12 April 2012)

4 http://www.hrc.utexas.edu/exhibitions/web/gwtw/wardrobe/curtain/curtchoose.html(accessed 12 April 2012)

5 http://www.utexas.edu/opa/blogs/culturalcompass/2010/11/30/conservation-work-begins-on-gone-with-the-wind-dresses-with-study-of-stitching-and-construction/ (accessed 12 April 2012)

6 http://www.utexas.edu/opa/blogs/culturalcompass/2010/11/30/conservation-work-begins-on-gone-with-the-wind-dresses-with-study-of-stitching-and-construction/ (accessed 12 April 2012)

7 'Making *Gone With The Wind*', Pt. 1/5.

8 David O. Selznick, quote in http://www.retroweb.com/40acres_gwtw.html (accessed 20.1.13)

A Box

1 Margaret Lane, 'The Queen is Crowned,' *New Statesman*, June 1953, in Tom Nairn, *The Enchanted Glass: Britain and Its Monarchy* (Radius 1988), p. 17.

2 'Rosina Rowland, California.' http://news.bbc.co.uk/onthisday/hi/witness/june/2/newsid_2947000/2947912.stm (accessed 12 April 2012)

3 'John, Canada.' http://news.bbc.co.uk/onthisday/hi/witness/june/2/newsid_2947000/2947912.stm (accessed 12 April 2012)

4 *Manchester Evening Chronicle*, 1953.

5 BBC broadcasting schedule, 2 June 1953. http://www.bbctv-ap.co.uk/coronam.htm (accessed 12 April 2012)

6 'Sally Freeman, Australia.' http://news.bbc.co.uk/onthisday/hi/witness/june/2/newsid_2947000/2947912.stm (accessed 12 April 2012)

7 'Dave, Japan.' http://news.bbc.co.uk/onthisday/hi/witness/june/2/newsid_2947000/2947912.stm (accessed 12 April 2012)

8 'John Canada.'

9 Gary A. Steiner, *The People Look at Television: A Study of Audience Attitudes*, a report of a study at the bureau of applied social research, Columbia University (Alfred A. Knopf 1963), p. 79.

10 Peter Conrad, *Television: The Medium and its Manners* (Rouledge and Kegan Paul 1982), p. 11.

11 http://www.bbc.co.uk/historyofthebbc/resources/tvhistory/memories.shtml (accessed 12 April 2012)

12 Peter Dimmock, in *We Bring You Live Pictures – On This Historic Day*.
 http://www.youtube.com/watch?v=vKIHlSUrhl4 (accessed 12 April 2012)

13 Richard Dimbleby, commentary on coronation 1953. http://www.bbc.co.uk/
 historyofthebbc/resources/tvhistory/memories.shtml (accessed 12 April 2012)

14 Conrad, *Television: The Medium and its Manners*, p. 44.

15 Margaret Lane, 'The Queen is Crowned,' *New Statesman*, June 1953, in Nairn,
 The Enchanted Glass, p.17.

A House

1 *Intra Magazine*, August 2007, p. 27.

2 Kate Lawler, 12 July 2002, quoted in Su Holmes and Deborah Jermyn, eds,
 Understanding Reality Television (Routledge 2004), p. 118.

3 Holmes and Jermyn, eds. *Understanding Reality Television*, p. 120.

4 Holmes and Jermyn, eds, *Understanding Reality Television*, p. 117.

5 Holmes and Jermyn, eds, *Understanding Reality Television*, p. 117.

6 Holmes and Jermyn, eds, *Understanding Reality Television*, p. 120.

7 Holmes and Jermyn, eds, *Understanding Reality Television*, p. 132.

8 Holmes and Jermyn, eds, *Understanding Reality Television*, p. 104.

9 George Orwell, *Nineteen Eighty-Four* (Secker and Warburg 1949).
 http://www.george-orwell.org/1984/0.html (accessed 12 April 2012)

A Labyrinth

1 Lovecraft in *Quake*, Sources and Inspiration. http://www.quaddicted.com/
 webarchive/kell.quaddicted.com/stuff_lovecraftinquake.html (accessed 31.8.12)

2 'Goblin', *Thresh: the Legend of Quake*. http://webcache.googleusercontent.com/
 search?q=cache:6BJ2MyecXD4J:www.cyberfight.org/offline/strategy/52/+&cd
 =9&hl=en&ct=clnk&gl=uk (accessed 4.4.12)

3 'Goblin', *Thresh: the Legend of Quake*.

4 'Goblin', *Thresh: the Legend of Quake*.

5 'Goblin', *Thresh: the Legend of Quake*.

6 'Goblin', *Thresh: the Legend of Quake*.

7 David Kushner, *Masters of Doom: How Two Guys Created an Empire and Transformed Pop Culture* (Random House 2003), p. 295.

8 'Goblin', *Thresh: the Legend of Quake*.

9 http://mpqarchive.pauked.com/index.php?view=viewcomments&review_link=17378 (accessed 12 April 2012)

10 http://mpqarchive.pauked.com/index.php?view=viewcomments&article_link=71 (accessed 12 April 2012)

11 http://www.quaddicted.com/webarchive/teamshambler.planetquake.gamespy.com/A2-DD_SP.txt (accessed 12 April 2012)

12 http://www.quaddicted.com/webarchive/teamshambler.planetquake.gamespy.com/A2-DD_SP.txt (accessed 12 April 2012)

13 http://mpqarchive.pauked.com/index.php?view=viewcomments&article_link=58 (accessed 12 April 2012)

14 'Goblin', *Thresh: the Legend of Quake*.

A Cloud

1 *The Wi-Fi Alliance: An In-depth Look.* http://www.wi-fi.org/knowledge-center/articles/wi-fi-alliance-depth-look (accessed 12 April 2012)

2 *Cloud Computing Trends to Watch in 2012 (part 2)* on *Data Center Knowledge.* http://www.datacenterknowledge.com/cloud-computing-trends-to-watch-in-2012-part-2/ (accessed 12 April 2012)

3 *Who Will Win the Cloud in 2012?* on *Seeking Alpha.* http://seekingalpha.com/article/319545-who-will-win-the-cloud-in-2012 (accessed 12 April 2012)

4 Jelle van der Zwet, 'The World According to Cloud at Cloud Expo New York,' *Cloud Computing Journal,* 5 April 2012. http://cloudcomputing.sys-con.com/node/2234438?utm_source=twitterfeed&utm_medium=twitter (accessed 12 April 2012)

5 http://www.apple.com/uk/icloud/?cid=mc-uk-g-icloud-icloud

6 E. Laveille, *The Life of Father De Smet, S. J.* (P.J. Kenedy and Sons 1915), p. 83.

Acknowledgements

FIRSTLY, I MUST THANK KATE DYSON, WHO AWAKENED ME TO THE pleasures of the interior when I was young, and Les Maden, who gave me the opportunity to rekindle that interest when I entered academia a decade and a half ago.

I'd also like to thank those who have worked so hard in recent years to grow this field as an area for study, particularly my colleagues in the Interiors Forum Scotland, notably Andrew Milligan, who has also contributed a great deal to the story of the Big Brother House narrated here.

There are many who have lent their expertise and editorial eye to various sections of the book: Leo Hollis, Rachel and Stephen Holmes, Elspeth Jajdelska, Emma Gieben-Gamal, Jared Taylor, Jonny Murray, Brendan de Caires and my mother. There are also those who have helped me in various researches, among them Heike Zech at the V&A, and Mark Collins at the Palace of Westminster.

And then there are a great many people who have put up with having a writer around: the students who have tolerated my experimenting on

them in lectures; my colleagues, notably Alan Murray, Juliette Macdonald, Willie Brown and Rachel Simmonds; and most importantly my partner Paul.

I'd like to thank those whose patience and trust have turned the book from whim to reality: Patrick Walsh my agent, Philip Gwyn Jones my editor, Prue Rowlandson, Sally Green, Christine Lo and the team at Portobello Books.

And last and most of all, of course, I have to thank my grandmother.

Bibliography

Aitchison, Nick. *Scotland's Stone of Destiny: Myth, History and Nationhood*. Tempus 2000.

Amt, Emilie and Church, Stephen, eds. *Dialogus de Scaccario, and Constitutio Domus Regis/ The Dialogue of the Exchequer, and The Establishment of the Royal Household*. Oxford University Press 2007.

Ashford, Daisy. *The Young Visiters*. Chatto & Windus 1919.

Auerbach, Jeffrey A. *The Great Exhibition of 1851: A Nation on Display*. Yale University Press 1999.

Babbage, Charles. *The Exposition of 1851*. Frank Cass 1968.

Baillie, H.M. 'Etiquette and the Planning of the State Apartments in Baroque Palaces.' *Archaologia*, vol. 101 (January 1967), pp. 169–99.

Balfour, Ian. *Famous Diamonds*. Antique Collectors' Club 2009.

Ball, Victoria Kloss. *Architecture and Interior Design*. John Wiley 1980.

Barnett, Anthony, ed. *The Power and the Throne: The Monarchy Debate*. Vintage 1994.

Barnwell, Jane. *Production Design: Architects of the Screen*. Wallflower Press 2004.

Barthes, Roland. *Arcimboldo*. Franco Maria Ricci Editore 1978.

Barton, Ian, ed. *Roman Domestic Buildings*. University of Exeter Press 1996.

Bastide, Jean François de. *The Little House: An Architectural Seduction*, tr. Rodolphe El-Khoury. Princeton Architectural Press 1996.

Bauer, Rotraud, and Haupt, Herbert, eds. 'Das Kunstkammerinventar Kaiser Rudolfs II 1607–11.' *Jahrbuch der Kunsthistorischen Sammlungen in Wien*, 72 (1976).

Baynes, Norman. *Byzantine Studies and Other Essays.* Athlone Press 1955.

Beaussant, Philippe, and Bouchenot-Dechin, Patricia. *Les plaisirs de Versailles: Théâtre et musique.* Fayard 1996.

Beaussant, Philippe. *Le Roi-Solei se lève aussi.* Gallimard 2000.

Beaver, Patrick. *The Crystal Palace: A Portrait of Victorian Enterprise.* Hugh Evelyn 1970.

Berger, Robert W. 'The Chronology of the Enveloppe of Versailles.' *Architectura*, vol. 10 (1980), pp.105–33.

Biddle, Martin. *King Arthur's Round Table: An Archaeological Investigation.* Boydell Press 2000.

Binski, Paul. *The Painted Chamber at Westminster.* Society of Antiquaries 1986.

Bird, Anthony. *Paxton's Palace.* Cassell 1976.

Bluche, François. *Le Journal secret de Louis XIV.* Éditions du Rocher 1998.

Boëthius, Axel. *The Golden House of Nero: Some Aspects of Roman Architecture.* University of Michigan Press 1960.

von Borries, Friedrich, Walz, Steffen P., and Böttger, Matthias, eds. *Space Time Play: Computer Games, Architecture and Urbanism: The Next Level.* Birkhäuser 2007.

Buonanno, Milly. *The Age of Television: Experiences and Theories*, tr. Jennifer Radice. University of Chicago Press Books 2007.

Byars, Mel, and Barré-Despond, Arlette. *100 Designs/100 Years: Innovative Designs of the 20th Century.* RotoVision 1999.

Campkin, Ben and Cox, Rosie, eds. *Dirt: New Geographies of Cleanliness and Contamination.* I.B. Tauris 2007.

Cath, K.J., Geertman, Prof. Dr. H.A.A.P., and Goedkoop, C.H., eds. *Leids Kunsthistorisch Jaarboek 1892: Rudolf II and his Court.* Delftse Uitgevers Maatschappij B.V. 1982.

Chandernagor, Françoise. *The King's Way.* Harvill Press 1984.

Church, Ella Rodman. *How to Furnish a Home.* D. Appleton and Co. 1881.

Church, William Farr. *Louis XIV in Historical Thought.* Norton 1976.

Cicero. *Ad Herennium*, tr. Harry Caplan. Loeb Classical Library 1954.

Clark, John R. *The Houses of Roman Italy 100 B.C.–A.D. 250: Ritual, Space, and Decoration.* University of Califorinia Press 1991.

Comnena, Anna. *The Alexiad of the Princess Anna Comnena*, tr. Elizabeth A.S. Dawes. Kegan, Paul, Trench, Truber and Co. 1928.

Conrad, Peter. *Television: The Medium and its Manners.* Routledge & Kegan Paul 1982.

Constantine Porphyrogenitos. *Le Livre Des Ceremonies Tome 1*, tr. Albert Vogt. Société d'Édition Les Belles Lettres 1935.

Copernicus, Nicolas. *De revolutionibus orbium coelestium (On the revolutions of the heavenly spheres)*, tr. Edward Rosen. John Hopkins University Press 1985.

Copland, Aaron. *How we Listen*. 1939. http//www.montgomeryschoolsmd.org/uploadedFiles/schools/wheatonhs/departments/aphonors/CoplandHowWeListen.pdf (accessed April 2012)

The Crystal Palace Exhibition: Illustrated Catalogue London (1851). Reprinted by Dover Publications 1970.

Curl, James Stevens. *The Life and Work of Henry Roberts 1803–1876 Architect: The Evangelical Conscience and the Campaign for Model Housing and Healthy Nations*. Phillimore & Co. Ltd 1983.

Da Costa Kaufmann, Thomas. *Variations on the Imperial Theme in the Age of Maximilian II and Rudolf II*. Garland Publishing 1978.

Darley, Andrew. *Visual Digital Culture: surface play and spectacle in new media genres*. Routledge 2000.

Dean, Christopher. *Arthur of England: English Attitudes to King Arthur and the Knights of the Round Table in the Middle Ages and the Renaissance*. University of Toronto Press 1987.

Desjardins, Gustave. *Le Petit-Trianon: Histoire et Description*. L. Bernard, 1885.

Dickens, Charles, in Stone, Harry, ed. *The Uncollected Writings of Charles Dickens: Household Words 1850–1859*, Volume 1. Allen Lane 1968.

Doel, Fran and Geoff, and Lloyd, Terry. *Worlds of Arthur: King Arthur in History, Legend & Culture*. Tempus 1999.

Donawerth, Jane, and Strongson, Julie, eds. *The Other Voice in Early Modern Europe*. University of Chicago Press 2004.

Fay, Charles Ryle. *Palace of Industry, 1851: A Study of the Great Exhibition and Its Fruits*. Cambridge University Press 1951.

Fell, Bryan H., and Mackenzie, K.R. *The Houses of Parliament: A Guide to the Palace of Westminster*. HMSO 1930 (fifteenth edn 1994).

Fenton, Edward, ed. *The Diaries of John Dee*. Day Books, Charlbury 1998.

Flete, John (J. Robinson, ed.). *The History of Westminster Abbey*. Cambridge Universtiy Press 1909.

Foucault, Michel. *The Order of Things: An Archaeology of the Human Sciences*. Routledge 2012.

Fucikova, Eliska, ed. *Rudolf II and Prague: The Court and the City*. Prague Castle Administration/Thames and Hudson 1997.

Gallet-Guerne, Danielle, and Baulez, Christian. *Versailles, Dessins d'Architecture de la Direction Générale des Bâtiments du Roi.* National Archives, France 1983–9.

Garrigues, Dominique. *Jardins et Jardiniers de Versailles au Grande Siècle.* Champ Vallon 2001.

Geanakoplos, Deno John. *Byzantium: Church, Society, and Civilization Seen through Contemporary Eyes.* University of Chicago Press 1986.

Gerber, Pat. *Stone of Destiny.* Canongate Books 1992.

Gibbs-Smith, C.H. *The Great Exhibition of 1851: A Commemorative Album.* HMSO 1950.

Gould, Cecil. *Bernini in France: An Episode in Seventeenth-Century History.* Princeton University Press 1981.

Graafland, Arie. *Versailles and the Mechanics of Power, The Subjugation of Circe: An Essay.* 010 Publishers 2003.

Grant, Michael. *Nero, Emperor in Revolt.* American Heritage Press 1970.

The Graphic Bird. Crystal Palace 1871.

Greed, Clara. *Inclusive Urban Design: Public Toilets.* Architectural Press 2003.

Green, William. 'The Lupercalia in the Fifth Century.' *Classical Philology*, vol. 26, no. 1 (January 1931), pp. 60–69.

Greene, Sir Hugh. *The Third Floor Front: A View of Broadcasting in the Sixties.* The Bodley Head 1969.

Griffin, Miriam T. *Nero, the End of a Dynasty.* Batsford 1984.

Hales, Shelley. *The Roman House and Social Identity.* Cambridge University Press 2003.

Halliday, Stephen. *The Great Stink of London: Sir Joseph Bazalgette and the Cleansing of the Victorian Capital.* Sutton Publishing 1999.

Hamilton, Ian. *The Taking of the Stone of Destiny.* Lochar Publishing 1991.

Hanawalt, Barbara A., and Wallace, David, eds. *Bodies and Disciplines: Intersections of Literature and History in Fifteenth-Century England.* University of Minnesota Press 1996.

Hansard: the UK Parliament Record. http://hansard.millbanksystems.com/commons/1836/jul/21/new-houses-of-parliament (accessed 12.4.12)

Haupt, Herbert, Irblich, Eva, Staudinger, Manfred, and Vignau-Wilberg, Thea. *Le Bestiaire de Rodolphe II.* Editions Citadelles 1991.

Hautecoeur, Louis. *Louis XIV: Roi Soleil.* Librairie Plon 1953.

Hendrix, Lee. *Nature Illuminated: Flora and Fauna from the Court of Rudolf II.* Getty Trust Publications: J. Paul Getty Museum 1997.

Hendrix, Lee, and Vignau-Wilberg, Thea. *An Abecedarium: Illuminated Alphabets from the Court of the Emperor Rudolf II.* Thames & Hudson/J. Paul Getty Museum 1997.

Higham, N.J. *King Arthur: Myth-Making and History*. Routledge 2002.

Hobhouse, Christopher. *1851 and the Crystal Palace: Being an Account of the Great Exhibition and its Contents; of Sir Joseph Paxton; and of the Erection, the Subsequent History and the Destruction of his Masterpiece*. E.P. Dutton 1937.

Hobhouse, Hermione. *The Crystal Palace and the Great Exhibition: Art, Science and Productive Industry: A History of the Royal Commission for the Exhibition of 1851*. Athlone Press 2002.

Holmes, Su and Jermyn, Deborah, eds. *Understanding Reality Television*. Routledge 2004.

Hoog, Simone, ed. *Les Jardins de Versailles et de Trianon D'André Le Nôtre à Richard Mique*. Réunion des Musées Nationaux 1992.

Hopkins, Harry. *The New Look: A Social History of the Forties and Fifties in Britain*. Secker and Warburg 1963.

Horne, Richard Hengist. 'A Penitent Confession.' *Household Words*, vol. III (1851), pp. 436–7. http://www.djo.org.uk/household-words/volume-iii/page-437.html?layout=restore (accessed 12.4.12)

Hoskins, Lesley, ed. *The Papered Wall: The History, Patterns and Techniques of Wallpaper*. Thames and Hudson 1994.

Hunt, Alice. *The Drama of Coronation: Medieval Ceremony in Early Modern England*. Cambridge University Press 2008.

James, Liz, ed. *A Companion to Byzantium*. Wiley-Blackwell 2010.

Jestaz, Bertrand. 'Trianon.' *Gazette des Beaux Arts* (1964).

Jestaz, Bertrand. *Jules Hardouin-Mansart: Vie et Oeuvre*. Éditions A. et J. Picard 2008.

Joergensen, Dolly. 'The Metamorphosis of Ajax, jakes, and early modern urban sanitation.' *Early English Studies*, vol. 3 (2010).

Jones, Colin. *Madame de Pompadour: Images of a Mistress*. Yale University Press 2002.

Kazhdan, Arthur, ed. *The Oxford Dictionary of Byzantium*. Oxford University Press 1991.

Keating, Patrick. *Hollywood Lighting, from the Silent Era to Film Noir*. Columbia University Press 2010.

Koestler, Arthur. *The Sleepwalkers: A History of Man's Changing Vision of the Universe*. Macmillan 1959.

Kulturstifftung Ruhr Essen/Kunsthistorisches Museum Wien. *Prag Um 1600: Kunst und Kultur am Hofe Kaiser Rudolfs II*. Luca Verlag Freren 1988.

Kushner, David. *Masters of Doom: How Two Guys Created an Empire and Transformed Pop Culture*. Random House 2003.

Lange, Lillian. *Grott of Thetys*. Art de France 1961.

Laporte, Dominique. *A History of Shit*, tr. Nadia Benabid and Rodolphe El-Khoury. MIT Press 2000.

Laveille, E. *The Life of Father De Smet, S. J. (1801–1873)*. P.J. Kenedy and Sons 1915.

Lees-Maffei, Grace, and Houze, Rebecca, eds. *The Design History Reader*. Berg 2010.

Lethaby, William. *Westminster Abbey Re-Examined*. Hazell, Watson and Viney 1925.

Levron, Jacques. *Daily Life at Versailles in the Seventeenth and Eighteenth Centuries*. Macmillan 1968.

Liutprand. *Relatio*, tr. Ernest Henderson, in *Select Historical Documents of the Middle Ages*. George Bell 1910.

Lough, John. *Seventeenth-Century French Drama: The Background*. Clarendon Press 1979.

Louis XIV (Simone Hoog, ed.). *Manière de montrer les jardins de Versailles*. Éditions de la Réunion des Musées Nationaux 1982.

Lunenfeld, Peter. *The Digital Dialectic: New Essays on New Media*. The MIT Press 1999.

Lupack, Alan. *The Oxford Guide to Arthurian Literature and Legend*. Oxford University Press 2005.

McCorquodale, Charles. *The History of Interior Decoration*. Vendome Press 1983.

McKean, John. *Crystal Palace, Architecture in Detail*. Phaidon Press 1994.

McKellar, Susie, and Sparke, Penny, eds. *Interior Design and Identity*. Manchester University Press 2004.

McLean, Adam, ed. *The Amphitheatre Engravings of Heinrich Khunrath*, tr. Patricia Tahil. Phanes Press 1981.

Maguire, Henry, ed. *Byzantine Court Culture from 829 to 1204*. Harvard University Press 1997.

Making *Gone With The Wind*, Pt. 1/5, *Our World*, ABC 1987. http://www.youtube.com/watch?v=DroCn55mgnU (accessed 12.4.12)

Malitz, Jürgen. *Nero*, tr. Allison Brown. Blackwell Publishing 2005.

Marie Antoinette, Archiduchesse, Dauphine, et Reine (exhibition catalogue). Éditions des Musées Nationaux 1955.

Marshall, Peter. *The Theatre of the World: Alchemy, Astrology and Magic in Renaissance Prague*. Harvill Secker 2006.

Marx, Karl and Engels, Friedrich. *Marx/Engels Selected Works*, vol. 1. Progress Publishers 1969.

Massey, Anne. *Interior Design of the 20th Century*. Thames and Hudson 1990.

Mercure Galant. http://gallica.bnf.fr/ark:/12148/bpt6k115298j/f4.image (accessed 12.4.12)

Miles, Gary B. *Livy: Reconstructing Early Rome*. Cornell University Press 1995.

Mitchell, Margaret. *Gone with the Wind*. Scribner 2011.

Mitford, Nancy. *The Sun King*. HarperCollins 1966.

Moine, Marie-Christine. *Les Fêtes à la Cour du Roi Soleil 1653–1715*. Éditions Fernand Lanore 1984.

Molière, J.B. Pocquelin. *The Dramatic Works of J.B. Poquelin Molière, vol. 2: The School for Husbands, The Bores, The School for Wives, The School for Wives Criticised, The Impromptu of Versailles, The Forced Marriage*, tr. Henri Van Laun. William Paterson 1878.

Molière, J.B. Poquelin. *The Dramatic Works of J.B. Poquelin Molière, vol. 3: The Princess of Elis, Don Juan, or, The Feast with the Statue, Love is the Best Doctor, The Misanthrope, The Physician in Spite of Himself*, tr. Henri Van Laun. William Paterson 1878.

Montclos, Jean-Marie Perouse de. *Versailles*, tr. John Goodman. Abbeville Press 1991.

Montespan, Marquise de. *Memoirs*. H.S. Nichols and Co. 1895.

Muddiman, Joseph George, and Cook, John. *The Trial of King Charles I*. W. Hodge and Co. Ltd 1928.

Muneles, Otto, ed. *Prague Ghetto in the Renaissance Period*. The State Jewish Museum in Prague 1965.

Murray, Susan, and Ouellette, Laurie, eds. *Reality TV: Remaking Television Culture*. New York University Press 2009.

The music, with the form and order of the service to be performed at the Coronation of Her Most Excellent Majesty Queen Elizabeth II in the Abbey Church of Westminster on Tuesday the 2nd day of June 1953. Novello 1953.

Nairn, Tom. *The Enchanted Glass: Britain and its Monarchy*. Radius 1988.

Nolhac, Pierre de. *La Création de Versailles*. L. Conard 1901.

Nolhac, Pierre de. *Versailles, Résidence de Louis XIV*. L. Conard 1925.

Nolhac, Pierre de. *Versailles au XVIII siècle*. L. Conard 1926.

Nolhac, Pierre de. *Trianon*. L. Conard 1927.

Nolhac, Pierre de. *La Résurrection de Versailles, Souvenirs d'un Conservateur 1887–1920*. Plon 1937.

Official Descriptive and Illustrated Catalogue of the Great Exhibition of the Works of Industry of All Nations, 1851. Spicer Brothers 1851.

Orsenna, Érik. *Portrait d'un homme heureux: André Le Nôtre 1613–1700*. Fayard 2000.

Orwell, George. *Nineteen Eighty-Four*. Secker and Warburg 1949. http://www.george-orwell.org/1984/0.html (accessed 12 April 2012)

Ovid. *Fasti*, tr. Sir James George Frazer. http://www.theoi.com/Text/OvidFasti4.html (accessed 1 April 2012)

Parissien, Steven. *Interiors: The Home Since 1700*. Laurence King 2008.

Pearce, Christopher. *Fifties Source Book*. Virgin Quarto 1990.

Perec, Georges. *Species of Spaces and Other Pieces*, tr. John Sturrock. Penguin Classics 1997.

Perrault, Gilles. *Le cabinet des dépêches: Histoire de la pièce la plus secrète de Versailles*. Mille et Une Nuits 1998.

Pevsner, Nikolaus. *High Victorian Design: A Study of the Exhibits of 1851*. Architectural Press 1951.

Pile, John. *A History of Interior Design*. Wiley 2000.

Plutarch. *Parallel Lives*, tr. Bernadotte Perrin. Loeb 1914.

Praz, Mario. *An Illustrated History of Interior Decoration: From Pompeii to Art Nouveau*, tr. William Weaver. Thames and Hudson 1964.

Praz, Mario. *The House of Life*, tr. Angus Davidson. Methuen 1964 (originally Arnoldo Mondadori Editore 1958).

Pryce, Hugh, and Watts, John, eds. *Power and Identity in the Middle Ages: Essays in Memory of Rees Davies*. Oxford University Press 2007.

Purbrick, Louise, ed. *The Great Exhibition of 1851: New Interdisciplinary Essays*. Manchester University Press 2001.

Raley, Rita. *Tactical Media*. University of Minnesota Press 2009.

Ramírez, Juan Antonio. *Architecture for the Screen: A Critical Study of Set Design in Hollywood's Golden Age*. McFarland and Co. Inc. 2004.

Riding, Christine and Jacqueline. *The Houses of Parliament: History, Art, Architecture*. Merrell 2000.

Riewoldt, Otto. *Intelligent Spaces: Architecture for the Information Age*. Laurence King 1997.

Rosser, Gervase. *Medieval Westminster 1200–1540*. Clarendon Press 1989.

Safran, Linda. *Heaven on Earth: Art and the Church in Byzantium*. Pennsylvania State University Press 1998.

Saint-Simon, Louis, Duc de. *Versaille, the Court and Louis XIV*, tr. Lucy Norton. Harper and Row 1958.

Selznick, David O. *Gone with the Wind*. Produced by Selznick International Pictures 1939.

Shorter, Clement, ed. *The Brontes: Life and Letters*. Hodder and Stoughton 1908.

Sparke, Penny. *Elsie De Wolfe: The Birth of Modern Interior Decoration*. Acanthus Press 2005.

Spence, Jonathan D. *The Memory Palace of Matteo Ricci*. Viking Penguin 1984.

Steiner, Gary A. *The People Look at Television: A Study of Audience Attitudes*. A report of a study at the bureau of applied social research, Columbia University. Alfred A. Knopf 1963.

Stone Harry, ed. *Charles Dickens' Uncollected Writings from 'Household Words' 1850–1859*. Indiana University Press 1968.

Strouse, Jean. *John Pierpont Morgan, Financier and Collector*. Metropolitan Museum of Art 2000.

Sturluson, Snorri. *The Prose Edda*, tr. Arthur Gilchrist Brodeur. American–Scandinavian Foundation 1916.

Suetonius. *The Twelve Caesars*, tr. J.C. Rolfe. Loeb Classical Library edition 1914.

Tacitus. *The Annals*, in Alfred John Church, William Jackson Brodribb, and Sara Bryant, eds. *Complete Works of Tacitus*. Perseus, reprinted 1942.

Teyssèdre, Bernard. *L'Art au siècle de Louis XIV*. Le Livre de Poche 1967.

Thomas, Chantal. *The Wicked Queen: The Origins of the Myth of Marie-Antoinette*. Zone Books 1999.

Thomas, Keith. *Religion and the Decline of Magic*. Weidenfeld and Nicolson 1971.

Thornton, Peter. *Seventeenth-Century Interior Decoration in England, France & Holland*. Yale University Press 1978.

Thornton, Peter. *Authentic Decor: The Domestic Interior 1620–1920*. Weidenfeld and Nicolson 1984.

Thornton, Peter. *The Italian Renaissance Interior 1400–1600*. Harry N. Abrams 1991.

Toynbee, Arnold. *Constantine Porphyrigenitos and his World*. Oxford University Press 1973.

Vasari. *Life of Giovanni da Udine*. http://members.efn.org/~acd/vite/VasariUdine.html (accessed April 2012)

Vincent, Monique. *Anthologie des Nouvelles du Mercure Galant 1672–1719*. Société des textes Français Modernes 1996.

Vitruvius. *Ten Books on Architecture, Illustrated Edition*, tr. Morris Hicky Morgan. Echo Library 2008.

Walton, Guy. *Louis XIV's Versailles*. Viking Penguin 1986.

Wardrip-Fruin, Noah, and Montfort, Nick, eds. *The New Media Reader*. The MIT Press 2003.

Warren, Samuel. *The Lily and the Bee: an Apologue of the Crystal Palace*. Blackwood and Sons 1851.

Wharton, Edith, and Codman, Ogden. *The Decoration of Houses*. Rizzoli 2007.

Whewell, William. *Inaugural lecture, November 26, 1851: The General Bearing of the Great Exhibition on the Progress of Art and Science*. Royal Society of Arts 1851.

Whitehead, John. *French Interiors of the 18th Century*. Laurence King 1992.

Williams, John. *Method to Learn to Design the Passions*, translation of *Conférence de M. Charles Le Brun sur l'expression générale et particulière*, E. Picard 1698, in The Augustan Reprint Society, no. 201. University of California Press 1980.

Williams, Raymond. *Television: Technology and Cultural Form*. Fontana 1974.

Williams, Raymond. *Raymond Williams on Television: Selected Writings*. Routledge 1989.

Wiseman, T.P. *Unwritten Rome*. University of Exeter Press 2008.

de Wolfe, Elsie (Lady Mendl). *The House in Good Taste*. The Century Company 1913.

de Wolfe, Elsie (Lady Mendl). *Elsie de Wolfe's Recipes for Successful Dining*. Heinemann 1934.

de Wolfe, Elsie (Lady Mendl). *After All*. Heinemann 1935.

Wright, Lawrence. *Clean & Decent: The Fascinating History of the Bathroom and the Water-Closet and of Sundry Habits, Fashions, and Accessories of the Toilet, Principally in Great Britain, France and America*. Routledge and Kegan Paul 1960.

Yates, Frances A. *The Art of Memory*. Routledge and Kegan Paul 1966.

Young, Paul. '"Carbon, mere carbon": The Kohinoor, the Crystal Palace, and the Mission to Make Sense of British India.' *Nineteenth-Century Contexts*, vol. 29, no. 4 (December 2007), pp. 343–58.

Zimmerman, H. 'Das inventar der Prager Schatz und Kunstkammer vom 6. Dezember 1621.' *JKSAK*, vol. 30, no. 2 (1905).

Illustration Credits

Page 2 *Reconstruction*, from *The Penguin Osbert Lancaster*, Penguin 1964. Reproduced by kind permission of Clare Hastings.

Page 24 *A Hearth and a Home*. *Denarius* of Quintus Cassius Longinus, showing the *Aedes Vestae*. Wikimedia Commons.

Page 68 *A Table for Games*. Facsimiles of Irish Manuscripts Vol III plate xxxvii Exchequer cloth, 15th century. British National Archives.

Page 116 *The Catalogue of an Unknown Collection*. Liechtenstein Princely Collections.

Page 162 *A Magic Mirror*. Engraving published in *Les Plaisirs de L'Île Enchantée*. Paris, 1673–74, the ballet *La Princesse d'Elide* at Versailles in 1664, Israel Silvestre. Reproduced by kind permission of Fabien de Sylvestre.

Page 206 *A Gilded Cage for a Worthless Crystal: The Koh-i-noor Diamond in the Crystal Palace in 1851, Punch* 1851. Corbis.

Page 256 *A Palace in Your Front Room*. http://craig-y-nos.blogspot.co.uk/2007_12_01_archive.html, Ann Shaw, 15 December 2007. Reproduced by kind permission of Ann Shaw.

Page 302 *Deconstruction*, from *The Penguin Osbert Lancaster*, Penguin 1964. Reproduced by kind permission of Clare Hastings.

Index

Keep in touch with
Portobello Books:

Visit portobellobooks.com to discover more.

Portobello

Also available from Portobello Books

www.portobellobooks.com

THE SECRET LIVES OF BUILDINGS
Edward Hollis

'A tremendous book... Hollis recounts the stories of 13 structures with passion and panache... His book is a rare thing: non-fiction you can reread' *Scotland on Sunday*

'Accessible and ambitious... Hollis has the gift of making these buildings seem real and alive' *Sunday Times*

'A beautifully wrought book: a kind of illuminated manuscript with words taking the place of pictures... Here are wondrous stories writ in stone, and Edward Hollis has written about them very well indeed' *Guardian*

'Engaging, erudite and readable... Hollis is magical on the layers of myth and history in the classical world' *Financial Times*

'There is something Sebaldian about *The Secret Lives of Buildings*: a digressive pleasure in the sheer strangeness of architecture and the mortal intrigues by which it was wrought' *Independent*

LONGLISTED FOR THE GUARDIAN FIRST BOOK AWARD
AND THE BBC SAMUEL JOHNSON PRIZE